MERVYN PEAKE

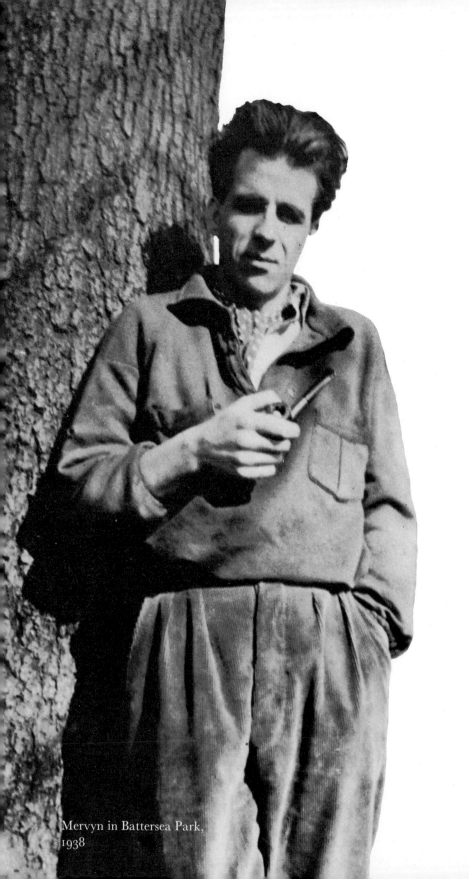

Mervyn in Battersea Park, 1938

MERVYN
PEAKE

Basil

John Watney

MICHAEL JOSEPH · LONDON

Also by John Watney

Non-fiction

THE ENEMY WITHIN
HE ALSO SERVED
CLIVE OF INDIA
BEER IS BEST
LADY HESTER STANHOPE

Fiction

THE UNEXPECTED ANGEL
COMMON LOVE
LEOPARD WITH A THIN SKIN
THE QUARRELLING ROOM
THE GLASS FAÇADE

First published in Great Britain by Michael Joseph Limited
52 Bedford Square
London WC1B 3EF
1976

ISBN 0 7181 1495 7

Filmset and printed by BAS Printers Limited, Wallop, Hampshire
Bound by Redwood Burn Ltd., Esher, Surrey

CONTENTS

ILLUSTRATIONS

All illustrations are reproduced by kind permission of Mrs Maeve Peake, except for those on pages 143 and 144 which are reproduced by kind permission of Mr Fabian Peake.

ACKNOWLEDGEMENTS

First of all I would like to thank Maeve Gilmore, without whose co-operation this biography of her husband would have been impossible. She allowed me to read letters, manuscripts and papers that had been seen by no one else outside the family, and she personally selected the photographs and drawings, the great majority of which have never been published before. I would also like to thank the Peakes' children, Sebastian, Fabian and Clare, for their help, and Fabian in particular for permission to reproduce some of his father's drawings in his possession. All three are now married, but only Phyllida Barlow, Fabian's wife, met Mervyn Peake, and I am grateful to her for her contribution.

Leslie Peake, Mervyn's brother, has provided invaluable information, particularly about the early years. His wife, Ruth Peake, has also been most helpful. Maeve Gilmore's sister Ruth added many useful facts, and Matty and Henry Worthington, Maeve Gilmore's sister and brother-in-law, were generous in their contributions.

I am grateful to those people who knew Mervyn Peake and sent me their recollections. I am indebted to Eric Drake, who wrote from Australia, John Grome, Tom Pocock and Edwin Mullins for their contributions.

I am particularly grateful to Graham Greene for permission to quote from various letters to and from Mervyn Peake, and Josephine Reid, his secretary, for her research. Frederick Crooke gave his time generously despite the fact that he was busy preparing an exhibition.

9

Richard Buckle has been most helpful in producing well-documented material. I would also like to thank Tony Bridge, who came to London to see me, Norah Smallwood, whose recollections were very helpful, Billy Thorne for his descriptions of the Peake family, the Reverend Phillips for his assistance, Quentin Crisp, who allowed me to interview him at his home, Diana Gardner, who gave invaluable information about Mervyn Peake's teaching at the Westminster School of Art, Michael Moorcock for his memories of Mervyn Peake, and Dr 'Robbins', whose real name cannot be given for professional reasons. I am particularly happy to have had a chance to meet Mrs John Brophy who was extremely helpful, despite her recent serious operation.

In working on this book I have made many contacts by telephone and letter. My particular thanks in this respect are due to the following (in alphabetical order) : Rodney Ackland, Laura Beckingsale, Sir Anthony Bowlby Bt, Benjamin Britten, Cecil Collins, Louise Collis, Peter and Joan Cotes, Ethelwyn Crowley, Cynthia Dehn, Francis Dillon, Bill Evans, Susan French, Beatrice Greek, Rolf Harris, Dr Hewitt, Leslie Hurry, Lt-Col. D. A. Johnson, Joan Jolly, Aaron Judah, Esmond Knight, Edmund and Sonia Laird Clowes, Hazel McKinley, M. McIver, Michael Meyer, Lady Moray, John Morris, Christopher Porteous, Marita Ross, Derrick Sayer, Dr Gordon Smith, Maurice Temple-Smith, Hans Tisdall, Victor Waddington, Lyall Watson, Jonathan Williams, Kaye Webb.

I would also like to thank Christian Robertson for her sympathetic editing, and Amanda Estadieu and Lydia Wysocka for the typing and the general secretarial work involved in preparing the various versions of this book.

J.B.W.

CHAPTER 1 A vast and populous plain

Mervyn Peake was born in China on a mountain over-looking a vast and populous plain, just as his hero, Titus Groan, was born in much the same circumstances, at Gormenghast, where

> mean dwellings . . . swarmed like an epidemic around its outer
> walls. They sprawled over the sloping earth, each one half
> way over its neighbour until, held back by the castle ramparts,
> the innermost of the hovels laid hold of the great walls, clamping
> themselves thereto like limpets to a rock.

Gormenghast was set in a great, endless and unknown plain, isolated from everyday thought, a strange, yet recognizable, world with its own rigid ritualistic laws and customs.

Mervyn Peake's birthplace, Kuling, in the province of Kiang-Hsi in Central Southern China, was, at the time of his birth in 1911, equally remote, mysterious and subject to ritual and tradition. It had its 'mean dwellings'—those of the Chinese—that clung to the base of the great hills where, during the hot season, Europeans and their families took refuge, and lived, like the inhabitants of Gormenghast, a superior and remote life, completely separated from the millions who existed around them.

Mervyn Peake's father was Dr Ernest Cromwell Peake, a Congregational Missionary doctor who had graduated in 1898 from the University of Edinburgh and had come out to this remote part of China in 1899 in order to set up the first European medical district (the size of England and Wales) in that area. It had its surgery at

Hengchow (later Hengyang) in the Hunan Province. It was over three hundred miles along the Siang river from Hankow, which was six hundred miles along the great Yang-tse river from the international seaport of Shanghai.

There was no other European medical centre in the whole province; in the years Dr Peake had been there, he had had to overcome the hostility towards foreigners, bred by the Boxer Rebellion, as well as ignorance and superstition. He and his Chinese assistant, Dr Lei, had established a busy and successful practice. Dr Peake was a surgeon as well as a general practitioner and had designed and built the first and only European-style surgery in the area. Hundreds of Chinese came for medical attention every year.

In 1911, he set off as usual for the summer holidays at his bungalow at Kuling, leaving Dr Lei to look after the surgery. He took his wife and six-year-old son, Leslie, first on the two weeks' journey from the Missionary Station by native houseboat to the provincial capital Hankow, and then by British river steamer beyond the Hunan province, along the widening Yang-tse, a further two hundred miles to the disembarkation point at Kiukiang.

Here, amid the Chinese workshops that produced some of the finest pieces of porcelain in the country, was the rest house for foreigners setting off for cool summer mountains.

The journey onwards to Kuling itself was undertaken in special open palanquins, or sedan chairs, carried on poles. There would be four coolies to each palanquin, except in the case of children, for whom only two were enough. The travellers' baggage was carried by other coolies who followed the swaying palanquins.

For the first eleven miles, the procession wound slowly in the intense humid heat (it was usually around 100° Fahrenheit) through the bright green rice fields. Here and there ancient over-grown bridges crossed the streams, and small farms with curved pagoda-style roofs gave some shelter from the oppressive heat. Thousands of frogs croaked continuously, while tall herons stalked after them through the steaming, waterlogged fields. The travellers stopped from time to time in small villages, and while pigs and chickens swarmed around the chairs, the coolies drank their tea. In the distance could be seen the mountains rising out of the hot plain.

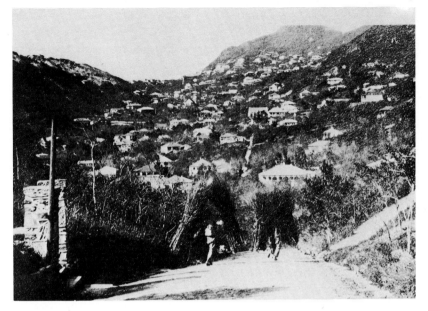

Kuling, 1911

There was another rest house at the foot of these mountains, and then the three-mile climb began: the 'road' was a track, about three or four feet wide, made of stone steps. As the party climbed up the steep path, gulleys, streams and waterfalls appeared. There were clumps of bamboos, over thirty feet in height, and the tall grass was speckled with tiger lilies. The European settlement, a cluster of one-storey bungalows, had, amongst all this grandeur, a somethat suburban air; the houses climbed, one above the other, on each side of a high valley. A rough road and some uneven paths linked the bungalows in which the families of European doctors, businessmen and functionaries gathered during the hot season. In 'the gap', as the high plateau between the mountain slopes was called, was a Chinese village where fruit and vegetables could be bought. On another plateau a herd of cows grazed, so that the visitors could be supplied with fresh milk. The settlement was refreshingly cool after the steamy heat of the plain, and from the high rocks around it the Yang-tse river, fourteen miles away, could be seen winding gently through the vibrating heat-haze.

When Dr Peake first came to Kuling he had rented a bungalow, but after a few years he had supervised the building of his own

house. It was for this that the party now headed, and Leslie re-
membered that

> It was built of stone and though not large had a wide, glassed-
> in veranda on three sides, and it was here that the indoor
> living took place in the day time. The garden was a steep
> slope with a stream running through, forming at one point a
> pool for bathing. Tiger, trumpet and day lilies were rampant
> along with holly-hocks and sunflowers, while a cultivated
> section contained tomatoes, cucumbers, onions and various
> herbs.

Here Dr Peake's wife, Elizabeth, awaited the birth of her child.
There was some anxiety, for twin daughters had been stillborn a
few years earlier. There had been no trouble with the birth of
Ernest Leslie, in December 1904, but the experience of the twin
girls and the long journey so recently undertaken by the expectant
mother gave an added anxiety to the family.

Not that Beth Peake was unused to hardships. She, too, was a
missionary. Born Amanda Elizabeth Powell in 1875 in Glamorgan-
shire, she had come to London as a young girl and had been educated
at Putney High School for Girls. She had become a member of the
Trinity Congregational Church in Croydon and, on 18 November
1901, had sailed for Canton as a missionary nurse. Two years later,
she had married Ernest Peake, whose surgery was three hundred
miles inland from where she was working in Canton. They were
married in Hong Kong on 31 December 1903, and had returned
to Dr Peake's remote medical centre by steamer and house-boat,
by way of Shanghai and Hankow.

Leslie, then a six-year-old boy, recalled that on the day of his
brother's birth there was a 'strange atmosphere' about the house
and, 'having been sent for a long walk in the charge of a houseboy,
a feeling of being banished from I knew not what. The mystery was
only partially resolved when father told me that I had a baby
brother.' This was on 9 July 1911, and the new baby, who had been
born without difficulty, was christened Mervyn Laurence Peake.

A new danger was threatening China: revolution. The country
had been ruled since 1644 by the alien Manchu Dynasty. Of Tartar
origin, the Manchus had overthrown the old Ming Dynasty and
set up their headquarters in Peking, far to the north. Though
inferior in numbers to the Chinese, they had ruled for over two

hundred and fifty years, but after the death in 1908 of the old Dowager-Empress, a two-year-old boy had become emperor. Intrigue and treachery immediately took over and the strong Manchu hold on the subservient Chinese weakened.

Suddenly, revolution broke out, and the Chinese rose in violence against their Manchu masters. There was terrible and fierce fighting, centred on Hankow, where huge areas of the city were burnt out. Casualties were enormous. Most of the foreigners had fled but some of the foreign doctors stayed behind, and Dr Peake, having seen his son safely born, now felt that he should offer his services to the Red Cross, which he knew was at work in Hankow. It was quite out of the question, in the existing state of unrest, to return to his isolated medical centre at Hengchow, and so, leaving his family at Kuling, he set off for Hankow:

> Leaving Kuling I took passage up-river to join the few doctors in Hankow who were organizing aid to the wounded under the Red Cross. We saw grim evidence of the struggle even before we reached our destination. As the steamer approached the city, we passed the scene of a recent battle, the dead still lying on the river bank just as they had fallen. Fighting was going on at the time, the rat-tat-tat of the machine guns being plainly audible.

When he arrived in Hankow, it was to find the greater part of the city in flames, and the foreign Concessions, those areas of the town allocated by the Chinese Government exlusively to European countries, and administered by the Europeans, were filled with Chinese attempting to escape from the fighting. He wrote:

> I made my way through the stupefied crowds to the residence of a friend, and found that his place functioned as the hastily improvised Red Cross Headquarters. There were several doctors there, both British and American, and I received a warm welcome as an addition to the party. It's wonderful what companionship will do in critical situations. I remember that we were a cheerful party, in spite of shells whistling over our heads and bursting in the streets.

The doctors improvised hospitals, but soon the flames from the burning city drew closer and the hundreds of wounded had to be moved to the American Episcopal Mission Church, which was further from the fighting.

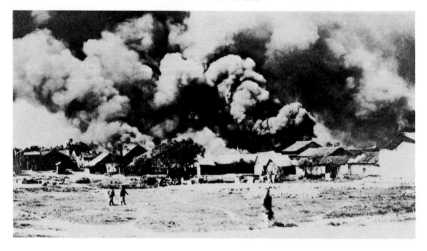

Hankow burning, 1911

Then Dr Peake and a few others commandeered a privately owned steam yacht, with a Chinese crew. She was, Dr Peake declared, 'no beauty, being low-lying in the water, and having a tall funnel', but they flew the Red Cross flag from her bows and launched a hospital shuttle service between Hankow and Han-Yang, a short distance up-river, where much fighting was taking place. Despite the heavy fire, they brought back hundreds of Chinese wounded, both soldiers and civilians caught in their sampans in the cross-fire between the opposing sides. Their frail ships drifted helplessly down stream, and Dr Peake and his boat sailed out to rescue any who might be alive.

> Most [he recalled] were dead in a crouching posture. Many of the boats were semi-swamped in blood and water. An oarsman, shot many times through head and chest, had lurched forward, but still held the oars in his dead hands. One woman, I remember, had fallen back with a baby held to her breast, one hand covering the infant's head. A bullet had passed through her hand, through the baby's head, and through her chest.

Looting was widespread in the almost deserted city, and the looters, when caught, were dealt with summarily, as Dr Peake found. On going down a practically deserted street, he saw 'a decapitated head suspended by its pigtail from a charred telegraph

pole. Along with the head were several cheap umbrellas and some skeins of wool. It was evident that this unfortunate had been caught red-handed with his loot.'

Despite the huge losses of the Chinese Revolutionary Armies, the Manchu forces were not able to put down the rebellion and they began to retreat towards Peking. Hankow, half-burnt and devastated, returned to normal. There was no more fighting in the streets or across the river. People were beginning to return to what was left of their homes, and Dr Peake resumed a more normal tour of duty.

CHAPTER 2 'The first travelling I ever did'

It was not until December 1911 that Hunan province was calm enough to allow Dr Peake and his family to return to the out-station at Hengchow. Mervyn was five months old at the time, a sturdy, healthy baby, who gave very little trouble. This un-remembered journey was to feature in his first published writing, 'Ways of Travelling', which appeared in the London Missionary Society's magazine *News from Afar* with the byline, 'Written and illustrated by Mervyn L. Peake, of North China, aged 10½ years':

> The first travelling I ever did was in a mountain chair when I was only five months old. I was carried shoulder high by four very sure-footed Chinese, while one false step on uneven ground would carry all five of us hundreds of feet below. From the chair I went on to a Yang-tse river steamer. The steamer was very nice and comfortable. I know, because I have been on some since.

At Hankow, which was still showing signs of the recent fighting, the party changed to a slow-moving Chinese houseboat, sailed across the Tung-Ting Lake and up the Siang River, until at last the mooring platform of Hengchow came in sight.

Dr Peake had returned to his surgery not in order to continue his practice, but to pack it up. The London Missionary Society had decided to hand it over to the American Missionary Society. As soon as the details were settled, he was to leave with Dr Lei for Tientsin, a thousand miles to the north, and there take over the MacKenzie Memorial Hospital.

Mrs Peake with Mervyn, Tientsin *c.* 1913

As he went methodically about the business of handing over the station, he must have recalled, with some nostalgia, his first arrival there in 1899, and his long struggle to be accepted as a member of the community. He was particularly sad to say goodbye to the many friends he had made, and to his garden, with its gold-fish pond and lotus lilies, and its oranges, figs and bananas, its beautiful *pumelo* tree, which had fruit the size of human heads, that 'glowed like spheres of gold among the dark green leaves'.

The handing over of the station was completed by the autumn of 1912, and once again Dr Peake and his family embarked on a Chinese houseboat, together with all their possessions. Mervyn was now fifteen months old. The older boy, Leslie, was nearly eight, and at school near Kuling. He was to be picked up at Hankow.

Normally, the three hundred or so miles to Hankow would be covered quickly, as the strong current would carry the clumsy houseboat along. But when they reached Tung-Ting Lake, they found themselves faced with a northerly gale. The houseboat could make no progress against the now bitterly cold wind. They had to moor up for shelter on the lee of a sandbank, and wait until the storm had blown itself out.

> We had of course [wrote Dr Peake later] brought provisions
> for the river journey with us; but had not anticipated such a
> serious delay. The food problem became acute. Fortunately,
> one of the last things which had been thrown on board when
> we left was a case of condensed milk, and this just saved the
> situation for our infant son.

Whether or not it was because of the condensed milk which provided food for Mervyn during those ten anxious days, it is a fact that he was extremely fond of milk for the rest of his life.

When the storm had blown itself out, the houseboat was able to cross the lake to the town of Yo-Chow on the northern side. Here, the travellers found a tiny Chinese tug about to steam to Hankow. Dr Peake would have liked to transfer his family to the tug, but there was far too much luggage. The Chinese skipper agreed, however, to speed matters up by towing the heavy houseboat to Hankow, where they picked up their elder son and continued the journey by rail, first to Peking, and then south-east for seventy miles to Tientsin. The whole journey took a month.

Tientsin was one of the 'treaty ' ports, which had, like Hankow, foreign Concessions. Although it was forty miles from the sea, the Pei-ho or North River, on which it stood, was deep enough for ships to sail up it on the incoming tide. In winter the Pei-ho froze over, and merchants would cut the ice, store it, wrapped in straw, underground, and sell it at a profit in the hot summer.

Like Peking to the north, Tientsin was situated in a flat, dusty plain. From time to time, north-westerly gales would roar down from the Gobi Desert, bringing with them tons of fine sand that would turn day into night for as long as forty-eight hours. It was a harder, bleaker land, very different from the luxuriant China of the south. There were new sights to be seen such as mule-drawn Peking carts, strings of camels from the Mongolian deserts, and even electricity. The shop fronts were covered with ornate carvings.

The city had at this time a population of over a million. The Chinese lived in the overcrowded ancient city, while the foreigners lived mainly in the British and French Concessions outside the native city, the two groups being joined by the Taku Road. It was here that the MacKenzie Memorial Hospital was situated. It had been built in 1861, under the directions of Captain Gordon, an engineer officer who had taken part in the Taku Expedition, and who was later to become better known as General Gordon. In 1868, Dr J. Kenneth MacKenzie had taken over the hospital, and it was later renamed after him. When Dr Peake arrived, it had fallen into disrepair and was sparsely attended, but by working overtime he and Dr Lei so improved it that by the summer of 1913, six months after their arrival, they had a daily attendance of over a hundred patients.

Dr Peake was allocated a three-storey house in the French Concession. It was very cold when he and his family first arrived there and the temperature was often below zero Fahrenheit. There were sledges on the frozen Pei-ho river, and everyone wore fur caps and coats to keep out the driving wind that blew straight from the Arctic regions of Siberia. On the other hand, the air was dry and invigorating and, for the development of a child of Mervyn's age, healthier than the humid, enervating air of the south. After the sudden departure of winter, the ice would melt, and in almost no time at all the temperature would be up in the hundreds.

By the following year, the hospital was running well enough for Dr Peake to think of furlough—that long stretch of home leave given to people stationed in tropical countries. He had not been back to England since a bout of sick leave in 1906–7, and in May 1914 he set off for Britain with his wife and his two sons. He decided that, instead of travelling home in the usual way by ship, they would go by Trans-Siberian Railway, as a branch line had been extended to China after the Russian lease of Port Arthur and Darien in 1898. The party joined it at Irkutsk, having already changed trains at Mukden and Harbin. The train stopped frequently, sometimes in the middle of dark and threatening pine forests, and then no one was allowed off it. But at one of these stops something on the line interested the eldest boy, now nine years old, and made him clamber down on to the track. Without warning, the train started moving again. The missing child was

seen running, headlong, beside it. Dr Peake rushed to an open door, and, holding out his hand, shouted to the boy to grasp it. The train was now moving faster, but with a final spurt Leslie managed to grasp his father's hand and was pulled up, panting and scared. It was a story that Mervyn was to hear many times, the story of a boy almost lost in the wilderness, an echo of which, like so much that was happening to him now, was to be found many years later in one of his tales, 'Boy in Darkness'.

For Leslie, however, this escapade was not the highlight of the journey. He remembered that 'on approaching a bridge over one of the huge Siberian rivers the guards directed all passengers to move to the right-hand side of their compartments, so as to counterbalance some engineering defect in the construction of the bridge.' Mervyn was already showing an intense interest and pleasure in the visual impact of colour. As his elder brother recalls, 'the highlight for Mervyn was when the train stopped at a village in the Ural Mountains and mother bought him, for a few roubles, a glass-topped case containing a hundred fascinating and diversely-coloured stones.'

There was a further change of trains at Moscow. The gleaming cupolas of the Kremlin and priests chanting dirges in a Moscow church seem to have impressed the two boys, and the priests, or perhaps some of the tall, helmeted guards who towered above the small boy, may have been the models for those sinister, helmeted figures that were to appear so many years later in *Titus Alone*, relentlessly pursuing Muzzlehatch.

The journey was resumed; the next change of trains was at Warsaw, and then came the run to Ostend, the cross-channel steamer, and, at last, London. The whole journey had taken twelve days.

How long Dr Peake originally intended to stay in England is not known. Whatever plans he may have had were interrupted by the outbreak of war in August 1914. He volunteered immediately for service with the Royal Army Medical Corps, was stationed for a while at Bulford Camp, and then sent out to a field hospital in Belgium, where he was surprised to find that the matron was his sister Grace, whom he had not seen for many years.

Before he left, he had rented a house—9 Clarence Road, Mottingham, near Eltham in Kent. Both it and the road have now dis-

appeared. Here, his wife and two sons settled down to the sedentary life of suburban England. The elder son went, as a day boy, to Eltham School for the Sons of Missionaries, but Mervyn was still too young to go to school.

W. J. (Billy) Thorne, whose family had known and worked in the missionary world with the Peake family for many years, remembered that:

> The Peakes were good, solid, worthy people. If they had dreams, they kept them to themselves; and then suddenly, woof, a genius. Mervyn's mother was well aware that she had given birth to a wonder. She loved him, and cherished him, for he was a special person.

There was nothing in the earlier background of the Peake family to account for Mervyn's talent. Dr Peake, it is true, could produce delicate water-colour paintings of Chinese landscapes, but that was all. His own father had married a Swiss countess and taken her, as a bride, to Madagascar where he had set up a Congregational Chapel. It was in Madagascar that Dr Peake, his brother George and the sister who became a matron, were born. No one in the Peake family had shown any signs of real literary or artistic talent. Nor did anyone, least of all Mervyn's mother, know where he had found his instinctive ability to 'make pictures'. To her, it was enough that he could do so, and she felt herself lucky to have been entrusted with the care of such a person. While her husband was serving in France and her elder son was studying at school, she had all the time in the world to look after this younger one.

Some holidays were spent with the boys' Peake grandparents, at Parkstone in Dorset. Grandpa—Philip George Peake—had retired from missionary work in Madagascar in 1909, and with his Swiss wife had settled in this part of Dorset. Within the restrictions and anxieties of wartime Britain, these days were tranquil enough for Mervyn, who was spending most of his time drawing and colouring the sheets of paper which his mother was always careful to provide.

In 1916, however, the family was once more on the move. Dr Peake had been released from Army service in order to return to China. During his two-year absence, his assistant, Dr Lei, had been in sole charge and was badly in need of help, and so, in October

of that year, Dr Peake, Beth and their two sons, Leslie, now eleven, and Mervyn, five, sailed for China via the Cape of Good Hope, on a Japanese ship called the *Kashima Maru*. It was quite an adventure for the two boys, for, as Mervyn was to record five years later in his 'Ways of Travelling', 'The whole journey took two months, and it was pretty risky because at that time the war was

Leslie and Mervyn in Dorset, 1915

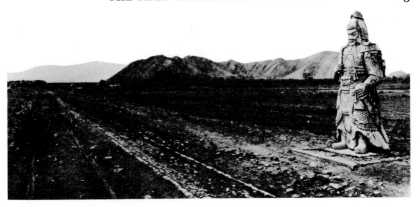

Old Chinese road, photographed by Dr Peake in 1914

on and the German submarines were out.' While they were visiting Cape Town, the boys were offered huge ostrich eggs, some plain and some decorated with colourful views of Table Mountain and other famous tourist attractions. They were asked to choose one each. Leslie as the elder had first choice. He chose a plain one. Mervyn followed. Perhaps in deference to his elder brother, he chose a plain one too, but almost immediately regretted having done so, for he had been instinctively drawn to the brightly-coloured egg. Deference to protocol robbed him of something he desperately wanted. Forty years later, he remembered this small incident and told his brother that he still wished he had stretched out his hand for a brightly coloured egg.

CHAPTER 3 Tientsin

The Peakes arrived safely in Tientsin and returned to the three-storey house with the double shutters which protected it against the dust from the Gobi Desert. Elizabeth Peake renewed contact with Ta-tze-fu, their cook, who liked to walk about the place sharpening a stick. Dr Peake took over the running of the hospital again; Leslie was sent to boarding school at Cheefoo, a small treaty port on the Shantung peninsula; and Mervyn, who was now old enough to go to school, went daily to the grammar school in the British Concession. It was the smaller of the two European schools in Tientsin, but was open to other than British nationals. For a time, he rode there and back on a donkey, which was 'great fun, because he used to gallop like anything'.

Many years later, in 1951, Mervyn started writing his auto-biography. Only a few pages were completed, of which one was a description of this school. It conveys so vivid an impression that it can only be regretted that pressure of other work at the time prevented him from continuing the project:

> It had nothing to do with China. It might have been flown over in a piece from Croydon. It faced the dusty street. Its windows were mouths that shouted, 'I know I'm ugly, and I like it.' There it stood, horrid and ugly among the sweet-stalls on the wide road. The rickshaws would rattle by in the sun, while we tried to remember the name of the longest river in England, the date of Charles II's accession, or where one put the decimal point. I remember only the lady teachers.

26

I think they were all lady teachers, except the headmaster, and a sprightly devil-may-care sort of man who took Latin, and whom we could see the headmaster and his lady staff thought too flippant. I saw him fourteen or fifteen years later in a train in Surbiton. The life had gone out of him. I remembered in a flash as I saw him how he had kept me in one night because of my backwardness, and how instead of punishing me I spent the long summer evening happily bowling to him in the big American recreation ground. What a huge desert that ground was. On the Sunday afternoon on the way back from Sunday school I would watch the huge Americans playing baseball without a smile on their faces. Great men, fifteen feet high at least with clubs to crack the devil's head for ever, dressed up like armadillos. How they would run. From base to base they sped crouching as they ran with their bodies slanting over like yachts to an angle of 45 degrees.

He was beginning to make his own friends and extend his horizons. At school there was one boy in particular, a one-eyed Russian, who fascinated him. The boy's father lived in a 'fantastic tawdry gaudy muddle of a flat'. One day when Mervyn was being taken to a polite tea-party in an unknown part of Tientsin, he saw the Russian boy clinging three-quarters of the way up an enormous Venetian blind, and whooping. To the well-behaved, sedately conducted Mervyn this perilous act of bravado was magnificent. 'He is my god,' he concluded. Throughout his adolescent life, there were to be these 'gods', and the one-eyed Russian boy from Tientsin Grammar School was the first.

The London Missionary Society's Compound was also in the French Concession. It was a quarter of a mile long and an eighth of a mile wide, and consisted of six semi-detached houses, a large single house known as Wilton Lodge, and Dr Peake's hospital, which had a frontage on the Taku Road. There were gate-keepers lodges at each end of the compound, which also had a tennis court, an arbour where the missionaries gathered, and an 'upside down' tree that intrigued the young Mervyn. It was under a tree in this arbour, among the bird-droppings from rooks and pigeons, that Mervyn first read *Treasure Island*. It was to be his favourite reading. He knew it almost by heart, and it was to inspire, many years later, some of his finest illustrations.

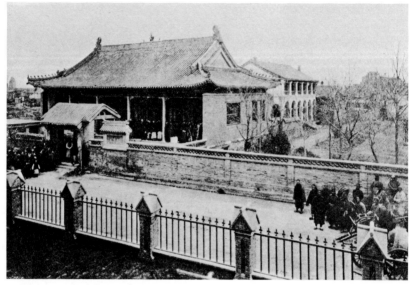

Dr Peake's hospital in Tientsin, 1912

His father's occupation fascinated him, too. He remembered the paperweight and the McVitie & Price boxes of biscuits in his father's room. Once, he watched his father operate while he himself hid, high in the rafters of the hospital. It was an amputation, and when the operation was finally completed and the amputated leg had been carried away on a tray covered with sawdust, the young boy fainted and fell from his perch, revealing his presence to the startled group below. He was to use this episode much later, in *Titus Alone*, when Titus falls through a glass skylight on to a startled group of people.

In 1917 there was a world-wide outbreak of *encephalitis lethargica*, or sleeping sickness. According to Dr Oliver Sacks, an expert on the subject, it started in Vienna in the winter of 1916–17, and soon spread. As many as five million people may have died directly from its effects, but this figure, huge as it was, went unnoticed because of the greater losses of the war and the Spanish influenza that followed it. Worse, perhaps, than the immediate effects of the illness were its long-range possibilities. It was an illness that could be contracted at any age and lie dormant for decades, only to appear many years later, in moments of stress. Somewhere, somehow, during those last few years of the war, it must have sought out and

found, as it did many thousands of other children at the time, the
active and busy young boy in Tientsin. There was nothing at the
time to show that anything had happened—perhaps a day or two
of lassitude—but, like many others of his age, Mervyn Peake was to
carry dormant within him this destructive germ.

Not that his life was affected at the time. His donkey gave place
to a bicycle, and he looked for adventures, particularly with Ngai
Teh, Dr Lei's son, who became his best friend, and with Dr Liang's
family. Dr Liang, who had been educated at Mill Hill School in
London, was now in private practice in Tientsin, and he gave
voluntary service to Dr Peake's hospital. Mervyn would spend
afternoons in the Liang house, admiring the dogs, parrots and
monkeys and making friends with Dr Liang's son, Tony, who did
drawings, and a daughter whose beauty made a strong impression
on Mervyn.

In every spare moment, he would draw. He would sit, as Laura
Beckingsale, a teacher in Tientsin, noted, at the table in his mother's
drawing-room, with sheets of paper around him, and he would
draw anything: shapes, objects, still life or scenes of action. He
would get quite annoyed when he had to clear away all the pictures
when it was time for tea, and he brought them back as soon as the
table was cleared. It was difficult to drag him away when it was
time for him to go to bed.

There were visits to places outside Tientsin, notably to Peking:
'One day,' Mervyn recorded happily, 'I was in a motor car in
Peking when I was seven years old, I counted about one hundred
camels.' Not that he was particularly fond of camels: they were,
he found, bad-tempered and smelly brutes. When he held out his
hand in a friendly way towards one of them, it tried to bite it off,
and only the prompt action of a coolie in pulling him to safety
prevented a serious, even catastrophic accident.

Peking, with its cities within a city, must have fascinated the boy.
Here, as in Gormenghast, there was a convoluted social and political
hierarchy. Designed originally by Kublai Khan, it was a perfect
square with each outer wall four miles long. The streets ran in parallel
lines from north to south and east to west. Massive gateways led
into the city. The great walled square was known as the Tartar
City, and within this was a second city, the Imperial City, itself
surrounded by walls six miles in circumference. Within this city of

The Mandarin,
drawn by
Mervyn Peake,
aged 11

artificial lakes and fine houses was yet a third, the Forbidden City or 'Great Within', once the home of the Manchu rulers, protected by purple walls two miles long. It was a veritable Chinese puzzle.

Mervyn Peake intended to start his autobiography with

CHAPTER ONE

Box within box like a Chinese puzzle—so it seems to me,
was my childhood. Only half do I believe in those far
away days, lost in the black and engulfing sea.

During the summer holiday the family often visited the small
treaty port of Cheefoo, where Leslie went to school. On one of
these holidays Mervyn collected hundreds of leaves to serve as
models for his drawings, for the shape of objects, as well as their
colour, was beginning to fascinate him. On one holiday, at Pei-
tai-ho in 1918, Leslie recalls that their parents,

> on going out for the evening, left us with paper and crayons.
> Having had supper we amused ourselves by sketching the sea
> and islands, fishing boats and kites to be seen from the verandah.
> My own effort was so paltry, set alongside seven year old
> Mervyn's, that for very shame I bribed him to switch our
> sketches. When these were presented to father and mother
> nothing was said, but I do not expect they were fooled.

In the following year, the family returned to Kuling for a holiday.
Dr and Mrs Peake had long wanted to revisit the place where they
had spent so many happy times, and they wanted to show their
youngest son the place where he had been born. The eight-year-
old boy was enchanted by everything he saw: the long climb up
'The Thousand Steps', as the stone path that led to Kuling was
called; giant trees, such as the clump known locally as 'The Three
Trees', under which the family had picnics; and the streams, full
of boulders, which spread out into pools, such as the Dragon Pool
where they could bathe all day. It was perhaps here that the
cautionary tale of the three men drowned while diving for one
another was told to the two boys. It had happened, reputedly,
years earlier. A missionary who was bathing too close to a waterfall
was sucked down by the undertow and failed to reappear. A friend
dived to his rescue, but he too vanished. A third man leapt into the
water only to drown like the other two. It was the sort of story that
would remain long in a boy's memory.

They left Kuling, never to return, and travelled back to Tientsin
and the missionary life in that large treaty port. Mervyn continued
to go to the grammar school to be taught by, amongst others, Miss
Powys, who had, according to Leslie, pink nobbly elbows, and by

Dr Peake and Mervyn, Kuling 1919

Miss Purdom, who was later to work with the Education Department in Malaya, where she was known as 'Cupie'.

In 1921, Leslie was sent to England in a K-class P. and O. liner, returning to Eltham College, the School for Sons of Missionaries, with the enormous—to a schoolboy—sum of £20, won on the ship's daily sweepstake. Mervyn remained in China with his parents, an active, growing, happy boy.

It was now, at the age of ten, that he began to write. His first completed book had the impressive title of *The White Chief of the Umzimbubu Kaffirs*. It was written in a small exercise book, and described the adventures of a boy who was the son of missionaries called Dr and Mrs Silver. It is not difficult to see whom he used for models. The adventures are of a *Treasure Island* type, and it is probably not a coincidence that the family name is Silver, like that of his favourite character, Long John Silver. He also wrote, illustrated and sent off his 'Ways of Travelling' to the London Missionary Society's magazine *News from Afar*. Taken together, these two juvenile efforts foreshadow a feature of Mervyn Peake's future work: the combination of adventure story and illustration which he was to use frequently and in many different ways.

Although no one realized it at the time, the long sojourn in China was coming to an end. Early in 1923, Dr Peake returned once more on furlough to England, bringing with him his wife and younger son. When he arrived on 23 January 1923, he had every intention of returning to Tientsin, but the long years in China had begun to undermine his wife's health. She was forty-eight, and it became apparent that a return to Tientsin would be too great a strain. Dr Peake realized that he would have to give up the work he had been engaged on for the past twenty-five years, and so, in 1924, he resigned from the London Missionary Society and looked for a practice in England.

Mervyn would never return to China. Early in 1923 he joined his elder brother as a boarder at Eltham College. The images and pictures of his childhood in China were exchanged for those of life in England, but though the English ones were to become more and more dominant, the old Chinese underlay stayed undisturbed, and its influence on his work would remain.

CHAPTER 4 Eltham College

Eltham College had opened as the School for Sons of Missionaries on 1 January 1842. The fees for boys under twelve years old were then £15 a year; for boys over twelve they were £20. In 1856 a new school was built, as the *Illustrated London News* announced, 'in the domestic style of the fifteenth century' at Blackheath. Known irreverently as 'The Old Barn', it served its purpose until in January 1912 the school moved to Mottingham in Kent, when its name was changed to Eltham College. Here Mervyn was sent in 1923. Leslie had gone there first in 1914, had done well both in work and games, and was now a prefect, as Mervyn was to find out only too soon. On his first day at school, he and another new boy, Colin Frame, who was later to become a journalist, were exchanging their impressions in their dormitory after lights out. Suddenly the door was flung open, and Leslie came into the dormitory.

'Who's talking?' he asked.

Mervyn replied that he was, and immediately received a caning. The two might be brothers, but school discipline was school discipline, and the penalty for talking after lights was the cane. Neither of the brothers enjoyed the next few minutes.

Leslie was to leave two terms later, but a schoolboy friend of his, Gordon Smith, who was five years his junior, eventually became Mervyn's friend and protector. It was a friendship that was to last for many years and to have some interesting artistic results.

Mervyn Peake was not a brilliant scholar: he was quite incapable of passing examinations. He even failed in English, but explained

34

seriously that it was merely an examination in spelling, and he never could spell. He was not the first, or probably the last, writer to consider spelling unimportant. He was, anyhow, heavily protected by the art master, McIver, who considered him even then to be a genius. When, at a staff meeting, there was some talk of sending him down for lack of academic progress, McIver, with unusual prescience, said, 'You may be turning out one of our greatest future Old Boys.' The Headmaster decided that this unacademic-minded boy should stay on.

If he did not shine at lessons, he did so as an athlete, a cricketer and a rugby player. Once again he found a god. This time, it was Eric Liddell, who as a boy had been at the school from 1908 to 1911, twelve years before Mervyn, and who had become a national hero. He played rugger for Scotland in 1923 and 1924, and in the 1923 match against Wales at Cardiff, which Scotland won 11–8, he and two other Scottish players were carried off the field shoulder-high by their Welsh opponents, as a tribute to the magnificent way they had played. In the 1924 Olympic Games in Paris Liddell won the 400-metre race, setting up a new world record. It is more than probable that he would have won the 100-metre race, his favourite distance, had he not refused to enter the preliminary heats because they were being held on a Sunday.

Inspired by this 'god' and also by the fact that his father, uncles and elder brother had distinguished themselves at games at the school, Mervyn, in his six years at Eltham, got his colours for cricket and rugby, and set up a school record for the high jump which was only recently bettered.

But in the end it was in neither art nor games that Eltham was to influence him most strongly. It was in literature. On the staff at this time there were two brothers, H. B. and E. S. Drake. They were the sons of a Baptist missionary and were old boys of the school, who had joined the staff in 1921, Eric Drake only five years after leaving it as a boy. A contemporary, F. W. Scott, wrote in *The Glory of the Sons*, a book about the school published in 1952:

> While their ideas were not generally adopted throughout the school, they stirred the imagination of staff and boys and threw some doubts on the alleged virtues of orthodox pedagogy. They left the feeling of a fresh if somewhat cool breeze blowing through a slightly stuffy scholastic atmosphere.

Their main interest was English literature. They produced and played in a record number of Shakespearian plays, and both of them encouraged imaginative and individual thought. E. S. Drake organized continental tours and camping holidays, and edited the school magazine. He, in particular, was to have a considerable influence on Peake's literary development both then and in the future.

Writing many years later (26 August 1975) from Australia, Eric Drake had this to say of the writing and drawing which Mervyn did at Eltham:

> His stories were typical 'westerns' and from the literary point of view were not quite as original and convincing as those of the two or three most brilliant boys (they did *not* become authors!) but on the other hand the drawings with which he filled the margins (they used 'Chapbooks' and were encouraged to leave wide margins for illustrations) were quite brilliant in both perception and vitality.

According to Leslie Peake, Mervyn 'thoroughly enjoyed his six years as a boarder at Eltham'. This is probably true. Apart from his successes on the playing-fields—a factor that always makes boarding-school life more attractive—he was undoubtedly fascinated, as he had been in China, by the intricate protocol of school life. Here there were customs to be observed, rules that could not be broken, behaviour patterns that were as traditional and immovable as the regulations that governed Gormenghast.

Eltham also provided much of the background material for descriptions of Titus Groan's school days. The professors' common room with its mixture of smells 'including stale tobacco, dry chalk, rotten wood, ink, alcohol and, above all, imperfectly cured leather' was undoubtedly modelled on the Eltham common room. The cloisters of Gormenghast were those of Eltham, as the sketches made later by Mervyn clearly show. The dangerous game played by Titus and his friends is much like the initiation rites of any boarding school.

There was, too, the linen-room, with 'Ma' Capon (all the ladies at Eltham were called 'Ma') as the Mistress of the Linen. There was the tower, reached by a spiral staircase, where the school flag was flown on speech days. There was the 'menagerie' (abbreviated to Mangag), the lowest form in the school; the quadrangle, with an

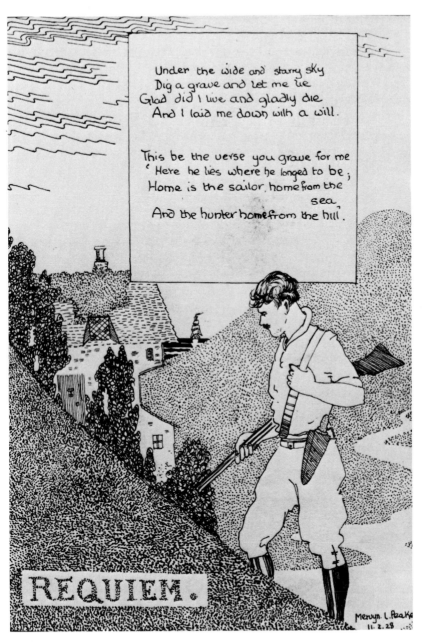

Under the wide and starry sky
Dig a grave and let me lie
Glad did I live and gladly die
And I laid me down with a will.

This be the verse you grave for me
'Here he lies where he longed to be;
Home is the sailor, home from the
 sea,
And the hunter home from the hill.'

REQUIEM.

Mervyn L. Peake
11. 2. 28

Requiem, 1928

asphalt surface, and buildings on four sides, where touch-rugger was played during break. There were the Eltham maids, all with their own nicknames: Sweet-as-Sugar, Beauty Comp, Sour Grapes and Inter-alia. There was the large hall at Eltham, known as the King George dining-hall, capable of holding a hundred and twenty boys at a session. During the summer tents were pitched next to the playing fields and here the boarders slept out. On the last Saturday of June, there was the annual cricket match between the School and the Old Boys, while on the last Saturday of October the School versus Old Boys' rugby match was played. Each event was followed by a concert.

To the watchful Mervyn, some of the Old Boys were remarkably fascinating and mysterious, and remained vividly in his mind long after his schooldays were over. In that projected autobiography of 1951, he mentions (tantalizingly, for one would wish to know more) two of them: 'The Old Boy who worked at perpetual motion was related to the man who found a white leopard', and 'The O.B. whom nobody talked to but who never failed to turn up'.

All these impressions and memories of Eltham College had their place in the store-room of his mind, upon which he relied for material for his imaginative work.

But there were even closer connections. Many of the professors in *Gormenghast* seem to be based directly on the Eltham masters. The fictitious Bellgrove must surely have been modelled on the real headmaster of Eltham at the time, the easy-going Scotsman 'Rabbi' Robertson, who allowed the school so much freedom that E. S. Drake could get up a Christmas party and recite the limerick

There was a young fellow named Rabbi,
Whose neck was exceedingly flabby,
So he wore a high collar
To help him to swoller
And now he can swill like a cabbi.

'Rabbi' Robertson would, according to an old boy, Clifford Witting, make 'his way between the banked tiers of boys and masters, in his white-hooded gown and tall white collar, his head—as always—tilted to one side'. Surely this is Bellgrove, or at least the germ of him, whom Peake describes thus:

In the cold light that now laid bare the rendezvous, the red gowns of the professors burned darkly, the colour of wine.

Not so Bellgrove's. His ceremonial gown was of the finest white silk, embroidered across the back with a large 'G'. It was a magnificent, voluminous affair, this gown, but the effect was a little startling by moonlight, and more than one of the waiting professors gave a start to see what appeared to be a ghost bearing down upon them.

When, possibly somewhat to his surprise, the mixed and often unruly group of professors obeyed his order to be silent, he

> . . . dropped his head so that with his face in deep shadow he could relax his features in a smile of delight at finding himself obeyed. When he raised his face it was as solemn and as noble as before.

The professors in *Gormenghast* often seem to speak like the real-life Dr Bakker, the language master at Eltham, who came from Holland, and who was so fond of gardening that he was often mistaken for the gardener. 'He was', recalls Witting, 'a very large old gentleman with enormous hands—or so they seemed—and pure white hair.' His pupils were, for the most part, his 'dear boysh', but if he was annoyed with one of them, he called him 'bloke'. Witting recalls that his methods of teaching were exceedingly dramatic:

> The first boy having failed to go beyond 'Er' (with an oral translation), Bakky would award him with an order-mark, and then would rap out the command: 'Next boy.' This unfortunate lad might prove as tongue-tied as the first and would also receive an order-mark, after which Bakky would press on with increasing momentum, the class now utterly panic-stricken: 'Next boy! . . . Order Mark! . . . Next! . . . Order Mark! Next! Order-mark! Next! Order-mark! Next . . .'

> Happily for us, the very speed of the proceedings prevented those black marks from being recorded against our names. In any event, Bakky had forgotten and forgiven in a matter of minutes and once again we were his 'dear boysh' until the bell in Central Hall summoned us to another classroom.

The diminutive George 'Gee-Gee' Griffiths, the classics master at Eltham, may well have been the model for Peake's disappearing Mr Throd. Griffiths was small enough to hide under a boarder's bed (to find out whether swearing really went on in the dormitories).

Tiny Professor Throd, who had not seen a woman for thirty-seven years, collapsed upon his face and lay, 'his arms and legs spread-eagle like a starfish', when he first met Irma Prunesquallor. Later, when Doctor Prunesquallor had undressed him, except for his mortar-board, and administered a sharp blow on his spine, Throd leapt up, and was 'seen to streak across the room and out of the bay windows and over the moonlit lawn at a speed that challenged the credulity of all witnesses'. It was at the very moment that Bellgrove was holding Irma, for the first time, in his 'gown-swathed' arms.

> Turning her startled eyes from his, she followed his gaze and on the instant clung to him in a desperate embrace, for all at once they saw before them, naked in the dazzling rays of the moon, a flying figure which for all the shortness of the legs, was covering the ground with the speed of a hare.

It is possible, of course, to exaggerate the effect on a writer of his early experiences. Bellgrove and the professors at Gormenghast are such rich and imaginative creations that they could not have been mere replicas of people observed at school. But just as Dickens used his father as the starting-point for the creation of Micawber, so Peake used his memory of his old headmaster as a basis for Titus's. As so often happens in literary creation, the character of Bellgrove, once set on its course, far outstripped the original model and he became a 'person' in his own right.

5 First successes

Soon after his return from China, Dr Peake bought a practice at Wallington in Surrey. He chose this district partly because a number of London Missionary and Baptist Society members had retired there, and partly because it was a growing residential area which attracted the professional classes. In a large, red-brick, Victorian house at 55 Woodcote Road, called Woodcroft, Dr Peake, after his twenty-five years as a missionary, put up his brass plate and went into private practice. Woodcroft took the place of the three-storeyed, double-shuttered, Tientsin house as Mervyn Peake's home. There could hardly be a greater contrast between the turbulent, international life of the great Chinese treaty port and the quiet, genteel, suburban existence at Woodcroft. It had a Victorian portico, and a conservatory on one side. Its rooms were large, cold and airy. Dr and Mrs Peake had brought some of their furniture back from the Far East, notably a Chinese carpet and table, and a Moutrie piano from Shanghai, made without gum because it would have melted in the heat. Beth Peake liked to sit at this piano, with her boys beside her, playing nursery songs and hymns. Her dark hair was starting to go grey, but her sharp Welsh features were as firm as ever, and her hazel eyes grew bright as the music filled the large room. There were other treasures from China, such as bronze bowls, candlesticks and eggshell china cups and saucers. There were water colours painted by Dr Peake, and albums of Chinese photographs. He had always been a keen photographer. On the long journey he had undertaken in 1903 from

Hengchow to Canton to join his fiancée, he had photographed the strange, heraldic beasts standing on each side of the ancient, stone-slabbed highway that had been the main trade route before the coming of foreign steamers on the great rivers.

> I felt [he recorded] that these pieces of sculpture, hewn out of solid blocks of hard stone, must have lain there for centuries. The pieces had been placed at regular intervals, and faced one another from both sides of the roadway. They represented savage replicas of the brute creation; rampant lions, elephants, wild boars.

The family was well-knit, close and friendly. Despite his experiences, often terrible in China, Dr Peake always retained a kind of innocence so that he saw life differently from those around him. It is recounted that on one occasion, soon after his return from China, he had to buy a train ticket. When the ticket clerk told him how much it cost, Dr Peake automatically offered half the sum: bargaining had been part of the way of life in China, and no one would think of paying the original sum asked. What the startled ticket clerk said is not recorded. Mervyn Peake inherited something of this innocence.

The family was fond of enlivening mealtimes with word games. One member would quote an excerpt from *Treasure Island*, and the others had to guess its context in the book. Soon, as Leslie recorded, 'we all became near word perfect'. At other times they would read passages from favourite books. Mervyn was particularly fond of declaiming long passages from Marlowe's *Tamburlaine*. These were not sterile intellectual exercises, but exuberant outbursts of well-known and much-loved passages of literature.

Mervyn left Eltham in 1929. Dr Peake was busy with his flourishing practice, and Leslie, now an accountant, commuted daily to the City. There was never any doubt, however, that the younger brother should become an artist, and there was none of the opposition from the family that is so often encountered by an aspiring painter. Even from his boyhood it was assumed that Mervyn would be a painter, and the obvious step was to send him to the nearest art school. So he went to the Croydon School of Art, travelling there daily from Woodcroft, and receiving for the first time some formal instruction in painting.

His first art teacher, apart from McIver at Eltham, was a lady

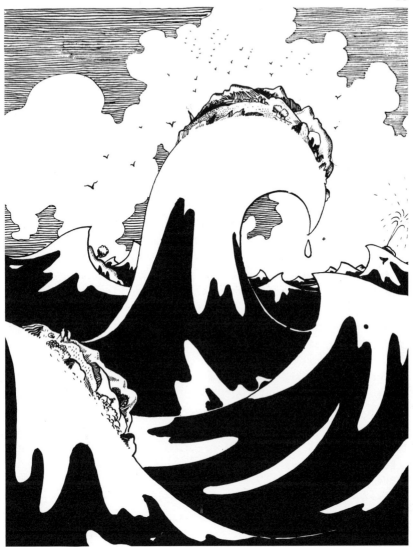

The Wave, c. 1933

from Wallington who gave private lessons in the use of water-colour. Her advice was simple: 'You start at the top left-hand corner and work downwards to the right. After that, you put in the "mystery" by covering the whole picture with Paynes grey wash.'

The same teacher took him to an exhibition of Dutch paintings

at the Royal Academy. When he reached the Van Gogh room, he was transfixed: he had never seen such a world of shock and colour before. He was pulled away with as much force as the elderly water-colourist could muster and told not 'to look at or consider this monstrous travesty of all things beautiful', but he had been introduced to a major artistic influence of the time, one that was to affect his painting for years to come.

Now, at the age of eighteen, he began to paint with increasing excitement and concentration, at the same time retaining his interest in games, particularly rugby. While he began to accept the disciplines of professional painting, he still had time to accompany his elder brother on a rugger tour of Devon and Cornwall. He played most Saturdays for the Eltham Old Boys team, although, as Billy Thorne, who organized these matches, ruefully remembered, 'I had to ring his house every Saturday morning, and ask his mother to remind him that he was due to play that afternoon. He was so absent-minded that he was quite likely to forget.'

He did not stay long at the Croydon School of Art, for on 17 December 1929 he was accepted by the Royal Academy Schools in London for a five-year course of study.

He was by now a tall, thin young man. He usually put his own height at around five foot eleven-and-a-half, but his mother, who was five foot three, told him that if he would stand up properly and hold his shoulders back, he would be six foot. Although he had not yet acquired the thin, haunting features he was to have as a grown man, his eyes were deep-set and extraordinarily intense beneath his dark eyebrows, and the young-lady tennis players who came to Woodcroft began to find him attractive.

He dressed casually but in a conventional way. His usual clothes were grey flannel trousers, an open-necked shirt, knitted pullover, sports jacket and black, fairly well-polished shoes. He often wore a very long grey mackintosh, and sometimes a beret. The more flamboyant outfits were yet to come. He had a sartorial sense of humour, as shown on the occasion when he turned up, much to the horror of his fellow students, in a blue pin-stripe suit, stiff white collar and sober tie, complete with bowler hat and umbrella.

He travelled each day to Piccadilly from Wallington. He did not hide himself behind the morning papers like the other com-muters, but spent the time sketching them on the pad he almost

always carried with him. As most of their bodies were hidden behind their newspapers, the only parts of them he could really see were their hands and so he would sketch these. In time, he could draw the human hand from memory in every kind of position.

The courses at the Royal Academy Schools were rigidly set. In the workshops, the students were expected to copy the original with complete accuracy. Hours would be spent in reproducing over and over again a portion of the human body, a perspective, a combination of tone. Individuality of expression was not encouraged. The emphasis was on a patient, exact rendering of the object under review. The goal was craftmanship and technical perfection.

There were many promising students there at the time, including Peter Scott, Leslie Hurry and Tony Bridge, but all would probably agree that Mervyn was one of the most talented. Tom Monnington, later to become Sir Thomas Monnington, President of the Royal Academy, was a teacher there at the time, and he must be one of the few people on whom Mervyn Peake made no appreciable impression, for on being asked if he remembered him at the Academy Schools, Sir Thomas replied:

> It is a strange thing that although Mervyn Peake was probably one of the most outstanding students of his time at the Royal Academy Schools, I have a far less clear memory of him than of many of his contemporaries, Tony Bridge for example. Perhaps there was no common bond of sympathy and understanding between us.

When not engaged at the Royal Academy Schools, Mervyn was busy at Wallington on a number of projects. Dr Peake, with the somewhat mistaken idea of helping his son in his chosen career, persuaded one of his patients to commission Mervyn to paint the portrait of his daughter. The patient promised to pay as much as £20 for the picture, and Mervyn set to work immediately. He was unfortunately going through an experimental phase where, à la Rembrandt, everything had to be in darkness, and now he pushed the experiment so far that the result was an almost complete 'nightscape' in which the sitter appeared to be coal black. It was with some difficulty that Dr Peake persuaded the irate customer to accept the painting and pay up.

For some time now, Peake had been engaged with his Eltham friend, Gordon Smith, on two rather esoteric productions, *The*

Illustration for *The Moccus Book*, 1930

Moccus Book and *The Three Principalities, Soz, Foon and Chee*. The words were by Gordon Smith, the illustrations by Mervyn Peake. *The Moccus Book* described a number of strange semi-animals with names like the Pleeka and the Arapooki, linked by rhyming couplets. It was a forerunner of work that Mervyn was to do later on. *The Three Principalities* told the tale of a fictitious land that had many similarities with China. There were, for example, the Yellow Plains

Illustration for *The Moccus Book*, 1930

of Ho, and the Castle of Barzelle (a hint of Gormenghast?) standing alone amid its swamps and marshes. They could not however find a publisher for the books.

The two young men had been to Clermont Ferrand (picked at random with a pin) in France on a holiday. There had been nightingales singing sweetly outside the house where they stayed. On the first few nights they listened enchanted: by the fifth, they were throwing their boots at the pesky little creatures.

At about this time Mervyn entered for the Arthur Hacker prize, one of the awards offered by the Royal Academy Schools. There were two of them, one for a portrait, the other for a painting of a lady in an evening gown. He chose the second, perhaps because particular emphasis had to be given to the arms and hands, and with his daily practice of sketching endless hands holding up newspapers on the commuter trains, he felt he might have a chance. He was right. He won the prize, for which he was awarded a silver medal, and, perhaps more important, the respectable sum of £30.

In the same year he had a painting accepted by the Royal Academy: a still life entitled *Cactus*. It shows very strongly Van Gogh's influence: the composition resembles that of the Dutch painter's *Chair* and the colour is as strong and heavily applied. Although his mother and father were pleased at his success, for it vindicated their faith in him, he seems to have felt, even then, that once was enough. He never submitted another painting to the Academy.

A photograph was taken of him strolling down the alley-way behind the Royal Academy, where so many hopeful exhibitors have walked before and since. He is carrying the painting under his arm, and is looking both pleased and shy. It was reproduced in the *Sphere* of 4 April 1931, under the somewhat misleading caption

> BOHEMIAN. The days and manners of Trilby and *les jeunes* are, it is believed by many overpast, but a greater knowledge shows that they still exist in artistic circles.

In fact, the only remotely Bohemian feature was the beret, heavily pulled down over the left ear, and this useful head-gear was a standard piece of an artist's clothing at the time.

Young painters were getting together in groups. A group could consist of as few as five or six painters, and was generally based on

the rendezvous—public house, restaurant or café—where they met for meals. Spontaneous exhibitions would be arranged. Thus the 'Soho Group' suddenly came into being. It was so called because its epicentre was the Regal Restaurant in Greek Street, Soho. Here six young painters, including Peake, would meet, and here, between December 1931 and January 1932, they held an exhibition of their work. An ambitiously-designed catalogue offered forty-two paintings and drawings 'on the first floor', at prices ranging from one guinea to thirty pounds. Mervyn Peake had twelve paintings, including one entitled *Cactus*, priced at twelve guineas, which was probably the Royal Academy exhibit of the previous summer.

Adherence to one particular group did not preclude membership of another. Peake was also a member of the 'Twenties Group', so called because all its members were aged between twenty and thirty. The Wertheim Gallery put on an exhibition by this group at 3/5 Burlington Gardens from 3 January to 23 January, 1932. Among the exhibits were works by Barbara Hepworth and Victor Pasmore. Mervyn Peake had three paintings in the exhibition, one of which was entitled *The Chef* and had already been exhibited under the aegis of the 'Soho Group' at yet another restaurant, the Chat Noir, in Old Compton Street. This painting was reproduced in the *News Chronicle*. It shows a chef looking confidently, and somewhat arrogantly, to the left. He wears a white chef's cap and his large hands rest complacently in his lap. Much later, in the Gormenghast books, Peake was to introduce another confident and arrogant chef called Swelter.

Frederick Crooke, who was at the Academy Schools at the time, recalled that

> The Chat Noir was a tatty little restaurant run by a French-man who was always in shirt sleeves and invariably wore a trilby, whether he was indoors or outdoors. It was said that he could get you a false passport if you wanted one. The food was very cheap, and there was plenty of wall space to hang paintings, and that was the point. We were the first of the groups. After that, lots of other people followed our example.

An astute reviewer of the *Birmingham Post* showed admirable Midland acumen in advising his readers to buy Mervyn Peake's work: they were, at 'their present prices, an excellent investment for the discerning speculator'. There is no record of who, if any-

one, followed this reviewer's advice, but right from the beginning
Mervyn was able to sell his paintings. The prices might not be high,
but his way of life, divided between his father's house at Wallington,
the world of the Royal Academy Schools, and the various groups
he had joined, was inexpensive. He was not one for drinking, and
his social life centred around the tennis parties at Woodcroft and
the lady art students at the Royal Academy Schools.

> There always used to be a party at the end of term [Frederick
> Crooke recalled] and a dance in the Exhibition Room. It was
> a very sedate business really. You had to wear dinner jackets;
> we wanted to make something of a splash. There used to be
> then two horse-drawn hansom cabs at Piccadilly. Their
> drivers were very ancient men. I remember a group of us,
> including Mervyn, hired one of these cabs and drove into the
> forecourt of the Royal Academy. Mervyn was sitting on top
> with the driver, and waving and shouting with excitement.

Since his elder brother, Leslie, had joined a firm of accountants
in Malaya in 1929, Mervyn had had the Wallington house much
more to himself. He had established the habit of spending many
hours, when at home, working in his room on the ideas that were
beginning to flood in upon him. He was now twenty-one, full of
energy and drive, with a talent that was beginning to spread out in
new directions.

He would accept any challenge. When a small repertory company
called the Tavistock asked him to design the costumes for a pro-
duction of *The Insect Play* by the brothers Capek, he did not hesitate
to accept the commission. Although he knew nothing of the stage,
he launched himself enthusiastically into the work, and soon the
large Victorian house at Wallington was full of wholly new and
imaginative renderings of the humanized insects of the play. Peake
took to designing stage costumes with the same spontaneous ease
with which he had taken to drawing, painting, cricket and rugger.

The play was scheduled for a two-day performance at the
Tavistock Little Theatre on Friday 25 and Saturday 26 November
at 8 p.m. Tickets cost sevenpence, one-and-six, and two-and-six.
Alec Clunes was cast as Felix (a butterfly), the Ichneumon Fly
and the Commander of the Yellows.

It was a routine 'rep' production, but the unusual costumes
attracted considerable interest. When the performance was over,

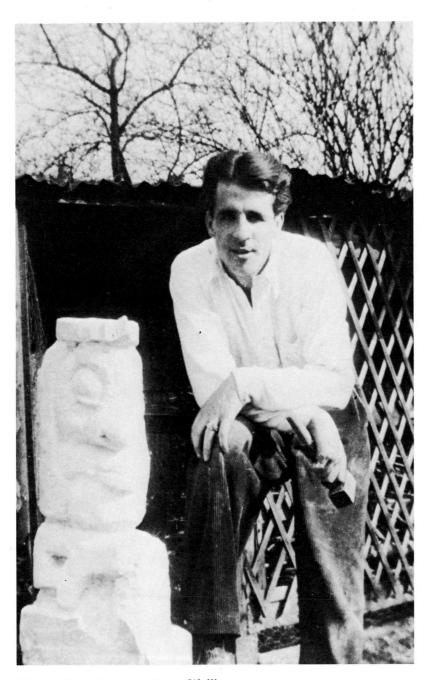

Mervyn Peake in the garden at Wallington, 1932

Peake collected his designs and took them back to Wallington. His first excursion into the world of the theatre left him with a liking for this visual mode of artistic expression.

Such activities as this were taking up more and more of his time, and he was finding the rigid and conventional teaching at the Academy Schools less and less rewarding. His lack of academic interest led, as it had done at Eltham, to the authorities considering the possibility of sending him down. In the meantime, the Wertheim Galleries held a second exhibition of paintings by the Twenties Group. In it was a portrait by Peake entitled *The Wild Head*, priced at five guineas. After the exhibition was over, he left the Academy Schools in June, never to return. A counter-attraction to London had appeared; it was the tiny Channel island of Sark, ten miles from Guernsey and under thirty miles from the French coast.

CHAPTER 6 Sark: 'an outstanding exhibitor'

Mervyn Peake had not chosen the isle of Sark, although he had been romantically attracted to islands ever since his affection for *Treasure Island* began: it was rather that Sark, through the agency of E. S. Drake, chose him. Eric had left Eltham College in 1926, when 'Rabbi' Robertson was appointed headmaster of George Watson's College in Edinburgh. Now, seven years later, he was married to an artistic American, Eloise (or Lisl, as she was called), and their joint ambition was to found an artists' colony in a remote part of the world. A number of communities of this type were being established at this time: some were as far away as the Pacific, others, such as Clough Williams-Ellis's Portmeirion experiment, as near as North Wales. The belief was that if artists could live together cheaply, free of the sordid necessity of making a living, they would produce fine work.

The Drakes settled for Sark, and in the extraordinarily short time of seven weeks a gallery was built to plans drawn up by Eric. A small, moustachioed man with a large dome of a forehead, hair brushed sharply back, glasses on his nose and a pipe in his mouth, he seemed to be everywhere, supervising the building of the gallery. It measured fifty feet by twenty feet, and the main gallery had two studios on top. It was surrounded by a verandah, and had a roof garden which could offer, as Drake pointed out in his prospectus, 'a pleasant rendezvous where ideas may be thrashed out'.

It incorporated a number of building novelties. A Sarkese contractor called Bryan Hurley was in charge of the construction; he

53

Mervyn Peake (*l*) with Eric Drake (*r*) at the Sark Gallery

had used reinforced concrete containing Guernsey granite dust (supplied by Messrs A. & J. H. Falla of St Sampson's, Guernsey), which gave the building a blueish tint, and Drake was convinced that there was a great future in the building trade for this kind of finish instead of the usual white. The ceiling was made of the then new 'hy-rib' reinforced metal lathing, and the lighting was so arranged that no shadows fell on the paintings. A spiral staircase in the centre of the gallery led to the two studios above. The verandah was of pink concrete.

On first arriving in Sark Mervyn Peake lived in a tin hut. There was a number of these huts, normally used to accommodate holiday visitors. They were comfortable enough for their purpose, and Peake painted in one of the new studios above the gallery.

Years later in December, 1946, Lisl, who was divorced from Eric Drake and married to a Viennese doctor, wrote to Mervyn from New York, addressing him as 'Dear Old Muffin'. This nickname he apparently acquired in Sark (his own family called him Merv); it derives from a phonetic distortion of Mervyn, which, pronounced in the Welsh manner, becomes Marffin. From there to the anglicised Muffin is a short step. Lisl writes:

Mervyn Peake painting in his Sark studio, 1933

Sark! — — how one's memory tingles at the word. It still remains to me one of the most vivid portions of my life, and I will never be satisfied until I can return there, if only to make sure that it is no less wild and charming than it was.

The reason for the letter was the reading of Mervyn Peake's first novel *Titus Groan*, which had brought back nostalgic memories of 'the deep-set eyes of the same old Muffin who used to strum his ukelele on the roads of Sark' and of

the days when you were mulling round in a heap of untidy canvases and odd sheets of paper each scrawled with one of your inimitable sketches, so full of life and vigorous line (and of course one must add the pet cormorant who was waddling around the studio shooting his doings with indiscriminate aim all over canvases and floor).

The first exhibition took place on Wednesday, 30 August 1933, which, according to R. H. Naylor's astrological prediction in his popular world-wide column 'What the Stars Foretell', was fated to be 'a remarkable day for many'. The opening date was to have been 1 August, but it had been put back because of construction delays. Even by 30 August, the iron spiral staircase had not received its

coat of concrete, but was in its unfinished state, rather more elegant than it was later to become.

La Dame de Sercq, Mrs Hathaway, and her American husband who was known as Le Seigneur, arrived at 3 p.m. to perform the opening ceremony. It was a fine, hot day. Visitors and reporters mingled with the artists and Sarkese. Eric Drake made what a local paper afterwards described as a 'bright little speech' thanking the Dame and the Seigneur for their interest, and the builder for his speed. The Dame then turned the key in the lock, saying, 'I declare the Sark Art Gallery open and have much pleasure in wishing all who exhibit their pictures success and prosperity.' The local reporter noted appreciatively that 'appetising refreshments were dispensed in a nearby marquee'.

Mervyn Peake had eight oil paintings in the exhibition, mostly views of Sark or portraits of Sarkese. He also exhibited eight water colours, which ranged from views of the Puy de Dome to spring in the Auvergne (presumably inspired by the time that he and Gordon Smith had visited that part of France), a Sussex farm, and further views of Sark. Finally, there were seven black-and-white figure drawings. Prices ranged from twenty-one pounds for a large oil painting entitled *Darts* to fifteen shillings for one of the black-and-white drawings.

There was a number of other painters exhibiting at the Gallery, including his old friend from the Academy Schools days, Tony Bridge, and Bridge's future wife Brenda Streatfeild. Bridge, an up-standing bearded figure, was the leader of the artist colony. Not all the Sarkese approved of the activities of these strange young painters, and some of the more conventional painters who had lived there for years resented the intrusion. However, the Dame and the members of the Chief Pleas (composed of the owners of the forty original telements) welcomed the establishment of a gallery on the island. So did the owner of the Dixcart Hotel and those involved in other commercial undertakings. The local press was enthusiastic, for nothing so newsworthy had come to the Channel Islands since Victor Hugo had been a voluntary exile in Jersey, eighty or so years earlier. Mervyn was a favourite subject of the press reports. The *Guernsey Press* called him 'an outstanding exhibitor' while the *Star and Gazette* used the words 'something approaching genius' when describing the work of this young man, 'still on the sunny side of

twenty-two'. Not all the Sarkese, however, agreed with this assess-
ment. One of them, depicted in the *Darts* painting, threatened to
sue Mervyn for making him 'look like a monkey'.

This first exhibition attracted enough attention for the Cooling
Galleries of 92 New Bond Street, London, to put on an exhibition
under the general heading 'Paintings by the Sark Group', from 1 to
14 May 1934. This was followed almost immediately by a second

Man with a scythe, 1934

exhibition at the Sark Gallery, entitled 'First Exhibition, Second Season 1934 May 21–June 16'. Peake was well represented in both exhibitions.

He exchanged his hut for more comfortable lodgings in a cottage owned by Miss Renouf, a kindly person who liked to walk about with a parrot on her shoulder.

The Press continued to be interested in him. On 2 May 1934, the *Daily Herald* published a photograph of him, with the somewhat unlikely by-line, 'Dug fields in tiny island to better his art.' Eric Drake had commented in an article that, in order to make money, some of the painters in the island dug potatoes for the 'Sark wages' of eightpence an hour, and the Press had seized on this, but it probably did not refer to Mervyn, who was selling enough paintings to pay his way. The prices he asked were low, but living was extremely cheap. His board and lodging came to less than a pound a week, and he was very frugal. He would go to a public house not so much for the drink as for the company. Though he was not a teetotaller, drink never, either at this stage or any time of his life, had much appeal for him. His missionary upbringing had taught him self-discipline.

Although he did not take a great part in the many processions across the island organized by some of his fellow painters, he would sit and talk with all and sundry. On one occasion, a neighbour asked him to help in the search for a well. As all the drinking water on the island came from wells, this was a serious occupation. The favourite method of finding a well was by divining, and now the neighbour gave Peake a forked stick, asking him to march, with the twig held resolutely out in front of him, up and down a certain field. Mervyn agreed to do so, and set off briskly. Without warning, the stick began to shake violently, and then pointed downwards. 'Water!' shouted the neighbour, and began digging frantically. Sure enough, there was water. After that, Peake was known on the island as 'the diviner'.

Eric Drake, recalling those years, had this to say of Mervyn's appearance during the Sark period:

> he wore his hair long and flowing, had his right ear-lobe pierced, and wore a gold 'pirate's' ring in it. To this he added a cape à la Augustus John, lined with scarlet (and thoroughly enjoyed the sensation caused among both down-to-earth

peasants and fishermen and respectable middle-class residents).
Long hair, ear-rings and brightly-coloured clothes were often
considered in those days to be hall-marks of effeminacy, and Eric
Drake remembered a Sarkese who made a remark of this nature
one day, in a pub, within Mervyn's hearing:

> Mervyn put down his mug of beer, and quite leisurely strolled
> up to the man and then let loose such an electric punch that
> it sent him reeling across the pub and crashing to the floor on
> the other side. Mervyn, still leisurely, apologised to the publican,
> finished his mug and quietly strolled out.

This demonstration appears not to have bred any ill-feelings in
either the man who was struck, or the Sarkese in general: in fact,
the opposite was the case.

> After that, he was asked to play for the Sark soccer club against
> Guernsey. He had never played soccer in his life, but he was
> brilliant at rugger (when he felt like it, for instance in quite
> surprising tackles when an apparently relaxed body suddenly
> behaved like a released spring), so he played goalie—with
> ecstatic success; Sark had never seen anything like it.

Eric Drake believed, at this time, that there was a connection
between Mervyn's physical energy and his creativeness, particularly
in 'its immediacy (Whitehead's "joyous immediacy"?), its per-
ceptiveness, its vitality'. Mervyn was, in fact, fond of talking of this
joyous immediacy where his art was concerned. 'To me,' continued
Drake, 'his physical activity was the key to his imagination's
creativity—joyous immediacy completely free—repeat completely—
of the inhibitions of "Casual efficacy" (Whitehead again) or any
other form of intellectualism.'

Mervyn Peake did not remain all the time on Sark. He was in
London on a number of occasions in 1934, including the time when
his brother returned from Malaya on long leave. 'In that year,'
said Leslie, 'I was married and Mervyn's present to us was a wonder-
ful portrait of Ruth [his wife], sadly lost when the Japanese invaded
Malaya some years later.'

He was probably in London, too, when his contribution to the
magazine *Satire* appeared in December 1934. He wrote a comic
verse under a nom-de-plume Nemo, which began:

> He must be an artist . . .
> Look at his shirt!

A Sarkese man, 1933

and an 'Ode to a Bowler' starting 'Oh, hat that cows the spirit'.
There was also a cartoon with a social content, entitled *Child Life,*
showing an emaciated child playing among dustbins and discarded
tins. At the same time, he continued to exhibit at the Sark Gallery,
and had a painting in April 1935 at the Royal Society of British
Artists in London.

That year an amiable ginger-haired Scotsman called Kirkland Jameson, principal of the Westminster School of Art, visited one of the Sark exhibitions. He was so impressed by the work of the young artist that he offered him a job as a teacher of life drawing. Perhaps Peake had outgrown the island's communal life, or perhaps that life had changed. Quarrels had broken out. There were disagreements between the imported staff and the Sarkese, who became suspicious when they discovered that the Gallery was selling teas, and who believed, erroneously as it turned out, that it was trying to attract custom from the islanders.

There was too, perhaps, an over-abundance of emotional entanglements. Mervyn undoubtedly had his share of love problems, although he appears to have sought safety in numbers; he would send the same love-poem to half-a-dozen girls, and then feel mildly surprised that they were annoyed when they found out. In one case, however, the matter went further, and he became engaged to an art student from Boston called Janice Thomson. Eric Drake recalls:

> I asked him what he proposed to live on, and he said his father 'would have to' make him an allowance. I said he was more likely to do so if Mervyn removed the ear-ring, his surplus hair and cape, and I left it at that. Mervyn went off as he was—I had merely eased my conscience.
>
> When his father saw him he took him into his surgery and removed the ear-ring, put him in a 'decent' lounge suit, and sent him to the barber. Needless to say, there was no allowance, and Mervyn returned to Sark hardly recognisable (but didn't remain so). The girl did the other thing—returned to Boston. She would have been lost in Mervyn's world, as he in hers.

She was, indeed, one of the young ladies who objected so strongly to being sent a 'round-robin' of a love poem, but she could have felt no lasting resentment, for some years later she sent him a little book of poems she had written called *Butterfly Mountain and Other Poems*.

After Janice had left, Mervyn was not displeased to find a solid occupation which would bring in enough to pay for his upkeep and give him sufficient free time to paint. He told Kirkland Jameson that he would accept his offer, and promptly returned to London.

7 Meeting with Maeve

By September 1935, Mervyn Peake had achieved a considerable success for a painter of twenty-four. His work had been exhibited an impressive number of times—at the Royal Academy, the Redfern and Wertheim galleries, and in Sark, not to mention the various shifting London groups; he sold his paintings. He was a teacher at the Westminster School. He had his own place now, a small room in Pimlico.

Despite the recognition he was gaining as a painter, there were some indications that this was not the only outlet for his genius. At all events he did not abandon writing and drawing. About this time, he began writing a novel called *Mr Slaughterboard*. It was about a pirate who was looking for an island. His ship was called the *Conger Eel*, the nickname which Mervyn had heard Congregationalists give to their church. It was a curious work, a mixture of fantasy and realism. It was not a children's book, nor was it an adult novel, but lay in a region of its own, somewhere between the two. It had some fine pieces of writing that hinted at promise to come:

> Lie with your head in the rain-gouged meadow, and bury your face in the reek of earth. There, there is space, and sympathy and quietness. But lie on the glacid [sic] ocean, though the sky is like a turquoise and the water like another—yet here is no peace—only a frantic silence.

There are extant just over eighty closely-written pages in a thick exercise book. Black-and-white drawings illustrate the story,

particularly the eyeless servant Smear, listening, 'his blind face turned a little upwards', to his master talking. The book was abandoned here, and not taken up again in this form.

Among the students at the Westminster was the Countess of Moray, who, like another student, Diana Gardner, the writer and painter, became a life-long friend. Diana was studying wood-cutting; she also had lessons in drawing with 'the new assistant in the Life Class', Mervyn Peake, and remembered that 'generally, he wore a light-grey Donegal tweed suit, a white, soft shirt, and a scarlet tie; but sometimes his suit was of dark brown corduroy, and then he would wear a black tie.' She noted, too, the strange way he held a pencil when drawing, 'between the thumb and the base of the first finger, and the lower part of the pencil between the first and third fingers'.

She and another student shared a flat at Campden Hill. Here, the latest political and social ideas of the time would be aired, and Mervyn would be invited to join the discussions. It was the era of Whitehead's Quantum Theory, and of Dunne's Theory of Time, but, try as he would, Mervyn could not understand the very first things about either of them. He seemed, when numbers came into discussion, to have a complete 'block'. 'It's no good,' he would declare desperately, 'I don't understand a word you're saying.'

At the beginning of one term, a new pupil who was very young, blonde and fragile-looking arrived at the Westminster School of Art. She was taking a course with Schilsky, the teacher of sculpture. Her name was Maeve Gilmore. The sculpture room, where she worked, was at the very top of the building in Vincent Square. During an eleven o'clock break, the male model was relaxing for a few minutes, and the students were drinking coffee. Maeve Gilmore, because of her extreme shyness, was still standing by her sculpture. She was, she later confessed, 'a convent-reared girl, with a built-in nervousness'. A man went up to an empty armature (the crinoline-like frame that takes the clay) and started to work on it, producing, in a few moments, a fantastic shape. The pupil who owned the armature was furious, but Maeve was entranced. The man came over to her and asked her to go for a walk. Almost tongue-tied with shyness, she replied that she never went for walks. Undeterred, he asked her to have tea with him, and eventually extracted a promise from the now completely speechless girl that they should meet

after school. When he had left, she discovered that his name was Mervyn Peake and was told that he was dying, romantically, of consumption.

When school was over, she went downstairs and found him waiting for her. He was wearing a very long grey mackintosh. They went to the Lyons Corner House near Simpsons in Piccadilly. Here they sat together on a balcony, were served by a 'Nippy', and ate tea-cakes, while a gipsy band below played *The Desert Song*. Mervyn told her that he should really be at an aunt's funeral, but now that he had met Maeve, 'there was enough fire here'. The aunt's funeral puzzled her for years, as no aunt appeared to have died at that time. Eventually, she came to the conclusion that it was one of Mervyn's inventions to enliven the scene; another was his habit of asking waitresses, in all seriousness, for camel stew. Visits to Lyons Corner House became an established part of the young people's courtship. Gypsy bands, particularly if they played *The Desert Song*, were to assume a poignant nostalgia.

The time came when Mervyn asked Maeve to tea at his studio. He had now left Pimlico and moved into three rooms over a ware-house in Hester Road, just south of Battersea Bridge. At the top of the stairs were bannisters which Mervyn painted. The three rooms had hardly any furniture, but made up in canvases and half-empty bottles of milk what they lacked in other respects. Maeve thought they were the most romantic rooms in the world, and after that, her visits to the studio became a regular feature of their life. Mervyn would sketch her, paint, talk, explain, make her see life in a way she had never seen it before, investing quite ordinary objects with a sense of the mysterious. Sometimes he would make very strong tea for her and hand her crumpets, lightly covered with butter. At other times they would go out, he dressed in his long cloak, with ear-rings in both ears, gesticulating and talking. Sometimes, to the astonishment of more conventionally-minded pedestrians, they would break into a dance. They would make for the Blue Cockatoo, on the Chelsea side of the bridge, and have a substantial meal. The cautious young man, who had until then found safety in numbers, now spent every moment he could with Maeve.

One day, he did not turn up after her class. She waited a while, and then made her way to the studio, crossing the gusty bridge, past Philippe Mills & Co.'s now-demolished warehouses with the

strange banner 'thousands of pounds wasted daily', turning left, as usual, into Hester Road, past the wolf-whistling busmen at the bus depot, until, at last, she came to the shed-like building, with the narrow door that led to the studio.

There was no one at home.

The next-door neighbour, a man who admired Peake for doing what he would like to have done himself, told her that Mervyn was desperately ill and had been taken to the Cottage Hospital at Carshalton. Thoroughly scared, not knowing what to expect, Maeve took a bus to Clapham Junction and another to Carshalton, arriving eventually in an advanced state of nervousness, only to find Mervyn lying in bed, looking quite cheerful. He had been taken violently ill at the Art School, and been sent back to his father's house in Wallington. Dr Peake had immediately diagnosed acute appendicitis and had operated on him. The nurses at the hospital called him Don Juan and made a great fuss of him. Maeve, however, could not stay long, for, as Mervyn explained to her, 'I haven't told my father about you yet.'

The time to meet their respective families had now come. Maeve Gilmore's father was also a doctor and had been to Edinburgh University, but there the similarity between the two families ended. Owen Eugene Gilmore, M.D., F.R.C.S., had been born into a poor Catholic family in the north of Ireland on 27 September 1862. By hard work and intelligence, he had got his M.D. and, for a time, practised as a sea doctor; 'a fact,' Ruth Gilmore, Maeve's elder sister was to recount later, 'that gave him a liking for parrots. He brought one home with him from the East, and always had one with him.' On 14 February 1906, at the age of forty-three, he married, at St James's Church, Spanish Place, Miss Matty Carr, and settled down to a practice in Acre Lane, in Brixton. According to Ruth Gilmore, it

> was then a very respectable residential area. Acre Lane was so called because each of the houses in it had an acre of land. All his children, three boys and three girls, were born there.
>
> Maeve was the youngest of them. When Father first went there, he kept a horse in the stables at the bottom of the garden. He had a groom called Robert Denis who looked after the horse. Later, when Father got a car, Robert became his chauffeur. He was a wonderful driver and never made a

mistake when Father went on his rounds. Robert would work out a route so that the same road was never crossed twice.

Dr Gilmore (although also a surgeon) had set himself up as a general practitioner; he had insisted that his wife should become a Catholic on marrying him, though she came from an agnostic family. Her father was Lascelles Carr, who owned and ran the *Western Mail*. He was a great admirer of Clara Novello Davies,

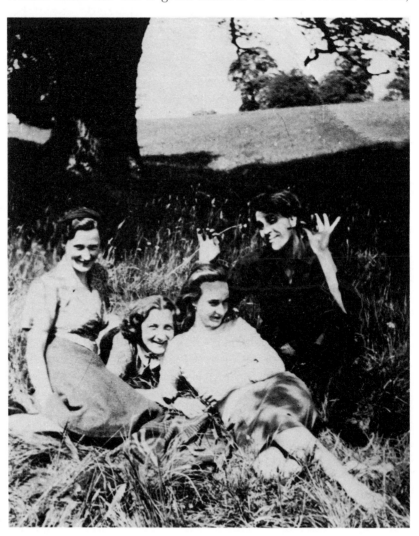

(l to r) Ruth, Matty and Maeve Gilmore, Mervyn Peake, 1936

Ivor Novello's mother, and financed her choir when it won first prize at the World Fair. He had, however, died in 1901 before his daughter met her handsome doctor from Ireland. Because of his agnostic beliefs, none of his children were baptised, but his daughter's transition from agnostic to Roman Catholic for her marriage was affected without too much difficulty.

Mrs Gilmore's children were, of course, Catholics from birth, and the three girls were sent to a convent. Maeve, because of her sparkling eyes, earned a nun-teacher's rebuke of 'Cast down those insolent eyes, Maeve Gilmore.'

Dr Gilmore had wanted all his six children, boys and girls, to become doctors—two of the boys, in fact, did so. He would not allow his second daughter, Matty, named after her mother, to become a ballet dancer, and only agreed reluctantly and under pressure from his wife to allow Maeve to go to an art school.

He was a good-looking, somewhat enigmatic man. Perhaps because he had married late and became a father at an age when other men were becoming grandfathers, he had difficulty in communicating with his children, and Maeve knew him only as an elderly man who

> would shut himself up for days and we would see nothing of him. Then he would come out of his room and take me on his lap and hold me tight, or get one of us to play the piano, while he sang Irish songs like 'The wearing of the green', or 'Phil the fluter's ball'. I think he wanted our affection but did not know how to get it.

The two families that Mervyn and Maeve chose to bring together could hardly have been more opposite—sophisticated and Catholic on her side, unsophisticated and Congregationalist on his.

> Nobody in my family [confessed Ruth later] had ever seen anybody like Mervyn. I remember the first time I ever met him. He was standing absolutely still. He had a thin, cadaverous face, with deep lines on each side of his mouth. He was very tall, and terribly thin. He wore the most extraordinary long mackintosh that went down to his ankles. And brightly-coloured socks.

On the other hand, the Peake family accepted the bright-eyed young Catholic with surprising ease, in view of their strict Congregational missionary background. Perhaps they found the shy

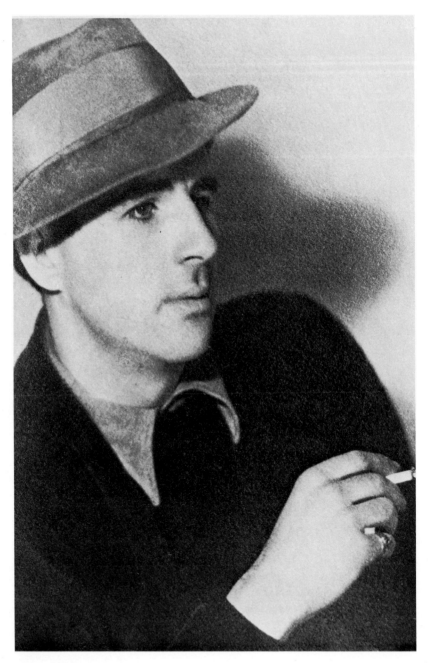

Mervyn Peake, 1935

girl their son had brought home something of a relief. Freddy Crooke recalled that 'Although they tried not to show it, I think Mervyn's parents were very shocked after his return from Sark at the startling clothes he was wearing and some of the very strange girls he brought home with him.' At all events, they accepted the fact that he might marry Maeve and were content to await developments.

In the meantime, Mervyn's work continued with increasing momentum. He heard that Miss Nancy Price was staging a revival of *The Insect Play* at the Little Theatre, and he still had, stored at Wallington, all the costumes he had done for the Tavistock Repertory Company. He promptly telephoned the theatre, but was told that a designer had already been engaged. Undeterred, he collected his drawings and, accompanied by Maeve, went to the Little Theatre. He asked to see Miss Price. He was told that she was busy. He insisted, and presently went in alone, spread his drawings on the floor, and said, 'There you are.' Then he left his name and address and walked out of the theatre. The next day a telegram came from Miss Price telling him that she wanted to use his designs.

Esmond Knight, who was in the cast, recalled his first meeting with Mervyn:

It was at the Little Theatre. Nancy Price called it, rather pretentiously I thought, the People's National Theatre. It was really very small and all the insects were crowded together on the tiny stage. We had heard that Nancy had engaged an 'unknown' designer. There was some uneasiness about this, as non-professionals can cause havoc. However, when Mervyn, a vital young man with black hair and pale face, arrived at the theatre, we were immediately reassured. He was going to be easy to work with; and more important still, his designs were first class. It's a tricky business designing insect costumes that look effective and are yet wearable. There are all those pinched-in and puffed-out bits that insects have. Mervyn had solved the problem brilliantly. One could actually be an ichneumon fly and enjoy life.

The revival was a great success for all concerned. There was excellent press coverage, and the 'unknown' young designer was signalled out especially for praise. Even the great and much-feared James Agate, theatre critic of the *Sunday Times*, managed a pat on

the back: 'Mr Mervyn Peake's brilliant costumes could not be bettered.' Despite the publicity and the praise, Mervyn's fee remained at £15.

Although the engagement was unofficial—'we did not really think in such formal terms,' Maeve was later to say—Mervyn was quite certain that he would marry her. By now, he told a friend, 'I can no longer imagine my life without her.' As Diana Gardner recalls:

> Mervyn mentioned, almost in passing, that he was going to be married in a few months' time. And this was announced by someone who had been accepted as a kind of perpetual 'Don Juan'! An equal amazement it was to learn that the chosen woman was also a student at the Westminster, although few knew her because she worked regularly and quietly in Eric Schilsky's sculpture class.

Diana and some of the other students went up to the sculpture room during break, and were diffidently introduced to her by Mervyn. Maeve had, according to Diana, 'her gold hair scraped back into a knot and pinned, and with two-inch gold rings hanging from small ear-lobes, she could be recognised as an artist's archetypal human being: someone from a Florentine painting.' But this person from a 'Florentine painting' was so overcome by shyness that she was unable to say a word to the welcoming committee.

The success of *The Insect Play* at the Little Theatre led to a request from the Arts Theatre Club for Peake to design the costumes for *The Son of the Grand Eunuch*, a somewhat obscure play adapted by Albert Arlen from a French novel. Some of the costumes had to have dragons painted on them. With his childhood in China to inspire him, these presented no difficulty to Mervyn, and he painted the dragons directly on to the costumes the actors were to wear. Mervyn and Maeve worked on them together in the studio in Hester Road. To the strong feelings already linking them was now added the additional one of being able to work and think creatively together.

Mervyn invited his father and mother to the first night of the play, at Christmas 1936. They came up to London especially for the event, two unsophisticated people who had very rarely been to the theatre before. They were impressed with the fuss that greeted them, but did not like the play. However, with their knowledge of

Chinese art, they approved of the dragons.

When the play was over, the manager came on to the stage and thanked the actors, actresses, stage-hands and even the bartenders for their contributions to the evening's enjoyment. The only person he forgot to thank was the designer. Mervyn was very upset on his parents' behalf, but they went home happy to have seen their son's work on the stage.

CHAPTER 8 Marriage

Sculpture was not the only subject Maeve Gilmore had been studying. She had also been learning German at a language school in Bond Street. Sometimes Mervyn would meet her there. He did not, however, wait discreetly near the school entrance, but would hide in the doorways of the Bond Street shops, and jump out at her—a bizarre and extravagant figure, carrying her off triumphantly to yet another Lyons Corner House, the permanent back-drop to their love affair.

Sometimes they would meet at Victoria Station. On one such occasion Heinz Waltz, one of her German teachers, saw them there together. The next day, he solemnly warned her that she should not go out with 'people like that'. Bohemians were considered antisocial and undesirable, even those who worked as hard as Mervyn did and had already received more success in a few years than some 'respectable' citizens in a lifetime; there is always something shocking, to the routine-bound citizen, about one who appears to be free of convention. Maeve, however, was impressed with the Bohemian life. Mervyn had introduced her to Barbara Norman, who was the niece of Sir Montagu Norman, Governor of the Bank of England: she had rejected her own background in order to write delicate and much admired poetry. Maeve remembered that

She was living in a terrible room, with everything in a filthy state. . . . The first time I met her, she took out a piece of jagged glass, and began combing her hair with a comb that had only two teeth left.

Mervyn asked Mrs Gilmore for the hand of her daughter at a charity dance. It was not the most auspicious moment to do so. The other male guests were formally clothed in white tie and tails, but Mervyn had turned up in an odd combination of dinner jacket, blue pin striped trousers and a large, floppy bow-tie. The result was incongruous, but Mrs Gilmore, who was one of the kindest and gentlest of persons in the world, received the proposal sympathetically. Some of the other members of the family, however, advised caution. They pointed out that Mervyn earned comparatively little, and that Maeve had neither personal income nor an allowance from her father, who did not believe in 'pampering' his children. Could anyone be sure that the love she felt for this strange Bohemian painter was real? It was remembered that, as a schoolgirl, she had had a 'crush' on Ivor Novello. She had been taken one day by her mother and Mrs Novello Davies, Ivor's mother, to the theatre where he was appearing in one of his musical comedies. They had had a box to themselves and, at the end of the performance, he had blown a kiss to his mother. For days after that Maeve could hardly eat for love. The convent authorities were so worried that they sent her to London to see a specialist, who suggested, rather unromantically, that she should have her tonsils removed.

The family decided that a trial separation between her and Mervyn was necessary, to test the love between them.

> The trouble was [revealed Ruth later] that, as Maeve was so beautiful, the family expected her to marry somebody with money. It was what girls were expected to do in those days. Mervyn had no money sense at all. It was said that his father still bought his clothes for him, and paid his rail fares, because Mervyn didn't know how to handle money.

This was undoubtedly an exaggeration. Although Mervyn might not understand high finance, he had, for some years now, managed to live within his income. Nevertheless, it was agreed towards the end of 1936 that Maeve should continue her art lessons in Bonn, and at the same time improve her German.

There was nothing particularly new for her about travelling. She had been at school at Fribourg in Switzerland, and had returned to Geneva for the wedding of her greatest schoolfriend, a Chinese girl: here, she had had a polite proposal of marriage from one of

the Chinese wedding guests. She had toured Spain with her sister Matty, just before the outbreak of the Spanish Civil War, where the clenched-fist communist salutes and the strangely empty churches remained sharply in her memory. Now she was given the address of a castle near Bonn, and she was accompanied by her sister Ruth, who acted as chaperone. They flew to Cologne in an old, very comfortable Imperial Airways plane, and then went on to the castle. Ruth stayed the night, returning the next day to London.

Burg Hemmerich belonged to a cheerful widow called Baroness von Nordeck, and it was here that Maeve now settled, travelling in to Bonn for her art lessons.

Mervyn wrote to her nearly every day. His letters were quite unlike any letters she had received before: they were combinations of words and drawings, illustrated anecdotes that were little short stories in themselves, exquisite poems and endearments. He had recently acquired a small Brownie camera, and would send her snapshots. The subjects were unusual. One was a drawing super-imposed on a photograph of a puffin, with the words 'he was laffin' scrawled across it. Another shows a book he had just illustrated— the first book-illustration commissions were coming in—propped up on a garden bench. A third was of a piece of rhubarb sticking out of the snow. It was almost worth being separated to receive such strange letters, and Maeve kept them all, but they were destroyed when her mother's house in Chelsea Square was demolished by a landmine during the war.

She was away six months, and it was obvious that the love affair was real and life-long lasting. With the coming of early summer there was no sign of any diminution in her feelings for Mervyn, or of his for her. At the same time, she had learnt all that the art school in Bonn could teach her; under the guidance of the Baroness, her German had reached a respectable standard of proficiency, and so, in June 1936, a few days before her birthday, she returned to England. Both her sisters, Ruth and Matty, were at Victoria Station to meet her. So was Mervyn.

The engagement was now official. The necessary announcements were made. A date for the wedding to take place, at the beginning of December, was agreed upon, and the two families now met. It cannot be said that the meeting was wholly successful. There were far too many differences between the former Congregationalist

missionary doctor from China and the Irish Catholic who had built up a large practice in London. Even the fact that they had both been to medical school in Edinburgh did not form a link. Dr Peake was polite, Dr Gilmore distant. But, on the level of those most intimately concerned, all was happiness and peace.

Mrs Gilmore planned to go on a Continental tour that summer. Ruth recalled that

> Mother was very fond of young people and loved to take them with her on motor tours of Europe. She often arranged for a pantechnicon—a van—to follow her. When she arrived anywhere, she would rent a house. It was usually badly furnished; so she would call up her pantechnicon, which was loaded with her own furniture, including a piano, and have it unloaded. When she left, the pantechnicon would be loaded, and wait for the next call.

This year, however, the planned expedition was of a more modest nature. They were to take only one car, which Ruth was to drive, and, as they did not plan to stay long anywhere, they would dispense with the pantechnicon. Now that Maeve was officially engaged, it seemed sensible that Mervyn should come along too.

They crossed to Antwerp by night. When they were at breakfast in the saloon in the morning, a man looked in and asked, 'I say, steward, any brekker?' This small incident was to lead to one of those family catch-phrases that would be remembered for years: the question, 'I say, steward, any brekker?' would recur at the most unlikely times.

From Antwerp the party travelled to Berlin.

> Mother was always rather nervous in cars, [recalled Ruth] but for some reason, she had confidence in me. It was the time when the first motorways were being built. I remembered that we covered sixty miles on one of them in exactly one hour.
>
> In Berlin, Mother, as usual, hired a car with a Cook's man as guide. We were in the Unter den Linden, when a huge Rolls Royce drew up beside us. The Cook's man said, 'That's Lilian Harvey.' She was a famous film actress who spoke several languages perfectly and made a different version of each of her films in a different language. What I remember most about her was the huge diamond on one of her fingers. It must have been the size of the Koh-i-noor—a walnut.

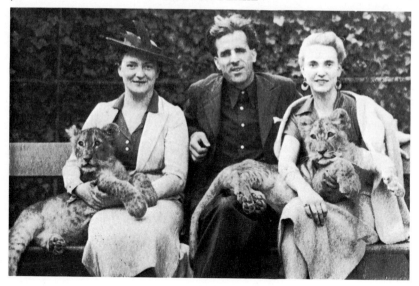

Ruth Gilmore, Mervyn Peake and Maeve Gilmore at Berlin Zoo, 1937

At the Tiergarten, Ruth and Maeve, with cuddly lion cubs on their laps, were photographed on each side of Mervyn. They visited Dresden, went on to Prague—'the most beautiful capital in Europe' —and then to Vienna. Franz Lehar, the composer of light musical comedies, spoke charmingly with them when they were having lunch at their hotel. In the Viennese restaurants, gypsy bands played. A cloakroom attendant, commenting on Maeve's beauty, said, 'They don't make them like you any more.' They strolled around the Vienna woods. They saw the Danube at Buda Pest. 'It is not blue,' said Maeve, 'even when you're in love.' Everything was romantic, charming, delightful.

They were not idle, however. Everywhere they went, Mervyn and Maeve would sketch and draw. Mervyn painted water-colours, some of which Ruth Gilmore kept. In Hungary, where no one could speak the language or understand what was being said, they relied upon his quick sketches to make their wants under-stood.

They returned by way of Paris, for it was the year of the Paris Exhibition. Here Matty, the third sister, joined them. The city was crowded with visitors, the decorated streets were full of people. The Exhibition was magnificent, noisy and exhausting. It was difficult

to find anywhere to stay. Matty and Maeve shared a room at the top of a narrow Paris hotel. One morning, on looking out of their window, they saw a small fox trotting unconcernedly along the top of a wall.

When they reached London again, the final arrangements for the wedding were made. One of Maeve's brothers suggested that Mervyn should take out a life insurance: Mervyn hadn't the slightest idea what a life insurance was, but thought it was something to do with making provision in case he died young. He had to have a medical examination, but his overwrought imagination convinced him, when the doctor told him to stand against the wall for his height to be verified, that this was to measure him in advance for his coffin. He promptly fainted, and fainted again when the doctor, in order to check his blood pressure, strapped the balloon-like pressure sleeve on his arm and began pumping. Not unnaturally the necessary certificate was not given, and Mervyn left the consulting room, confusedly believing that he had somehow cheated an early death. His grasp on matters of this kind was never very strong.

Although both Mervyn and Maeve would probably have preferred a simple wedding, they acquiesced, as did the Peake family, in the more lavish plans of the Gilmores. It was to take place in the smart Catholic church of St James's in Spanish Place and there was to be a reception at Mrs Gilmore's club, The Forum, in Grosvenor Gardens.

Dr Gilmore and Maeve were driven by Penfold, Dr Gilmore's new chauffeur, to the church where Mervyn and his best man, Gordon Smith, were nervously waiting. Everything went off beautifully.

Diana Gardner and two other girl students from the Westminster had been invited to the wedding. She recalled that

> It was odd to see his long narrow body dressed in the formal black clothes—was the coat faintly too large?—and his high-standing shock of dark hair above the white, winged collar: the only point of colour being his scarlet buttonhole. He went through the set paces carefully, nervously. It was also deeply touching to see the thin, dark figure beside the bride in her white veil and dress and long, pale gloves; their two heads inclined towards the priest. A contrast of light and dark which Mervyn's own eye would very likely have taken up and drawn dramatically.

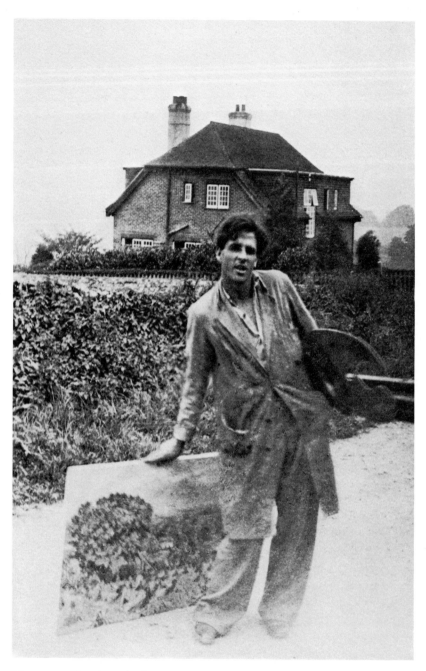

Mervyn at Burpham in Sussex, 1936

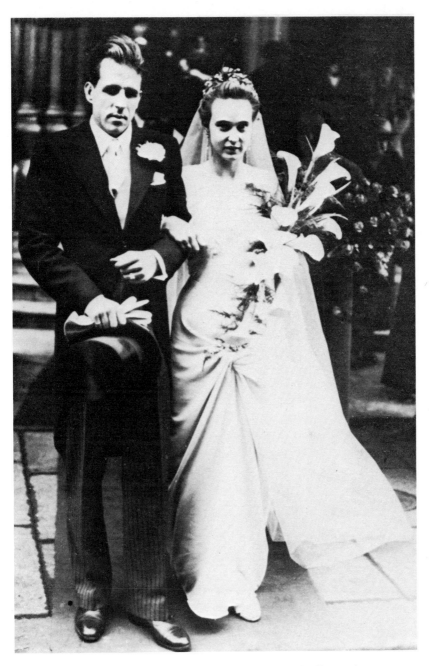

The wedding at St James's, Spanish Place, London, in December 1937

Another witness to the wedding was Ruth:

> We were moving from the Acre Lane house to Chelsea Square
> at the end of that year, so there was a great deal to do. It was
> a wonderful wedding. The Gilmore side of the church was
> packed, but there were not so many on the Peake side. At the
> reception, Aunt Jenny [Lady Carr, Mrs Gilmore's eldest sister]
> made the speech, because Sir Emsley [her husband] could not
> be present. She made a little pun, saying that she hoped the
> young couple would touch the peak of success.

As Mervyn was working once again at the Westminster School,
there was no time for a formal honeymoon, but the couple stayed
the week-end at Dr Peake's new house, Reed Thatch, at Burpham
in Sussex. This had been built to his own specifications, and he
had retired that year, handing over his practice to an Australian
doctor, but retaining the legal ownership of the Wallington house.

Reed Thatch was a lovely place, quiet and remote, with a view
across the river Arun to the wooded slopes of Arundel Castle.
Nearby was the site of a Roman camp. There was an ancient Norman
church, where Leslie had been married a few years earlier. The
Downs, with their beautiful solitary walks, stretched all around.
The air was fresh and salty from the sea. It was the perfect place
for a honeymoon, short though it might be.

On Monday they returned to London. They had originally
planned to start their married life at 163 Battersea Old Church
Street. This was a dilapidated ex-baker's shop which Mervyn had
taken over as a studio earlier that year on leaving Hester Road.
It was on the condemned list even then, but it was opposite Battersea
Old Church, where Blake had dreamt his dreams, and where now
Peake wrote, among the gravestones, his poetry. It was at this studio
that he composed for Maeve 'The Dwarf of Battersea', a rollicking
ballad that began:

> There lived a dwarf in Battersea
> (O lend me a tanner!)
> There lived a dwarf in Battersea
> Whose hands were white with leprosy
> (Sing you O to me O)
> And the river runs away.

It tells, in twenty stanzas, how, on seeing 'a maiden fair, with
tawny eyes and tawny hair', he drew a skewer from its sheath, but

was transfixed by a painter's brush before he could do any harm, and was then boiled in a tin of linseed oil.

Mrs Gilmore was adamant. The place might be romantic, but it lacked the amenities of life to such an extent that she could not let her daughter live there. She found, instead, a flat for them in Primrose Mansions, Prince of Wales Drive, overlooking Battersea Park. She had largely equipped it, and provided it, in particular, with the finest Irish linen. Two of the rooms were purposely left unfurnished, so that they could be used as store rooms for paintings. Both Mervyn and Maeve were now working on canvases: she had switched, during the stay in Germany, from sculpture to painting. Although they worked separately, one encouraged the other.

Early in 1937, they had a visit from Andras Calman, who had recently opened a gallery in St James's Place. He wanted to give Mervyn a one-man exhibition, and visited Primrose Mansions in order to choose the paintings and drawings for this first complete exhibition of Peake's work.

It opened in March. It consisted not only of oil paintings, but also of sketches and water colours done during the Continental tour the previous summer. There was a number of strange drawings of 'monsters', and it was these that attracted the most attention, from both the public and the press. Anthony Blunt wrote in the *Spectator* of 11 March 1938: 'The most exciting of the drawings represent monsters, which are at the same time terrifying and captivating, others show the strangest types of pirates.'

Mervyn Peake was developing the type of drawing he had used in the earlier Moccus stories, and was experimenting with illustrating and writing a children's book in which he could feature both the pirates and the strange animals he could draw so convincingly.

One day he and his wife went to a party given by Calman at his house. A number of intellectuals were there. One of them, rather condescendingly, asked Maeve what she thought of the recently completed glass-fronted shop, Peter Jones in Sloane Square. Overcome with shyness and completely ignorant of, indeed uninterested in, the subject of glass-fronted shops, Maeve blurted out, 'I think it's negative', burst into tears and had to be led away and comforted by her husband. After that, intellectuals were always a source of anxiety and distrust to her.

In the spring of that year, they went on the honeymoon they had

Mervyn and Miss Renouf on Sark, 1938

been unable to take at the time of the wedding. They went to Sark
and stayed with Miss Renouf, of the parrot-carrying shoulder, who
had looked after Mervyn before. The Gallery had closed down.
Eric Drake had left to try his luck elsewhere, and the young artists,
who had shocked the islanders by their dress and habits, had gone

too. The established, conventional artists were back in favour. The islanders were busy dispensing teas. Everything was as it had been before.

Two very different poems by Peake appeared this year. One, 'Epstein's Adam', was published in *Picture Post*, the other, 'Rhondda Valley', in the *London Mercury*. The first was a passionate defence of the statue which, when it was first shown, caused such antagonism that it was attacked not only verbally but also physically: on more than one occasion it was tarred and feathered. Peake opened his poem:

> I have seen this day
> A shape that shall outlive our transient clay
> And hold
> A virile contour when the world
> Renews its crust
> With our decayed and horizontal dust.

In all the clamour and heated arguments about the merits and demerits of the controversial piece of sculpture, Epstein wrote gratefully to Peake for his support, and invited him round to his studio. They had tea together. Later, Mervyn modelled Titus Groan's mother, Lady Groan, on Epstein's first wife, whom he met that day.

'Rhondda Valley' was the result of a visit Peake had made to the coal-mining valleys of Wales the year before his marriage. It was the time of great unemployment, particularly in the coal mines. The plight of those whom Mervyn called the 'doldrum army, stranded men, rusting the shovel' and of the 'gentle women with black lashes' found a sympathetic echo in his own half-Celtic soul. It is illustrated with drawings so untypical of the rest of his work that it is difficult to believe that they are all by the same artist.

That summer Mervyn and Maeve went to Paris. The French capital was jittery with war nerves, but they enjoyed themselves. They were travelling in a bus when they suddenly saw Leslie Hurry, Mervyn's contemporary at the Academy Schools. Jumping off, they joined him. As they had not decided where to stay, he took them to live at the boarding house he occupied in Montmartre. There was a view of the Sacré Coeur, but they got into trouble with the landlady, as Mervyn spilled Indian ink over the sheets and even managed to get some on to the curtains. When they

came home one day, they found the curtains swathed in newspapers, while the landlady told them bluntly that they were 'mauvais ambassadeurs pour la vieille Angleterre'.

One day, when seated at an open-air café, Mervyn sketched a nearby *poule-de-luxe*. The woman asked if she could keep the drawing. Mervyn handed it to her, and she folded it up into small squares, exactly as if it had been a pocket handkerchief, put it in her purse, and, with a 'Merci, Monsieur', walked contentedly away.

Soon after they returned from Paris, Britain was faced with the Munich crisis. People began to dig slit trenches in the parks, and to say that this time war with Hitler was inevitable. 'I remember standing on our balcony,' recalled Maeve, 'looking out over the Park, and saying that this was the end of the world. The trees, I remember, seemed more beautiful than ever that September.' But Chamberlain returned from Munich, the uneasy peace was maintained, and people went back to their normal occupations.

In the autumn, the Peakes made the first of many moves. Primrose Mansions was perhaps a little too prim, too genteel for them: they wanted the reality of a working studio. Collecting together all the canvases and the modicum of furniture and goods they possessed, they moved into a house belonging to Rebecca West's nephew in Portsdown Road, subsequently renamed Randolph Avenue, in Maida Vale.

They had two floors, with two very big rooms, a kitchen and a bathroom. A charlady called Mrs Peach was discovered, much to Mervyn's delight, to be a relative of the famous cricketer of that name. She came in once a week to clean the two floors. Below them was a flat owned by a couple obsessed by the colour red: every-thing—halls, carpet, ceiling and furniture—was painted red. Above them was a fencing studio. Here they would go, put on fencing masks, pick up épées and dance and play jokes on each other. Mervyn loved to surprise people by impromptu imitations, giving vent to that exuberance and over-abundant energy that was typical of him. Only, every now and then, did something different show. Looking back, his wife could recall that there were sudden moments of lassitude, and that, even at this age, he seemed to need more than the usual amount of sleep, but at the time, she paid no particular attention to this.

They loved the rather sleazy, relaxed neighbourhood. In the

house opposite, there was a man who, every evening, washed his hands for half an hour, dried them, and then, pulling on white gloves, went to bed. Gentlemen in bowler hats could often be seen hurrying down area steps for 'fantasy' assignations with ladies of easy virtue. Peake was fascinated by their round, squat shapes as they scampered down the area steps in eager search for pleasure. He used them, without their knowing it, as models in a painting entitled *Mr Brown's Resurrection*, a large canvas depicting elderly men surrounded by ethereal, aerobatic figures.

CHAPTER 9 'A question of direction'

1939 was heralded by the *Daily Express*'s cheerful and wonderfully inaccurate prophecy that there would be no war. Everybody else believed that it was merely a question of time before it broke out, but for most people life went on as usual, perhaps even heightened by the frailty of peace. For Mervyn and Maeve it was a busy time: they both had exhibitions, he at the Lecester Galleries from 22 February to 10 March, and she, under her maiden name, Maeve Gilmore, a week later, at the Wertheim Galleries. He exhibited forty-six drawings in all, including portraits of Augustus John—whom he had met at the Cafe Royal, and with whom he had become friends—and of miners from his earlier visit to the Rhondda Valley, some French and Sark drawings, and a number of portraits of his wife, with such simple titles as *The Artist's Wife in Chair*, *Maeve combing her Hair*, and *Maeve Resting*, which sold for seven guineas. The prices fluctuated modestly between four and ten guineas. On the first day, he made £63, from which £21 had to be deducted for commission.

The combination of miners, always a popular subject, and a husband and wife with simultaneous exhibitions, was a gift to the Press. The Peakes were photographed together—her hair appearing oddly dark for one so blonde—and featured in a number of newspapers under such startling headlines as 'Husband and Wife Rivals' (*Reynolds News*), 'Artist sleeps in Welsh Doss-Houses to Get Types for his Work' (*Daily Mail*, 24 February 1939). There were, the *Sketch* noted, a number of distinguished people at the private view, including Lord Moray and Sir Edward ('Eddie') Marsh, the famous collector of paintings. Lady Moray was also a student at the

86

Westminster School of Art and it was on her recommendation that Queen Elizabeth, George VI's wife, had bought one of Mervyn's drawings.

An article in *Cavalcade* neatly summed up the situation:

TWIN SHOWS

Husband and wife hold exhibitions at same time. Twenty-seven year old Mervyn Peake is showing some brilliant drawings at the Leicester Galleries at the same time as his petit, ash-blonde wife, Maeve Gilmore, exhibits at the Wertheim Galleries.

Recently the Queen, seeing a sketch by artist Peake hanging in the Countess of Moray's home, bought it on the spot, took it away under her arm.

Tall, shock-haired Peake, China-born son of a doctor, has a picture in the Tate Gallery, bought by the Contemporary Art Society. At his first London exhibition he sold six pictures in one day, the first being bought by art-connoiseur-diplomat, monocled Sir Edward Marsh.

DOSS HOUSES

Much of his best work was done in the Rhondda Valley, where he spent some time among the down-and-outs, living in doss-houses at 3d. a night. Peake says he found unemployed full of artistic appreciation.

Poet as well as artist, he has worked in the theatre, designed costumes for Karel Capek's *Insect Play*.

Wife Maeve Gilmore met Peake at the Westminster Art School, where he was a master. Asked if he might paint her, she said 'yes', and he has done 750 sketches of her since then.

Advantage of being married to an artist, both agree, are mainly that model fees are saved. Peake poses for his wife, and they share each other's frames and paint.

Both shows are worth visiting, Peake's for his fluent, vigorous style, Gilmore's for her sensitive delight in form.

The *Star* went one better, and got Maeve and Mervyn to pose in their Maida Vale studio, she painting him, and he sketching her. The photograph was published with the caption 'A MODEL COUPLE—Mervyn Peake sketching his wife, Maeve Gilmore, as she paints his portrait'. The *Evening News* also carried the same

print under the caption 'TWO PORTRAITS AT ONCE'. In fact, as Maeve Gilmore subsequently revealed, they never painted in the same studio but always had their separate places, even if they were only curtained-off portions of a larger room. Sketching, however, was a more or less permanent occupation, and Mervyn would sketch her at any time of the day, whether at home, out in the street, or at restaurants.

The two were interviewed for the radio programme 'In Town Tonight', along with film star Lilli Palmer, and spent the modest fee the same night at the Café Royal, then a favourite rendezvous of writers and painters. All this was good publicity, but a more thoughtful and prophetic note was struck by the *Sunday Times*:

> Mervyn Peake's drawings are those of a man at a cross-roads who hasn't yet made up his mind which way to turn. It is not a question of ability. His talent is remarkable. It is purely a question of direction, and he is right to hesitate; he has plenty of time to make up his mind, or, to be more accurate, to wait for something to happen to him that will make it up for him.

In the meantime, however, he was busy putting together his first book. Country Life had agreed to publish *Captain Slaughterboard Drops Anchor*. Apart from the similarity of names, and the fact that both books are concerned with pirates in search of an island, the earlier Mr Slaughterboard and the later Captain Slaughterboard have nothing in common. The Country Life book consisted of a series of elaborate and highly decorative drawings linked by a simple text. The treasure discovered is not gold, but a gentle 'yellow creature' (living gold?) that transforms the savage pirate captain into as gentle a person as itself.

Apart from Captain Slaughterboard, there was Billy Bottle, the bosun, whose arms were so long that he could run faster on them than on his legs; Jonas Joint, the acrobat; 'elegant' Timothy Twitch; Peter Poop, the cook, who had a cork nose; and finally, tattooed Charlie Choke. On Charlie Choke's left arm, just above the bend of his elbow, can be seen a pin-point portrait of Maeve. Her name can just be made out: MAE to the left, VE to the right.

An insight into Mervyn Peake's manner of working can be gained from looking through the Leicester Galleries' catalogue for the private view of the exhibition. The back pages were used to practise alternative names for the characters in *Captain Slaughterboard*. Thus

there is a whole list of thought-of and discarded names:

Savannah Swig	Claw
Mango Twitch	Knife
Daniell Dogg	Choke
Peter Plonk	Poop
Swop	Slice
Freddie Fangs	Skid

On another page, there are alterations on a theme: Mango Mylk becomes in turn Mango Mooch, Mango Moop and Mango Melt, before being abandoned. Harry Horse has a spell as Hieronymo Horse. Harry Hunk becomes Andrew Hank. There is a mysterious Mawl. This selective writing of lists on odd bits of paper is very typical of Peake's approach to a literary problem.

On 13 June 1939, the Delius Giesse Gallery at 2 Bennet Street, off St James's, held an exhibition entitled 'Satirical Drawings of Our Time'. Among the fifteen artists exhibiting were Edward Ardizzoni, Nicholas Bentley and Felix Topolski. The *News Chronicle* had this to say of Mervyn Peake's contribution:

> For his bitingly unreal, but acidly true satirical drawings, I commend Mervyn Peake, whose 'conversation piece' reminds me of all that is best in surrealist Salvador Dali, and all that is funniest in *Alice in Wonderland*.

It is the custom for leading galleries to hold caretaker exhibitions in the summer to tide over the holiday period. Usually one or two works of prominent or promising painters are exhibited, generally for the delectation of tourists and provincial visitors to the capital. 1939 was no exception, and the Leicester Galleries had 203 exhibits on show during that last summer before the war. Established painters like Graham Sutherland and Paul Nash were represented, and so were 'promising' young painters. Among the latter was Mervyn Peake with a *Nude Figure*.

But by now the threat of war was so real that it seemed to many people almost tangible. Despite his promise, and the scrap of paper Chamberlain had waved so hopefully the previous autumn, Hitler had overrun Czechoslovakia in March, and Mussolini had chosen Good Friday to invade Albania. Even the most optimistic could no longer doubt that war was very close, as Hitler's plans for the invasion of Poland went ahead.

To the mass of people, uninvolved and yet affected by the inter-

play of strategy, the last few weeks of August were like the last few days of a condemned prisoner who knows that the date of his execution has been fixed. Many townspeople felt an irresistible urge to get away, if only for a short while, and to savour, before total annihilation overtook them, the simple pleasures of the country.

Mervyn and Maeve Peake felt the same urge. Mrs Gilmore lent them her car and they drove to Stratford-on-Avon to see *As You Like It*. If the trees in Battersea Park had been lovely the autumn before, the countryside now seemed far more beautiful than either could ever remember. The threat of destruction enhanced this beauty, and they watched it with the attentive eyes of those who thought they were seeing it for the last time.

From Stratford-on-Avon they went to Chipping Campden, where Gordon Smith's father, a retired Baptist minister, and his wife lived. They had dinner with them on 2 September and went to bed in the hotel across the square. The next morning, news that war had broken out was conveyed to them by the town crier who stood in the centre of the square below their window, dressed in tricorne and cape, ringing his bell like a master calling his pupils to class.

Maeve was expecting her first child in five months' time, so that the onset of war gave them an added sense of apprehension. London, it was said, would be flattened or gassed out of existence within the first few hours. However, they returned to the flat in Maida Vale to find that, apart from a false air-raid alarm immediately after Chamberlain had announced the news, nothing had happened. Indeed, in the days to come, there were more casualties from the black-out regulations, which forbade the showing of any kind of light, than from the enemy.

Soon after the start of the war, the Westminster School of Art, like others, was evacuated to the country, and it became impossible for Peake to go on teaching there. The problem was what to do. Though Bohemian in dress, speech and gesture, he was still the son of an English missionary doctor. He had, like his father, a deep sense of patriotism. Unlike many of his contemporaries, he had taken no sides in the Spanish Civil War. He was completely apolitical and indifferent to the loud claims of left- and right-wing extremists. But when his own country was threatened, he wanted to spring to her defence.

Unfortunately, no one wanted volunteers. People were told to wait their turn to be called up. Once Poland had been overrun, the Western Front, which had started almost where it had ended in the Great War, settled down to immobility, broken only by the activities of routine patrols. The heaviest 'bombs' which the various air-forces dropped on each other's countries were bundles of propaganda leaflets. People began to talk of the Great Bore War, the Phoney War. However, by continually badgering the local authorities, Mervyn did find an occupation that had some kind of connection with the war: he was enrolled by the nearest Passive Air Defence centre to fit people with gas masks. This appealed to his sense of humour, and he would gently ease the elastic bands behind the head, wipe the goggling eye-pieces, adjust the black, pig-like snouts, and assure the recipient, in mock-seriousness, that the mask was a beautiful fit.

The Peakes stayed on at the house in Maida Vale. The fencing studio above them closed; the people downstairs blacked out their red-drenched rooms. Maeve, when not painting, spent much of the time sticking Sellotape in elegant patterns on the large windows, to prevent them splintering if a bomb exploded outside, and each evening, half an hour before dark, she would draw the dusty black curtains across the windows.

Early in October, they were called urgently to Reed Thatch in Burpham. It was almost two years since they had spent the first week-end of their marriage there, and now they learnt that Beth had had a stroke, and was not expected to live. Mervyn had always had a deep feeling of affection for both his parents. The family had always been a united one, and now it was to be disrupted. On 8 October 1939, Beth died, at the age of 64. Mervyn did a number of sketches of her on her deathbed. When he finished, he was crying and clung to Maeve for support.

The art world had closed down with the declaration of war, but when the fighting did not break out and the bombs did not come, it opened up again. The Leicester Galleries mounted an exhibition called 'Six by Eight'. At the time, people were being exhorted to buy savings certificates, and it was considered unpatriotic to spend large sums of money on canvases, but it was 'all right' (a favourite word) to spend *small* sums of money on them.

The exhibition opened at the beginning of December 1939.

Mervyn's mother, 1939

Dr Peake, 1948

There were a hundred and thirty-two paintings, all exactly the same size and price, on display. Both Mervyn and Maeve contributed canvases. Hers was entitled *Cherries* and was bought by Hugh Walpole. It pleased her very much that her painting had been bought by the creator of Rogue Herries, her current hero of fiction. She would tell people delightedly that 'Herries has bought my cherries'.

At almost the same time *Captain Slaughterboard Drops Anchor* was published by Country Life. It had an oddly uneven and unpredictable Press. The *Tail Wagger* magazine praised it, but *Punch*, which might be expected to have a more sophisticated approach, declared firmly that the illustrations, 'though brilliant, are quite unsuitable for sensitive children'.

Mervyn seemed not to let adverse criticism worry him, but Maeve always got very angry. Once, she recalled, 'We were in a train and saw a bad review of *Captain Slaughterboard*. Mervyn didn't mind. He just laughed and made fun of it. But I *hated* the reviewer. I could have *killed* him.'

The time was coming for Maeve to have her baby. The Maida Vale flat was no place, under war conditions, to bring up a child, and they decided that they had to find a safer, quieter place. Dr Peake, who was still living at Reed Thatch, suggested that they should come down to Burpham until Maeve went into hospital, and so, as soon as Christmas was over, they packed up the Maida Vale flat and set off for Sussex.

It was one of the coldest winters on record, but the weather was classified as war news and so nothing was said about it. The South Downs were clamped in ice and snow. Soldiers in the nearby reinforcement camps ski-ed over the soft undulating slopes, and Dr Peake, who was going to be in charge of the delivery of Maeve's baby, was afraid that the narrow road out of Burpham to the main road two miles away might be blocked with snow. He got his daughter-in-law safely installed at the Littlehampton hospital.

The baby was born on 7 January 1940 and weighed six pounds. There were no complications, and both mother and child were in perfect health. When the delivery was over, Dr Peake leant over his daughter-in-law and said, 'Maevie, you've got a little boy.' Mervyn had been ordered to keep away, as his propensity for fainting in a close medical atmosphere was well known. He listened to a

Maeve and Sebastian at Lower Warningcamp, 1940

rendering of Beethoven's *Pastoral Symphony* during the arrival of his first-born, Sebastian. He saw Maeve as soon as he was allowed to do so, and was amazed to discover her sitting up cheerfully in bed as if nothing at all had happened. Later, Dr Peake planted a willow tree in his garden, in honour of the baby's birth.

Mervyn had found a small house at Lower Warningcamp, a mile or so away from Reed Thatch. Maeve remembered it as being 'very dark and damp. It was near the river and the railway line. It was supposed to be haunted; but although I do not remember ever seeing a ghost, I always felt that one might jump out at me at any moment.'

It was here that they took their young son, and it was here too, during the long, dark, candlelit evenings, that another 'child' was born: Titus Groan, the central figure of the first, and perhaps greatest, of Mervyn Peake's novels.

CHAPTER 10 The birth of Titus

Scholars have analysed and re-analysed the *Titus* books, in an effort to find in them an overall plan or intention, but if the two people most closely concerned, Mervyn Peake and his wife, can be believed, this never existed and there was never any thought of publication. Originally, there were two characters speaking together in a kind of void. Mervyn read the pages to Maeve, and, in the discussion that followed, a larger dimension was considered. Slowly something new began to emerge. The original characters disappeared, and fresh ones appeared. There were to be events, and these were to happen in a castle in an undefined area of time and space, perhaps inspired by the dusty plains of Northern China, or those fictitious ones of the Plains of Ho. Perhaps it was Arundel Castle across the river, or the island of Sark, standing like a fortress in the surrounding sea, or maybe it was an amalgam of these.

'Titus', as a name, appeared from the very start, and was never altered. But the other names were the subject of long and intense discussion between Mervyn and Maeve. Even the name of Gormenghast for the castle itself was accepted only after many others had been thought about and rejected. It was Captain Slaughterboard all over again, with long lists of names covering endless sheets of paper on the sitting-room table. Some of the names were not to change until the book was well under way. Thus, Dr Prunesquallor was, for a long time, de Prune-Squallor; Lord Sepulchrave was Lord Seuma; and even Steerpike started off in life as Smuggerly.

97

Mervyn applied for a position as war artist. In order to impress the authorities he went to Augustus John for assistance—they had long been friends, and John admired Mervyn's talent as a draughtsman. He was only too pleased to help, and wrote:

Dec 28 1939

To whom it may concern

I wish to recommend Mr Mervyn Peake as a draughtsman of great distinction who might be most suitably employed in war records.

Augustus John

But though Mervyn sent the application hopefully to the War Office, nothing came of it. Perhaps enough war artists had been appointed already; after all, it was the time of the Phoney War, characterised by the almost complete lack of fighting, except between the Finns and the Russians. Both Mervyn and Maeve were disappointed that something he could do superbly well was not to be used.

The call-up papers arrived at last. He was ordered to report to the Royal Artillery depot at Dartford. Now came the day to leave. The hard winter was over, and it was warm again. The station was on their side of the town. Mervyn did not want Maeve to go on to the platform, and so they said goodbye on the towpath, and, as he walked on towards the station, she returned to the cottage. A bicycle lay under a tree in the garden. He had asked a neighbour to put it there while they were walking along the towpath: it was, to her, the most wonderful present she had ever received.

Mervyn went on to London and then to Dartford, along the Thames. On his first 'square-bashing' parade, the sergeant told him to get his hair cut, adding with heavy military humour, 'You look like a bloody poet.' 'That,' replied Mervyn calmly, 'is exactly what I am.'

Maeve remembered going to Dartford one day to see him for a few hours' leave:

The train drew into the station. There was a tall close-cropped soldier with a funny hat on his head standing by the door. He held out his hand to me. At first I did not recognise him; and then I realised it was Mervyn, and wanted to cry because of what they had done to him.

But he had cheerfully accepted the situation. At least he was doing something, even if he was doing it wrong. He never could work out which was his left and which his right hand, and the mysteries of gun-laying were completely beyond his powers of comprehension.

Despite the endless drill, however, he was working on the illustrations for *Ride-a-Cock-Horse and Other Nursery Rhymes*, which Chatto & Windus had commissioned. His painting came to a standstill, for he could not carry easel, wet canvases and tubes of paints with him. The space for personal effects in a barrack room was just enough to accommodate a copy of *Ride-a-Cock-Horse*, some drawing books, pencils, pens and Indian ink, and the exercise book, which was the thickness of a small address book, in which he was writing about the world of Gormenghast and the birth of his hero, Titus. He used to say later that the war changed him from a painter to an illustrator, but this is an over-simplification of the facts. His first illustrated book, *Captain Slaughterboard Drops Anchor*, had been conceived and executed in peacetime, and from it sprang the Chatto & Windus commission. It is probable that, even if there had not been a war, he would have continued illustrating, but not with such concentration. It was the war that accelerated the change-over from painting.

He did contribute one canvas, entitled *I was called*, to an exhibition of 'The War as I See It' at the Stafford Gallery in April 1940, but this was painted before his call-up. The exhibition was not well received. Eric Newton, in his *Sunday Times* review of 21 April 1940, sarcastically wrote that it should have been called 'This War as I Think I Ought to Feel It'. He did, however, pick out a few painters, including Mervyn Peake, and praised them because they had chosen subjects really seen or truly felt.

On his first forty-eight hours' leave home, Mervyn brought back the Gormenghast exercise book. Despite the cramped conditions, the drill parades and the potato peeling, without which no military training was complete, he had filled the pages with neat handwriting, not unlike his father's, and had completed what was to be the first few chapters of *Titus Groan*.

Maeve and Sebastian had moved from the damp house at Lower Warningcamp to a dryer one, the School House, about a mile away in Upper Warningcamp, which was on higher ground and backed on to a large wood. It was rented by an ex-cook of Maeve's

Dr Peake and Sebastian at Burpham, 1940

mother who had retired there on leaving domestic service, and
Maeve and the baby had three rooms on the top floor. Besides
being dryer, the School House was less lonely than the isolated
cottage by the railway.

Burpham was now beginning to take on a significance for both sides of the family. When Mervyn returned to barracks, he left the first manuscript with Maeve; she was to keep it by her bed, as she was to do in the future, when the next instalments arrived.

Eventually, that unlikely piece of military material known as Gunner Peake 5917577 (he was to use his army number later in *Gormenghast* as the start of the number of the Edict which Bellgrove had to read out to the assembled professors) was pronounced fit for service. He managed, however, to make a slight error on the passing-out parade. When his squad marched smartly, rifles on their shoulders, past the commanding officer and was given the order to salute, instead of turning his head to the right and slapping the butt of his rifle, Mervyn brought his hand up to his cap instead, and gave a cheerful wave, a gesture that might have been more appreciated had he not been the only one to make it.

However, the Phoney War was now over, the German Army had overrun France, and the bombing of London had begun. One of the first casualties of the blitz was *Captain Slaughterboard Drops Anchor*. The warehouse containing all available copies of the book was among the first to be bombed. Every copy was destroyed, cutting off Mervyn's income from that source and turning into rarities such copies as had already been sold.

He was posted to (or enlisted in, as the Department of Defence puts it) the 12 Light Anti-Aircraft Regiment, on 29 July 1940, and was sent to the Isle of Sheppey, at the mouth of the Thames Estuary. The island was under the command of Colonel E. C. Bolton, D.S.O., of the Queen's Royal Regiment, who had instructions to hold the island, in the event of a German invasion, to the last man and round. The only bridge leading to the mainland was to be blown up. There was to be no surrender.

Gunner Peake was assigned to an anti-aircraft-gun battery, firing at the Luftwaffe bombers as they flew up the Thames estuary to London. This was one of their favourite approach routes, and the gunners on Sheppey were on constant alert. Living conditions on the gun-site were so rudimentary as to be almost non-existent, and the crews lived with the guns, so as to be ready for instant action. Despite the appalling conditions, Peake felt that at last he was doing something worthwhile in the war: he was defending the capital and, at least in a small way, hitting back at the enemy.

Mervyn at Dartford in 1940

Curiously, during his periods of rest, even when the heaviest
bombardments were in progress, he could sleep beside his gun,
without tremor or twitch, and wake, when his turn of duty came
round again, as refreshed as if he had just got up from his bed at
home.

One day that summer, as the crews stood around their guns, an

officer walked into the site, and asked if anyone knew how to drive. Mervyn Peake was the only member of his crew to put up his hand. His name was duly taken, and he thought no more of the incident. But soon afterwards, on 21 August 1940, he was posted to the 228 Anti-Aircraft Driver Training Unit. His movements now become slightly difficult to follow. According to his own accounts, he started Exercise Book II of his writing on 3 October, at Dartford, but by the end of the month he was in Blackpool, having been sent there, to his amazement, as a driving instructor to a Royal Engineer Regiment. Though he could drive, he had never passed a test (he had a driving licence before tests became obligatory in 1933), and he knew nothing about the internal combustion engine. However, orders were orders, so to Blackpool he went.

Unlike Sheppey, Blackpool was not in the front line, and wives and families were allowed to join the men stationed there. Soon Maeve and Sebastian left Upper Warningcamp and set off for Blackpool. Because of wartime restrictions, trains moved very slowly, and there were frequent stops during the long cross-country journey. At night, because of the blackout regulations, the train was in almost complete darkness. Sebastian howled his disapproval for most of the journey. The compartment was packed with soldiers who, with extraordinary patience and good humour tried, by songs, to lull the fractious baby to sleep. At one point the train was attacked by a German bomber. Undeterred, Sebastian managed to outdo in sheer noise the sound of bombs and exploding shells outside. Eventually, after fourteen hours of slow progress through the countryside, he and his mother arrived at Blackpool in the early hours of the morning.

Mervyn was waiting on the platform. He had found a billet for them in Coronation Drive, Blackpool. It consisted of one minute room, into which husband, wife and baby were crammed. It was very much a question of self-service. Maeve was given a broom and told that she was responsible for keeping the room tidy. She was not very good at it, a fact that made the Blackpudlian owner comment 'Ma parents said that mooney don't make for cleanliness, and bar goom, they're raght.' Though why he should think Gunner Peake and his wife were rich is another war mystery.

Equally mysterious, perhaps, is why Mervyn was in Blackpool at all. It became painfully evident that he never would be able to

master the intricacies of the internal combustion engine, let alone teach anybody else. He was, therefore, taken off driving and, because somebody had discovered that he was 'artistic', put to painting elaborate notices saying 'This lavatory is for the use of officers only'.

After four weeks at Coronation Drive, with high teas downstairs at 5.30 p.m. sharp, relieved only by the presence of a young R.A.F. man with the soul of a poet, and his wife, Peake, with the help of an understanding billeting officer, moved to a house in Bloomfield Road in Blackpool, owned by two spinsters. To him and his wife it was luxurious, for it had two rooms. The spinsters were kind-hearted and helpful. One of them called Sebastian 'my little flower'. Downstairs, a number of R.A.F. men were billeted. They would spend hours playing the latest Glenn Miller tunes on a piano, while upstairs, Maeve polished Mervyn's R.A. regimental crested 'Ubique' buttons with Brasso, and his boots with Dubbin. He had been promoted to Lance-Bombardier, and now life took on an oddly remote and yet domestic appearance. Cut off in this strange town from the main events of the war, the couple went for long walks on the breezy, gritty front of Blackpool sands, pushing the pram in front of them as if this was how their life had always been and always would be.

In this weird vacuum, with very few army duties to perform— the number of officers' lavatories needing signboards was obviously limited—Peake was able to get on well with his book, which he was still writing in small ruled exercise books. Book III, for example, has a note saying that it was started in Blackpool in October 1940. The story has not been given its final title of *Titus Groan*, but is called *Goremenghast* (the original spelling of the name has an extra 'e'). There is a note stating which portions had already been completed; the first exercise book containing chapters 1–8, and the second, called Book II, chapters 9 and 10.

By December 1940, he was working in a black exercise book. It had a meticulous drawing of a rickety pillar, cut across at intervals with

GOREMENGHAST
(continued)
by
Mervyn Peake

At some stage, the word Goremenghast is crossed out and, above the drawing, the title *Titus Groan* is put in for the first time. These small exercise books, which are now kept in the library of University College, London, contain family sketches and drawings of Maeve and Sebastian, as well as Peake's ideas of how his own characters might appear. The development of characters such as Prunesquallor, Steerpike and the Twins can be traced through these pages, not only through the scribbled and often crossed-out words, but also through the numerous tentative sketches and drawings.

While he was at Blackpool, an event of great importance to Mervyn Peake's future took place in London. Chatto & Windus published in December 1940 the book *Ride-a-Cock-Horse and Other Nursery Rhymes*. The price was five shillings. It was dedicated to Sebastian, who appears in the frontispiece, held in the arms of a stylized drawing of his mother.

Besides the title-piece, the nursery rhymes consisted of 'Old King Cole', 'How Many Miles to Babylon?', 'Doctor Foster went to Glo'ster', 'Sing a Song of Sixpence', and nine others. Each is illustrated with a drawing that combines vivid imagination with precise care for detail. In three of them—'How Many Miles to Babylon?', 'I Saw a Ship A-Sailing' and 'The Man in the Wilderness'—small boys, aged perhaps seven to ten, appear. Although Sebastian was only a few months old at the time, and Fabian, the younger son, was yet to be born, these drawings bear an astonishing likeness to the children as they were later to become. The inclusion of the final poem, 'I Saw a Peacock', was suggested by Walter de la Mare, who had long admired Mervyn's poetry and had invited both Mervyn and Maeve to his house.

The *Times Literary Supplement*, dated 17 December 1940, had nothing but praise for the book. It carried a reproduction of Doctor Foster floundering through his outsize puddle. The drawings were, the anonymous reviewer declared, something better than most pictures for nursery rhymes. They were not tagged on as mere illustrations of what the words had already described: instead they 'opened a sort of window onto the unknown'.

Like Tenniel's, Peake's drawings were directed as much to the adult as to the child. They have the same quality of exaggeration and attention to detail, and they somehow create a new dimension for the words they illustrate. Peake had an adult and a child-like

side to his character. He loved playing practical jokes and making up puns: 'Mary Rose sat on a pin. Mary rose.' When he illustrated a book, he entered fully into it, through either the adult or the child-like door of his personality. Then he brought all his talent, expertise and patience to bear. The quality of the story also affected his drawing. The better it was, the better the final result.

Not all reviewers were happy about this child–adult approach to the nursery rhymes. The *Nursery World*, on 4 December 1940, stated primly:

> A book presumably for children but which ought never to find its way within a mile of them is *Ride-a-Cock-Horse and Other Nursery Rhymes*, illustrated by Mervyn Peake. The rhymes are the old, familiar ones, but the pictures are nightmarish. Mervyn Peake is very gifted and his drawings have a certain sort of horrible beauty, but for children definitely NO.

But to many they were a revelation, an excitement to be savoured over and over again. On 26 May 1941, five months after they were published, Walter de la Mare wrote to Peake from his home in Buckinghamshire:

> I have been engrossed by the Nursery Rhyme pictures again and again, and was sharing them with some friends yesterday. Fantasy and the grotesque, indeed; a rare layer of imagination, and a touch now and then, and more than a touch, of the genuinely sinister [a note in the margin here modifies this with: 'Babylon and the baby and mother—so different from and as good in its own kind as Jack Horner—are touching and very profound indeed.'] But, as I think, not a trace of the morbid—that very convenient word. How many nurseries you may have appalled is another matter. How many scandalised parents may have written to you, possibly enclosing doctors' and neurologists' bills you will probably not disclose. Anyway, most other illustrated books for children look just silly by comparison.

Later in the same letter he wrote, 'It's very bad luck being billeted just now in Blackpool. What happens there in the summer now? Is it thronged with the gay?' This the Peakes were not to discover, for at the beginning of the summer the Army became once again, in its unpredictable way, interested in the fate of the driver-instructor who couldn't instruct: it transformed him from a gunner into a sapper and sent him away from Blackpool.

CHAPTER 11 Sapper Peake

According to the 'record of service' still kept by the Ministry of Defence, 6 June 1941 was a significant day for Mervyn Peake. The relevant entries are as follows:

Transferred to RE. Posted to No. 1 Bomb Disposal Group 6–6–41

Posted CRE (BD) London. Sapper 6–6–41

No. 1. Bomb Disposal Company 6–6–41. Mustered as Pioneer E.3. (6–6–41)

A week later, this enigmatic and cryptic message was amplified by the following equally mysterious entry:

Draughtsman (Art) A3—awaiting mustering

Whatever it was that led to his transference from the Royal Artillery to the Royal Engineers, and to his posting to London as a bomb disposal expert, it certainly could not be superior knowledge of the subject. He knew as little about the engineers and the disposal of bombs as about the gunners and their artillery. However, this consideration was of little importance to the Army.

It was goodbye to Blackpool, to the sisters in Bloomfield Road, to the Glenn Miller tunes, to the polishing of 'Ubique' buttons and the long walks on the gusty sands of Blackpool. He was posted to the Duke of York's Headquarters in King's Road, Chelsea. An entry halfway through the *Titus* exercise book, started at Blackpool on 14 April, has this note in the margin:

August 3rd 1941

Duke of York's Barracks, Chelsea

The return to London meant that he could renew the friendships he had made just before the war, and develop new ones, particularly with Graham Greene, who was being hailed as a 'promising young novelist', and Dylan Thomas, whose poetry Mervyn greatly admired. Although there were no particular groups or established sets, painters and writers still continued to gravitate towards Chelsea whenever they visited London, and the King's Road between the Duke of York's Barrack and World's End was particularly popular.

Though Mervyn was officially stationed at the barracks, he had a good deal of freedom. His duties as a bomb disposal expert seemed to have been almost as light as those of a driving instructor, the authorities having, perhaps wisely, come to the conclusion that it was safer for all concerned to keep him away from, rather than close to, bombs needing disposing. At all events, he was able to rent a cheap room in Store Street, and here, from time to time, Maeve, who had returned officially to Burpham, would visit him. She would bring Sebastian with her, and because the Store Street room did not contain a cot, bed the baby down, very comfortably, in the bottom drawer of a large chest of drawers, which was about the only piece of furniture in the room. The only precaution that had to be taken was not to shut the drawer while the baby was asleep.

During one of his peregrinations down the King's Road with friends, Mervyn met Stanley Grimm, a painter who had a studio at Trafalgar Studios, Manresa Road, just off the King's Road. Stanley told him that most of the artists had left the studios and that one could be had for a few shillings a week. This was an opportunity that could not be missed. Giving up the Store Street room, Mervyn took over one of the large, empty studios in the ramshackle building, and here, for the first time since the war had started, he was able, when off-duty, to paint again in surroundings that suited him.

Maeve and Sebastian would now come up to the studio from Burpham for long or short visits according to the dictates of army life at the barracks. There was practically no furniture in the studio, but lack of furniture never worried them much. It was wonderful to have a working studio where there was space, once again, to paint.

Though most of the studios remained empty, there was one on the ground floor where Dylan Thomas, when he was in London, would stay. Though physically so different (Dylan was short and

plump, Mervyn tall and thin), they had much in common in their attitudes towards poetry and literature in general. Mervyn, Maeve and Dylan would spend evenings in the almost-deserted studios, while outside the gunfire from the anti-aircraft batteries would sound almost too theatrically like the noises off for a new 'Journey's End' war play.

One day, having sat on the side of his bed in his barrack room writing and smoking for a while as was his habit, Mervyn finished the paragraph on which he was working and left the room. When he came back later, he found the floor round his bed had disappeared: it had been burned to the joists. It occurred to the army authorities that he might be wilfully trying to set fire to the place, and he was ordered to attend a Court of Enquiry.

> I remember waiting all day [Maeve wrote] with a friend, Diana Paul, in her flat in Petty France for the result. I was very worried. I had seen him for a few minutes in the morning. He was standing between two soldiers. He did not seem at all worried, but thought it was rather a joke.

The Court of Inquiry found that that military oddity 'Sapper Acting Lance-Bombadier' Peake (he had retained his artillery rank though now an engineer) was not guilty of wilful damage, but had been negligent. The fire, it was thought, had been started by a cigarette end carelessly thrown into a waste-paper basket.

Whatever the official verdict, one thing was certain. The authorities did not wish to keep in London a bomb disposal man inclined to create rather than prevent incidents, and shortly after this he was posted to a camp in the Lake District which seems to have been a place where people who could not be fitted in anywhere else were dumped. There were men from countries all over the world. Every now and then, the camp was swept with epidemics of gingivitis and scurvy. Wives and families were not allowed in the area, although it could hardly be farther from a front line, and so Maeve and Sebastian stayed at the School House in Upper Warningcamp. But they kept on the Manresa Road studio in the hope that Mervyn might be posted south again one day.

Despite the appalling conditions, he was extremely busy. Chatto & Windus had, as a result of the success of *Ride-a-Cock-Horse and Other Nursery Rhymes*, commissioned him to follow this up with an illustrated version of Lewis Carroll's *The Hunting of the Snark*. Published in December 1941, it was a very small book, smaller

than *Ride-a-Cock-Horse and Other Nursery Rhymes* and cost only one shilling. Years later, Nora Smallwood of Chatto & Windus explained that

> Paper was rationed during the war. The policy—a correct one I feel—of the firm was to give what stocks we had to our long-standing or established authors. Much as we wanted Mervyn to work on larger books, we could only give him small ones, which did not use up too much of our limited supplies of paper.

But the firm did agree to print a book of his poems. It was entitled *Shapes and Sounds*, and Peake designed the jacket. The book sold at four shillings and sixpence, and he was paid £10 in advanced royalties—a not inconsiderable sum for a first volume of poems in those days.

The *Times Literary Supplement* of 27 December 1941 devoted a long and appreciative article to the book under the heading of 'Poet of Shapes and Sounds'. The *Manchester Guardian* (now the *Guardian*) had this to say: 'Mr Mervyn Peake, already an artist of note, is a new-comer as a poet and one of the most promising that recent years have produced.' Stephen Spender, writing in *Horizon*, was more critical:

> Mervyn Peake is a poet who impresses me by his sincerity. His writing is technically weak, but there is a genuine feeling for life, and also a generous personality behind it, combined with a sense of words that is sometimes striking. His poems are enjoyable, and he must be a remarkably sincere and intelligent person.

But perhaps the most important event of that December was the exhibition of drawings mounted by the Leicester Galleries. They included the original work for the 1940 edition of *Ride-a-Cock-Horse and Other Nursery Rhymes*, as well as those for the recently published *The Hunting of the Snark*.

Mervyn obtained special leave from the army to attend the private view. He had hoped that the gallery would give him one of the larger inner rooms, but accepted, with his usual cheerfulness, the smaller outer one.

It was a fine occasion, a refreshing change from the mud and discomfort of the camp, and Peake's fame attracted a great number of people, many of whom did not know either him or his wife

personally. Two women were standing in front of some of his drawings; one turned to the other and said, 'It's all very clever.' The other nodded and laughed. Though Maeve was upset, this did not bother Mervyn. He always took criticism as calmly as praise.

Once again the army moved in its incomprehensible way and sent Sapper Peake on a theodolite course on Salisbury Plain. Mervyn did not even know what a theodolite was, let alone how to operate one. Figures confused him, too. He explained to the pipe-smoking Commanding Officer that a 6, 9, or 0 appeared to him to be female, while a 7 and 1 were masculine: it was quite impossible for him to look at figures in any other way. The Commanding Officer listened patiently and then knocked his pipe out on his hand. Mervyn became aware of an astonishingly hollow sound which he could not understand until he realised that, incredibly both pipe *and* hand were made of wood. The Commanding Officer told his confused Sapper to go away and write. Mervyn gratefully did so, and the result, in a standard S.O. army exercise book, was the long poem 'A Reverie of Bone'.

Mrs Gilmore, Ruth and Matty all foregathered at a hotel at nearby Westbury for Christmas. Mervyn obtained leave and he, Maeve and Sebastian, then almost two, shared a double room in the hotel:

> It was wonderful waking up in the morning [said Maeve] and having breakfast in bed. Such luxury that one had not known for years. There was a large wardrobe opposite the bed, with a looking-glass. Suddenly it began to tip slowly and mysteriously towards us. Mervyn threw off the tray, jumped out of bed and just caught it before it fell. Who should walk out of it but Sebastian, who had decided it would be fun to tip it over.

These small domestic scenes were few and far between. As soon as the theodolite course was over, it was back to the Lake District for Mervyn, and back to Burpham for Maeve. Another baby was due in April, a fact that made the ex-cook at the School House remark, 'You're a two-year breeder!' But by now the small family had moved a few hundred yards along the road to a thatched cottage at the end of Dr Peake's garden, officially known as 94 Wepham (Wepham being, like Upper and Lower Warningcamp, yet another sub-division of Burpham). It belonged to the Duke of

Norfolk. The rent was three shillings a week. There was an ivy-covered outside privy, no running water except for a tap outside the back door, and cooking was done on a paraffin stove.

In the Lake District, Mervyn had now begun to illustrate a new book. Batsford had commissioned him to work on *Witchcraft in England* by Christina Hole, or 'Christ-in-a-hole', as Mervyn, somewhat irreverently, called her. It was, perhaps, appropriate that such a book should be worked upon in an area where witchcraft had been so prevalent. Mervyn would walk for miles drawing inspiration for the illustrations from the feel of the Lake District hills. He had a great love for, and deep knowledge of, country matters: animals, birds, plants and trees. He made friends easily. Many people invited Mervyn to their houses, and some, perhaps appreciating the true person in this unlikely soldier, offered him rooms where he could put down his drawing-pad and work. No doubt, to this day, drawings of his are to be found in old cottages and farms of the Lake District. He was always very generous. For every drawing he sold, he gave away ten. He would sit down and tell a story and draw, and then hand the drawing over.

The new baby was expected in April 1942, and Mervyn wanted very much to be with his wife. He had telephoned her from the home of one of the Lake District families who had befriended him (and given him high tea at 6 p.m.) and had written saying that he hoped to see her, but when he asked his sergeant for compassionate leave because his wife was having a baby, he received an uncompromising 'No', with the rejoinder, 'What's so new about having a baby?' Undaunted, he promptly forged a pass and, taking advantage of the fact that an army friend was driving a lorry south, jumped into it and headed for Sussex.

Maeve had entered the Peter Pan Nursing Home at Rustington, and was looked after, appropriately, by a nurse called Wendy. Here, her second son, Fabian, was born. Mervyn arrived shortly afterwards and accompanied his wife and child back to 94 Wepham. Maeve, despite her new responsibilities, noticed that Mervyn seemed strained and tense. His previous cheerful acceptance of the vagaries of army life had given place to an anxious fretfulness. It seemed to her that he had reached the end of his tether, but he went back to the Lake District and to the inevitable trouble that forging a pass and being AWOL (absent without leave) must inevitably

have entailed. What happened during the next few weeks can only be guessed at, for he would not talk about it later. Maeve did not know and the army remained reticent. She received a telegram from the War Office informing her that he had been sent to the Neurosis Centre at Southport suffering from a nervous breakdown.

In the bed next to him was a man who had broken down because army routine had disrupted his daily communication with his mother who had, in his own words, 'passed over'. Around him were others who had been unable to reconcile themselves to army life. Mervyn would sketch them while they queued up in their long white nightshirts and army boots for their food. He sent these drawings and many others to Maeve.

He took part in the occupational therapy that was the stock treatment for a nervous breakdown, and made a bamboo recorder. He also spent much of his time writing. It was here that he wrote chapter 56 (The Dark Breakfast), and chapter 57 (The Reveries), of *Titus Groan*. All but the first of the Reveries are in a small exercise book with the reference: 'Occupational Therapy, Southport Neurosis Centre'. On the last leaf of this exercise book is the cheerful note: 'End of Book One (at last) Southport, 24 July 1942'. Such were Mervyn's charm and powers of persuasion that he even managed to enlist the help of the matron to type out his book.

The summer of 1942 passed, while the letters, drawings and small exercise books flowed steadily south to the thatched cottage at Wepham. 'He would cut out strange animal shapes out of cardboard,' Maeve recalled, 'colour them, put a stamp on them and send them through the post. They would always arrive, wonderful ready-made toys.'

Sebastian, their eldest son, could
 just remember the hazy chirping of the birds in the garden in Burpham in 1942. The cool sound merged with the fine air, when the open windows of morning let them in.

In September 1942, Mervyn was sent on indefinite sick leave, and came home, at last, to 94 Wepham.

There was a lot to be done. Chatto & Windus had asked him to illustrate Coleridge's *Rime of the Ancient Mariner*. This was a task that admirably suited his talents, for his visual conception of Coleridge's poem was clear and definite, and the strange half-world of the mariner and his shipmates was one that he could understand

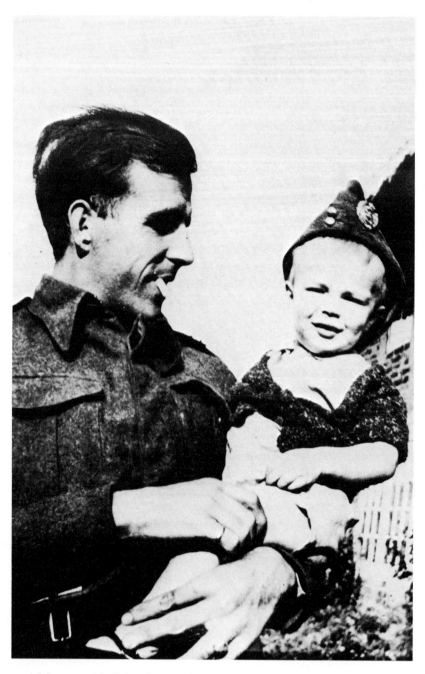

Mervyn with Sebastian, on leave at Lower Warningcamp, 1942

immediately. As usual, the quality of the poem brought out the best in him.

The last few chapters of *Titus Groan* were now completed. He had started writing the novel in a small house at Lower Warningcamp, and two and a half years later he was completing it in a small cottage a mile or so away. The bulk of it, however, had been written during his army service. He was told that it was unlikely that he would be asked to serve again. Had he not been in the army or had he served as something less humble than unemployed gunner turned engineer-pioneer, the book might not have been written.

There was, as yet, no idea of publication, though during an evening at the Café Royal he told Graham Greene that he had been writing a long novel. He gave a few details of it. They talked about it for a while, and then the conversation drifted on to other subjects.

Mervyn was essentially a family man, building his life around the love and security which a family can bring, and he was anxious to get to know his two sons. Sebastian, recalling later those early childhood days, gives this impression of family life:

> From the terrace of my grandfather's house [Reed Thatch, Mervyn and Maeve's cottage was at the bottom of the garden] I could see the river and the clump of trees called Chanctonbury Ring. I could see no other houses, just the space between my eyes and heaven. [While] up on the lepers' path where flints looked like heads, or feet, marbles or crags and chalk caked my shoes, I saw the sky above and the blue and the green of the Downs.

Almost the only reminder of Mervyn's army life was the recorder he had made at Southport, and while Maeve accompanied him on the piano his father had brought back from China, he would play tunes like 'Plaisir d'Amour' and 'Jesu, Joy of Man's Desiring'. He went up to London from time to time, to see editors and others about his work. He had a cheap room in Frith Street (as well as the working studio in Manesa Road) where he would stay and where Bill Brandt photographed him. The photograph was to appear in *Lilliput*, with which his connection was considerable. Kaye Webb worked there, and became a friend of both Mervyn and Maeve. She persuaded him to submit work to the magazine. His unmilitary army career had inspired Anton (Mrs John Yeoman) to draw for

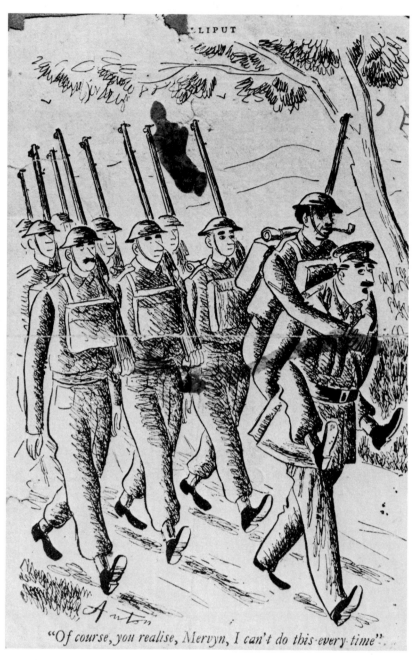

Cartoon by Anton in *Lilliput*, 1943

Lilliput a picture of troops marching along a lane. The officer at the head of the party is carrying, piggy-back fashion, a soldier with Mervyn's unmistakable features. The caption runs: 'Of course, you realise, Mervyn, I can't do this every time'.

But his military career was coming to a definite end. His sick leave was extended in January 1943, and again in March of the same year. He was finally discharged on 30 April. His conduct, during his three years' service in the army, was described in the official records as 'Excellent'.

On 5 May 1943, he wrote to Graham Greene:

I've been discharged from the army—have just heard today and wanted to tell you for I'll be able to concentrate on Gormenghast [*Titus Groan*]. It's a grand feeling—and I'll be able to complete it much faster than I had imagined—more time—and a sense of liberation.

CHAPTER 12 'The greatest living illustrator'

As he had prophesied to Graham Greene, Mervyn managed to finish *Titus Groan*, which he still from time to time called *Gormenghast*, very quickly, and when it was typed he sent it to Chatto & Windus. They kept it for some time and then turned it down.

Mervyn immediately wrote to Graham Greene, who had now accepted a post with Eyre & Spottiswoode:

Chatto & Windus have, after a good deal of delay, turned down *Gormenghast* and I am writing to tell you this at once. Raymond wanted me to 'prune' it, before he sent it to another reader—or rather, to say that I'd be willing to prune it. I did not feel I wanted to say 'Yes, I'll prune it,' in order for his prize reader to have less to read (a very busy man, I gather)—so I said I was sorry but as I had been writing and attempting to simplify the things for four years, I couldn't suddenly jump in with shears in an arbitrary manner. No doubt there is some of it which is redundant, but I can't say I know *which* part it is. It isn't to me, at this moment anyway—although I'd be only too glad to cut out anything that's not *of* the story—once I'd realised it. Anyway that's that, as far as Chatto & Windus goes. I've got half a chapter to complete—but would you like me to send the manuscript to you—or shall we meet?

It was eventually sent to Graham Greene, but his reaction was not at first very favourable. In a letter written from the Reform Club, he started, 'I'm going to be mercilessly frank—I am very

disappointed in a lot of it & frequently wanted to wring your neck because it seemed to me you were spoiling a first-class book by laziness.'

He went on with his 'merciless' frankness and wrote that it seemed to him there was:

> a long patch of really *bad* writing, redundant adjectives, a kind of facetiousness, a terrible prolixity in the dialogue of such characters as the Nurse and Prunesquallor, and substantially too in the case of Eda [*sic*] and to some extent in Titus's sister. In fact—frankly again—I began to despair of the book altogether, until suddenly in the last third you pulled yourself together and ended splendidly. But even here you were so darned lazy that you called Barquentine by his predecessor's name for whole chapters.

Despite these harsh comments—the original letter can be seen at the University of London library—he went on to say, 'I want to publish it; but I shall be quite sympathetic if you say "to hell with you: you are no better than Chatto", and prefer to take it elsewhere.' He finished the letter: 'Write and let me know how you feel about all this. If you want to call me out, call me out—but I suggest we have our duel over whisky glasses in a bar.'

Mervyn read this out to Maeve in a small room across the passage from their studio in Manresa Road. 'We were both terribly upset by Graham Greene's letter,' Maeve remembered, 'but, after the first shock was over, Mervyn began working on it.' The result must have been satisfactory, for the manuscript was then sent to Eyre & Spottiswoode's production department and on 22 July 1943 Mervyn wrote to Graham Greene from Trafalgar Studios,

> It was only yesterday that I was able to see Mr Jarold [*sic* for Douglas Jerrold, a director of Eyre & Spottiswoode]—hence my not being able to write to you till now. He was, I think, rather surprised about the idea of [*Gormenghast*] being illustrated. I said that I was not dead set on the idea, but the drawings had formulated in my mind as I wrote. His point, however, that if it were illustrated it would be placing it apart from 'fiction' and making a sort of ivory tower of it (not that I want to do ivory tower drawings!) has a good deal to be said for it. He was not definitely *against* the idea though it was left vagueish.

The production of *Titus Groan* seems to have remained 'vagueish' for some time but a new idea for a book was talked about. Mervyn continues his letter:

> As for Grimm—nothing could be better. He mentioned £150's worth of drawings which is very generous I think. Mrs M [Mrs Miller of Eyre & Spottiswood] showed me a book which was the size of what they have in mind and I was delighted. A large squarish shape.
>
> I look forward to getting down to it—and will work in the country.

And so he returned to 94 Wepham and started working on the numerous illustrations he was to prepare for the *Household Tales* by the brothers Grimm—illustrations whose heroines, particularly the one on the jacket, had a remarkable likeness to Maeve.

The previous autumn, a friend in Amberly had introduced Mervyn Peake to Professor C. E. M. Joad, a regular contributor to the BBC's intellectual programme 'The Brains Trust' and the author of a number of books popularising philosophy. He was so impressed by Peake that, a few days later, he walked over to Burpham to meet him again. Peake was out, so Joad wandered up to Reed Thatch and came face to face with Dr Peake, who was at first under the impression that Joad was some kind of tramp. A friendship sprang up between Joad and Peake. Joad asked Mervyn to illustrate a book to be called *The Adventures of a Young Soldier in Search of a Better World*. It was a political satire, and Mervyn threw himself into the work with his usual mixture of enthusiasm and diligence. He completed the twenty or so drawings in record time, and the book was published in the summer of 1943. It was widely reviewed. Most of the reviews were concerned with the writing and the value, or otherwise, of Dr Joad's philosophical conceptions but the *Times Literary Supplement* of 4 September 1943 had this to say:

> Once, for an instant, Professor Joad makes a slip. He speaks incautiously of 'unearthing' Mr Peake to do the illustrations. It would almost serve him right if his book came to be valued less for the text than the illustrations, as it might be. Like Mr Peake's pictures for nursery rhymes three years ago, nearly all these drawings show a strong and extraordinary imagination.

As it turned out, the reviewer's forcast was correct. *The Adventures*

of a Young Soldier in Search of a Better World is prized today for its illustrations, not for its text.

Of far greater importance, however, was the publication soon afterwards of *The Rime of the Ancient Mariner* with Mervyn Peake's seven magnificent illustrations. They represent, perhaps, his highest achievement as an illustrator: certainly, they show that he had reached a mastery of his medium and the *Times Literary Supplement* of 8 December 1943 declared that Peake's drawings were 'finely impregnated with the spirit of the supernatural in the rime'. *Current Literature* declared that the illustrations added 'a spiritual content' to the poem. Others followed suit. Here was that rarity in an illustrator: a man who could add a new dimension to the work he was illustrating. From this date, Peake was openly spoken of as 'the greatest living illustrator of the day'.

Another book illustrated by Peake and published in 1943 was *All This and Bevin Too* by Quentin Crisp. Crisp had met Mervyn, Maeve and their two sons on one of their visits to London. 'It was at the Bar-B-Q in the King's Road,' recalled Crisp, 'that I first met Mr Peake. It was during the Happy Days, i.e. during the war. You could sit there all day if you wanted to, and nobody came in and bothered you.' He had a very clear visual impression of Mervyn at this time:

> He was tall and thin. Sometimes he looked gaunt, just like his drawings, but he never looked ill. He had a tremendous vitality. Sometimes, when he was with his family, I got the impression that he was a very 'cosy' man. You couldn't get a real picture of his private life when you were talking with him. He kept it to himself; but it looked very nice.

Although Peake was held in such esteem as an illustrator that Quentin Crisp went to considerable lengths to persuade him to illustrate his book, Crisp said later:

> He was always very good to me, and did all the illustrations for my book without any fuss; but though he never said anything, I think he was a little disappointed, when the book came out, as it was so small, not even in hard covers.

Although Mervyn was now invalided out of the army, he still made sporadic, and usually short-lived, attempts at playing some kind of role in the war. He worked for a time with the Ministry of Information, and was ordered to produce a visual record of glass-

blowers making cathode-ray tubes for army wireless sets. This meant a visit to a glass-blowing factory in Birmingham. He became entranced by the movements of the glass-blowers as they scooped up the molten glass with their long blow-pipes, and executed strange ballet-like steps, twisting and turning their bodies, while the hardening glass took on the required shape. He did an enormous number of studies for this work, and the completed painting, *The Glassblowers*, was shown at the National Gallery.

He also painted an R.A.F. bomber station in Sussex. There were complaints from the squadron concerned that the airfield was far too small, and was lost in an expanse of Sussex countryside. The truth was that painting of this conventional kind did not suit Peake. Indeed, it can be argued that although painting was his first love, it was not his real forte: his sense of colour was sometimes weak, and the draughtsman and illustrator in him always outshone the painter. He was looked upon no longer as an up-and-coming painter but as an established illustrator of the first importance. Here, as in the writing of *Titus Groan*, his development was helped by the cramped conditions of wartime life.

Other activities included drawing small scenes for propaganda leaflets, a spell with the Army Theatre Unit, and work for a camouflage unit, although what he camouflaged seems to have been as secret as the unit itself. He was tireless in his efforts to help, and though he enjoyed the work with both the camouflage unit and the Army Theatre Unit, neither was in the main stream of war effort. The war had become professional, and there was less room than ever for a cheerful amateur with a tendency to play jokes and the ability to see the humorous side of life. There was no sign of any employment as a war artist. There were too many of them already.

To his sons, the war had a different meaning, as Sebastian was to recall later:

> American soldiers gave me chewing gum, 'for the boy' . . . My brother had a bath with me in the garden, the water spilled and splashed and we'd jump in the soggy grass and jump again. The war was on and all around me there was love. The tiny village teemed with flies, they buzzed and I flicked them away and my mother was there. The thatch hid birds and eggs and the rain never came and the war was on.

While the armies were getting ready to cross the Channel and

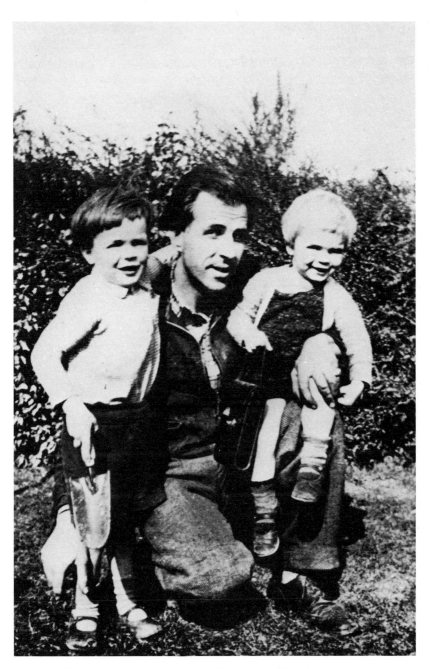

Mervyn with Sebastian and Fabian at Burpham, 1944

start the liberation of Europe, the department store of Peter Jones, despite its vulnerable glass frontages, staged an exhibition of Mervyn Peake's paintings beside the haberdashery department. It lasted the whole of June 1944. Most of the shoppers seemed to be completely unaware of the paintings as they hurried about matching patterns and thread, but two women stopped in front of one of Mervyn's paintings and began laughing at it, pointing at the strange clothes in the portrait. Maeve happened to be there at the time. Although normally intensely shy and self-effacing, she would rush incautiously into the attack if she thought Mervyn's work was being denigrated. In this instance, she recalled 'I went straight up to the two women and began laughing at them, pointing at their hats, shoes and clothes and saying how funny they looked. They were flabbergasted, and I don't think they understood what was happening.'

There were other exhibitions throughout the year at Peter Jones, and John Grome, a painter and friend of theirs, wrote later:

> I remember Mervyn and Maeve (or was it Maeve and Mervyn?) organising an exhibition for me at Peter Jones where, at that time, there was an art gallery. I even sold a painting. The evening after the show had ended I was in their studio to find the painting had been purchased by Mr and Mrs Mervyn Peake. There it was hanging on the wall!

By this time the tenancy of 94 Wepham had come to an end, as the Norfolk estate needed it for other purposes, and Mervyn had found a studio in Glebe Place, just off the King's Road, Chelsea, for £200 a year, to which they had moved. It was a beautiful, spacious place with enough room for the whole family, a working as well as a living studio. He had a second studio in Manresa Road, which cost £78 a year to rent. There were, it was true, the V.2 bombs to face, but they were a hazard that could be accepted.

In an earlier letter to Maeve, dated 26 July 1944, Mervyn wrote about the progress he was making with a number of projects, including his relations with 'Migraine'. This was their private word for the publishing firm of Eyre & Spottiswoode and came from an abbreviation of the firm's name to 'Eye and Spot', and then to 'Migraine':

> I went to Migraine too—and they are going ahead with R Without R [*Rhymes Without Reason*, a book of nonsense verse

he had submitted]. I must do the jacket quickly. . . . I asked Mrs Ruby Miller if I could have an extra galley and she referred me to Graham Greene who is working at Migraine in the mornings. I received a p.c. to this effect this morning — so I 'phoned him about an hour ago. He wants me to lunch with him on Thursday.

Rhymes Without Reason was published at seven-and-sixpence at the end of the year. A quaint little book of humorous church stories, called *Prayers and Graces*, by Allan M. Laing, illustrated by Mervyn, was published at four shillings and sixpence by Gollancz. It was very popular and continued in print for some time.

Around eleven o'clock in the morning of 8 May 1945 came the news that had been expected for the past few days: the war in Europe was over. A friend of Mervyn and Maeve's who had a young baby came round to the studio in Glebe Place, and 'baby-sat' for them, while they went out. A bonfire had already been lit in Glebe Place. They went on to the West End. The whole of Piccadilly, from Hyde Park Corner up to Piccadilly Circus, was a mass of dancing people. Linking arms with complete strangers, they danced, singing and shouting, all the way up Piccadilly. The bonfires, the dancing, the prayers of thankfulness went on all night. In the early hours of the morning, they returned to Glebe Place, footsore, hoarse from singing and shouting, and more exhausted than they had ever been during the war.

Ironically, as soon as the war was over Mervyn was appointed an accredited war artist, with the unfamiliar rank of Captain. Charles Fenby, the editor of the *Leader* magazine, impressed by Mervyn Peake's drawings, had commissioned him to tour Western Europe in the immediate aftermath of the war and record on paper his impressions. Tom Pocock, who was then a young journalist of nineteen, went along to write the reports.

They started in Paris, staying at the Scribe Hotel and visiting, inevitably, a Montmartre nightclub, called Le Paradis, which, as Pocock recalled,

> was exactly as I had imagined a Parisian night-club would be. It was dark and decorated with green cardboard palm trees and the cabaret was a troupe of uncomely girls wearing top hats and satin drawers, clumping up and down a little stage in wedge-heeled shoes screeching music-hall songs such as Toulouse-Lautrec must have known by heart.

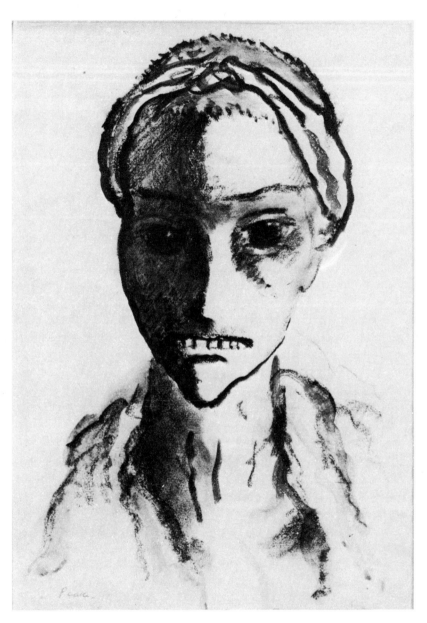

Girl at Belsen, 1945

Against this hackneyed background, Mervyn would quietly sketch and slowly lure to his table waiters, girls and hefty American soldiers on leave.

When he got to Germany itself, the realities began to assail him. There was the hatred of the population: the children would jeer and whistle, the grown-ups turn away. He had never experienced such hatred before, and it hurt him. There were the ruins of bombed-out cities, so much worse than anything experienced in London. There were the war trials of petty Nazi officials, who struck him as pathetic rather than terrible. About all this he wrote in his letters to Maeve. But he wrote nothing of his visit to Belsen, the concentration camp where thousands had starved to death. The shock was too great for comment. For years he had drawn strange worlds. Now he was seeing, in its reality, a monstrous world more terrible than any he could have imagined; he made sketches of the skeletons as they died.

He brought back many drawings, some of which were published in the *Leader* magazine in the issues of 30 June, 14 July and 4 August 1945. Many more were not used and were kept for possible future publication. He also made sketches of Laurence Olivier, Dame Sybil Thorndike and many others who had been in Hamburg on an ENSA-sponsored tour of the Old Vic, playing *Richard III* to army audiences.

Most of all, he brought back the haunting memories of the people dying in Belsen. He felt ashamed to be sketching them as they died, as if he were intruding on something too terrible and too sacred to be the subject of public curiosity. This last act of the war was to have a more profound effect on him than the rest of his wartime experiences put together. Maeve noticed a change in him. 'He was quieter, more inward-looking, as if he had lost, during that month in Germany, his confidence in life itself.'

CHAPTER 13 Publication of *Titus Groan*

Eyre & Spottiswoode had agreed to publish *Titus Groan* in 1946. The rest of 1945 was busily spent in revising the text, correcting the proofs and designing the dust-jacket. Mervyn was a fastidious worker and the publishers were almost in a state of despair at the number of corrections he made, even at an advanced stage, so that they thought of charging a correcting fee. Something of his feelings towards the construction of *Titus Groan* can be gained from the following notes. He hardly ever explained his method of work, and these are almost his only comments on this book:

1) No initial conception of plot.
2) The characters 'took their way'.
3) On the qui-vive while waiting for opportunities for the imagination to take its own course—as long as that course didn't hurt the mood of the book.
4) Hard to make characters talk on the same scale that they look.
5) The scale of the book—its slow pace—and its fantasy—allow me the chance to say practically anything, or make the characters *do* practically anything—a kind of pantechnicon.
6) A third was cut out. Typed five times—each copy blackened.

At a later date he added, 'If I had set the story in Paddington, I should have been restricted by the need for urban accuracy.'

The same year found Mervyn Peake busy working on the illustrations for a limited luxury edition of Maurice Collis's *Quest for Sita*, which was to be published by Faber & Faber. In those days of

utility paper and cramped wartime texts, it was, with its hand-made paper and elegant presentation, a delight. Mervyn and Maurice Collis had met earlier, and Collis, much impressed by Mervyn's talent and reputation, had asked him to illustrate this old Eastern story which he was translating into English for the first time. Collis, who had spent a number of years in the Colonial Service in Burma, retained a love and understanding of the East, and it was not difficult for Mervyn, with his early memories of China, to capture the feel and style of this romantic story about Sita and Rama, who were involved, in an earlier life, with the dark angel Ravana.

It was while they were working together on this book that Mervyn told Maurice Collis of his plans for an extension of the *Titus Groan* book. It was not to be a sequel, in the strict sense of the word, but a continuation of the story that he had begun in 1940. He had left his hero, after 438 pages, exactly one year old. This new volume was to cover his childhood and arrival at young manhood. Some of the characters who had survived from the first book—Dr Prune-squallor, Irma, the twins, Steerpike, Fuchsia, Flay, Nannie Slagg and the Countess of Groan herself—would still be there, but there would be new characters, particularly the archetype of all head-masters, Dr Bellgrove. 'As I listened to Mervyn talking,' recalled Maurice Collis later, 'telling me what he hoped to achieve in this book, I realised that it would not be an ordinary novel, but a work of genius.'

Some of the drawings for *Quest for Sita* were shown at the Leicester Galleries in November 1945, along with Epstein's latest work, *Lucifer*. For both Mervyn and Maeve, exhibitions of their work were a regular occurrence. In 1945, Mervyn had exhibitions at the Adams Gallery in Bond Street and the Arcade Gallery in Royal Arcade, while Maeve had one at the Redfern.

Other work was also coming in or being completed. In December 1945 Richard Buckle, who was planning to bring out a new magazine called *Ballet*, called at the studio in Glebe Place and bought three of Mervyn's drawings. These were from his army period, and were sensitive black-and-white portraits of fellow soldiers in the various barrack rooms he had inhabited. At the same time Buckle asked Peake to produce a Gengi drawing for the first number of the magazine.

On 24 January 1946 he again visited the studio. This time, he brought with him Ursula Tyrwhitt, reputed to have been Augustus John's first girl-friend when they were art students together at the Slade in 1894. Although she did not really like Mervyn's work, she did buy one of his drawings, perhaps more in a spirit of artistic *camaraderie* than anything else. More important, Buckle wanted further illustrations for his magazine. So a working arrangement between editor and illustrator was agreed upon.

Titus Groan was published in February 1946, almost exactly six years after it had first been started in Lower Warningcamp. A first novel is always a matter of nervous tension and self-doubt, and a first review of a first novel is a matter of even more serious concern. The first review that Mervyn and Maeve read was by Edward Shanks. It was condescending and deprecatory.

Though he was undoubtedly hurt and upset, Mervyn's reaction was typical. Even at such a moment, he could not resist the inevitable pun, and wanted to send Shanks a telegram saying 'Shanks a million'. Maeve's reaction was rather more bloodthirsty: she wanted to stab the wretched reviewer to death. However, both eventually agreed to shelve their particular form of reaction, but the memory of this first adverse review long remained with them both, despite the fact that other reviewers were exceptionally appreciative, although some of them took two or three months to get around to the book. Henry Reed, in the *New Statesman* of 4 May 1946, gave it three columns and the top place in his article and wrote, 'I do not think I have ever so much enjoyed a novel sent to me for review.'

Charles Morgan gave it a full article coverage in the *Sunday Times* and Elizabeth Bowen praised it in the *Tatler*. One could not ask for more, and yet not one reviewer really understood that the book, despite its unusual setting, was as real a description of life as any novel of Dickens. Unable to find its equivalent in literature, they tried to match it with something familiar. Because it was set in an old castle, the word 'Gothic' sprang to mind, and, without further consideration, *Titus Groan* was neatly and wrongly presented as 'a Gothic revival'.

In the meantime Richard Buckle kept his promise and arranged another drawing commission. On Friday 3 May he invited Mervyn to be at his elegant house in Alexander Square, at 5.45 p.m., in

order to go to the Adelphi and see Jean Babilée dance, with a view
to drawing him in action. Babilée was the first French ballet dancer
to visit London since the war. He was a flamboyant figure with
long hair and decisive movements—more like a hippy of a later
generation than a bohemian of his own. He was staying at the
house in Alexander Square, and expected to return there for a
drawing session after the show. But when Buckle and his guest
reached the Adelphi, Babilée announced that he would not come
back, as he and his girl-friend had been invited to a party.

> I was furious [said Richard Buckle], and told him he could
> not let Mervyn down. I told him he had to come back. Babilée
> agreed, but was in a terrible temper too. We went back to my
> house and had supper. Afterwards, Mervyn and he went up
> to the top floor to do the drawings, and I stayed on the ground
> floor. Poor Mervyn was caught between two people in a temper.
> I kept pouring wine into his glass, which didn't help.

A friend of Richard Buckle's, Lauretta Hope-Nicholson, was
also there, and acted as an intermediary between the angry dancer
on the top floor and the even more angry editor below. After an
hour she brought down a sheaf of twelve drawings which Mervyn,
despite the unfavourable circumstances, had managed to do. There
were portraits and action drawings, just as Buckle wanted them to
be. As he was looking them over, commenting on their brilliance,
the door suddenly opened and the still infuriated Babilée strode in,
threw the front-door key on the floor, and disappeared into the
night. Mervyn, somewhat puzzled and exhausted by the tempo
of events, quietly went home to his family at the studio.

Eyre & Spottiswoode continued to support him, and in this same
year brought out the new edition of Grimm's *Household Tales* with
a fresh set of illustrations. John Murray commissioned, but did not
publish, an edition of *Bleak House* with illustrations by Peake, and
the Swedish firm of Zephyr *Alice's Adventures in Wonderland and Through
the Looking Glass*, with his illustrations.

Frances Sarzano, writing in *Alphabet and Image* in spring 1946,
had this to say about the Swedish *Alice*:

> Even Tenniel-charmed eyes should be captivated by the
> unfamiliar Walrus and the Carpenter, by the Sorry White
> Knight (who pleads for a Peake *Don Quixote*), by the Mad
> Hatter and the Duchess's choleric child, but sadly enough,

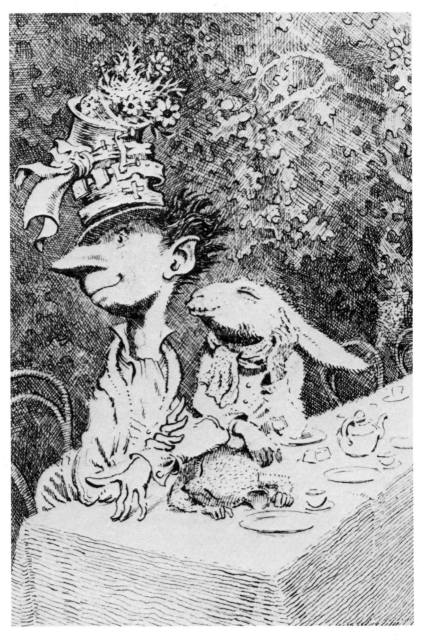

The Mad Hatter from *Alice's Adventures in Wonderland*

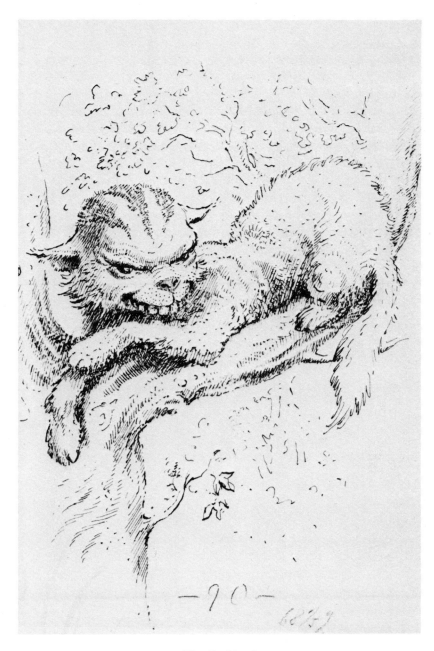

The Cheshire Cat

it will be at least two years before this Peake *Alice* can be
published in England, owing to the artist's contracts with
English publishers.

It was, in fact, to be eight. Contract restrictions and paper
shortages, which continued for some years into peace time, often
made it impossible for publishers to offer, or Mervyn to accept,
commissions. Frances Sarzano wrote: '. . . it is certain that for any
publisher contemplating new illustrated editions of Butler's *Erewhon*,
Swift's *Gulliver*, Sterne's *Journey*, Pope's *Rape*, Cervantes' *Quixote* and
Burton's *Melancholy*, Peake would be the first choice.' But alas,
Mervyn lived at a time when these books were beyond the means
of publishers to produce. He had the willingness, the time and the
talent, but he had been born into the wrong generation.

Nevertheless, the busy year of 1946 saw the publication by Alan
Wingate of a modest twenty-one-page book, measuring nine inches
by five-and-a-half, entitled *The Craft of the Lead Pencil*. The art
critic of *Books of the Month* wrote in May that it was 'free of tire-
some theories and full of sound basic advice of a sort to kindle the
student's imagination'.

An American edition of *Titus Groan* was published by Reynal
and Hitchcock of New York in October. The firm leant heavily on
the Gothic image and sent out advance publicity notices headed
'*Titus Groan*, a Gothic novel', with a lead-in paragraph beginning
'Into a cob-webby, candle-lit world—just the other side of human
experience! . . .' Just to make sure the point was made, a skeletal
hand held a three-headed candlestick complete with guttering
candles. The English reviewers had begun the Gothic myth. Now
the American reviews plunged in even deeper. A selection of titles
to some of them leaves no doubt:

'Chiaroscuro Grotesque'
'Gothic Day-dream'
'Fantasia'
'Old-Flavoured Tale of Castle Gormenghast'
'A tale of Deeds Done in a Non-existent Environment by Human
Oddities'

The novel's true flavour was lost beneath the outpouring of well-
intentioned but inaccurate praise. It was to be many years, and a
new generation had to arise, before this misleading viewpoint was
dispelled and the true nature of the novel was understood.

After the war had ended, Mervyn kept on the studio in Glebe Place. It was to this studio that Leslie Peake, who had been captured in Malaya during the war, came after his release from a Japanese prisoner-of-war camp. An emanciated figure (the taxi-driver bringing him from the station refused to take a fare), he spent his first few weeks of freedom there, and waited for the usual dock strike to end before sailing to join his family in Canada.

Many friends, including John Brophy, the author, who bought a hundred pounds' worth of his paintings on his first visit, and Dylan Thomas, came here too. Dylan was a great borrower, particularly of clothes. Although considerably shorter and stouter than Mervyn, he would often drop in to borrow a suit or a shirt. Sometimes, but not always, he would return them. One undated note from him went:

> Mervyn dear Maeve
> Will you please lend me coat and trousers for a day. Any coat and trousers so long as they aren't my own. I am supposed to speak on a public platform tomorrow Sunday just after lunch. May I call early morning say eleven. Love Dylan

On the reverse side was scrawled: 'I must, unfortunately, call for coat and trousers—doesn't matter that M is taller than D—before eleven. Say 10.30.'

Mervyn's younger son, Fabian, remembered those days at the studio. He used to have nightmares:

> They were always the same: a menacing dog and a lion would look in at the window, and I would wake up shrieking. One evening after I had had the usual nightmare, my father rushed at the window, which of course, to him was empty, yelling and shouting at these creatures to go away and leave me alone. They did, and the nightmare never came back again.

Chelsea in this post-war era was full of artists and writers. The Pheasantry still had studios, and in the basement restaurant a painter could get a free dish of spaghetti and a glass of wine. Augustus John would make his impressive way, sweeping his hat off to the ladies of his acquaintance, to the Queen's Restaurant in Cliveden Place, where writers, journalists and painters mixed with Cheltenham ladies up for a day's shopping. Matthew Smith, a small, quiet, self-effacing man, so different from his exuberant paintings, would hurry

past Galetas, the small restaurant where Mervyn, Maeve and their two young sons would sometimes have lunches costing a few shillings. It was a popular place with its old waiters in morning coats and starched dickies, its mournful murals of drooping bosomless females wandering across endless plains with sentences like 'And others may follow . . .' puzzling the habitués as they sat down to the starchy dishes, lightly peppered with undefinable lumps of meat (probably the ubiquitous and unrationed rabbit). For food was strictly controlled, and ration books were constant companions.

Chelsea life was more like that of a village: everybody seemed to know everybody else. People who had not met Mervyn personally would know him by sight. He could be frequently seen running down the King's Road after a bus—he never seemed to bother about bus stops; leaping agilely onto the platform, he would fit himself in somewhere with a courteous word of apology to the conductor. Nobody seemed to mind the sudden arrival of this energetic and attractive man, and at that time there was no strict limiting of the number of people on a bus.

There was a village atmosphere too in the way that people would meet and talk in odd places. With food still scarce, eating out was often more filling and cheaper than cooking meals at home.

> We only had a very old gas cooker at the studio [said Maeve later] and that didn't work very well. Anyway there wasn't much to cook. We all used to go out quite often to a baker's shop. There was a little room at the back where you could get a very cheap breakfast. John Davenport [for many years, until his death, book critic for the Observer], his wife and children would often have breakfast there. I suppose, like everybody else, we got to know lots of people in this way.

It became more and more obvious that with the two growing boys, a move of some kind would be necessary. Mervyn might be 'the greatest living illustrator', *Titus Groan* might be 'the literary sensation of the year', but fees were small, and royalties little and far between.

The idea of a return to Sark arose. Maeve recalled:

> It was not entirely for pecuniary reasons that we thought of Sark. Mervyn hankered for the place, and we felt mutually that it would be wonderful for the children to have it as a background, as well as our own desire to leave the hurly-burly of London.

He went over to the island on his own, to look for a house, and returned shortly with specifications of two or three possibilities. Then he and Maeve went over together to look at them. The most beautiful one was considered too remote, but another, inappropriately called The Chalet, had the necessary number of rooms. A rent of £80 a year for a ninety-year lease was agreed with Mr Hirzel Baker, from Guernsey, and the family set off for Sark, giving up the Glebe Place studio but keeping on the one in Trafalgar Studios.

CHAPTER 14 The freedom of a whole island

The few pieces of furniture, many books, and large stocks of canvases had been packed into a pantechnicon and came on separately. Accompanied by their two sons, a cat and a few personal belongings, they travelled by steamer, arriving at St Peter Port, Guernsey, on a beautiful, hazy morning. Here they had breakfast, and embarked on a small outboard motor boat to cover the eight miles or so to Sark.

The Chalet was a big, ugly house that had been the headquarters of the small German occupation force during the war. It had twelve large rooms, three small ones, a studio, and a wild garden with bamboos growing in it. As the Dame of Sark would not allow cars on the island, they were driven up from the harbour by the island's official driver, Charlie Perrée, in a Victorian horsedrawn carriage.

The house was completely empty, as their furniture was not due to arrive until the following day, and there was no lighting. But these were small matters beside the feeling of freedom and space that the house and garden gave them. They were given candles and some bread and butter. When night came, the wind rose and the house, though new, seemed to be full of the sound of creaking beams. There were no beds, and so they all huddled together, husband, wife, two sons and the cat, on the bare floorboards of the main bedroom, and slept uneasily until at last, at dawn, the wind dropped and daylight returned.

On its arrival at St Peter Port, the furniture had been disembarked

Le Chalet, Sark, 1947, after renovation

on the quay. The paintings were lined up against a wall, and this *al fresco* exhibition was the subject of much comment among the people of Guernsey. Everything was eventually loaded into small motor boats and conveyed to Sark, where it was carried, piece by piece, in Victorian carriages up to The Chalet. Mervyn and Maeve did not have many possessions, but as in all their moves, paintings and drawings were quickly hung on the walls, books placed on shelves, and almost at once the house seemed to have been lived in for years.

So began a new life in the island Mervyn loved. He was working regularly on *Gormenghast*, usually spending the morning writing it, or illustrating the books sent to him from the mainland. Publishers were particularly generous with their dummies—thick books of blank paper—and these were used for the novel. In the afternoons, there would be walks about the island and picnics in small coves and beaches, most of which could only be reached by narrow paths down the sides of steep precipices. Mervyn would scramble about these rocks with his sons, while Maeve followed with the picnic-basket, buckets and spades.

In the very cold winter of 1946–7, snow fell on Sark for the first time in living memory. Maeve told how

Mervyn cut out blocks of frozen snow, and made an igloo in the garden. It was a beautiful thing with a door and a window. Mervyn cut out a lifesize drawing of an eskimo, put it in the window of the igloo, and said, 'Look, there's an eskimo!' Half scared, half intrigued, the boys wanted to go out. I insisted that they should put on coats, hats and wellington boots. While they were doing this, Mervyn went out and took the drawing away, so that when the boys got to the igloo, the mysterious eskimo had vanished; much, I think, to their relief. We put rugs in the igloo, and they played in and around it until it eventually melted.

From time to time Mervyn went to London, in order to find new work. He would stay at Trafalgar Studios in Manresa Road. On one of these occasions, he was commissioned by the Brewers' Society to produce a series of illustrations of country scenes. These included a number of games, such as darts, cricket, bowls, dominoes and shove-ha'penny, and scenes of hunting, fishing and pigeon-racing. The idea of drawings and text was to show activities associated with beer, rather than beer itself.

The first of these advertisements appeared in various newspapers in December 1946, and for a while all went well. The extra money was appreciated, and the small, delicate drawings done in the mornings in Sark did not give Mervyn much trouble. Then, one day, he sent in a drawing of an inn with a tree outside it. Somebody at the Brewers' Society pointed out that, in its present position, the tree would undermine the building and bring it down. Would the artist kindly move the inn back. Mervyn replied by letter, saying that he could not do this as the composition of the drawing would be destroyed. The Brewers' Society, however, was adamant. Either the tree or the inn must be moved. Mervyn would not compromise on a matter of artistic principle, and, though needing the money, he resigned rather than change the design. The last of his illustrations appeared in April 1947. Copies are still to be found at the Brewers' Society headquarters in Portman Square, but the original drawings have disappeared.

There could be moments of fright for the family when Mervyn was away from the island. Sark was so small that it could become claustrophobic, especially during day-long mists or during tempests, when the whole island seemed to be shaking and on the verge of

falling into the sea. At such times, the atmosphere was not improved by Sebastian, who would come silently to his mother's room and, standing motionless by the bed, call out dramatically, 'Who's that knocking at the door?' Maeve would think then that 'there was no other sound anywhere but the sound of the wind'. But when Mervyn was there, and the days were clear, work and play would continue contentedly and the very name Sark would be synonymous with happiness.

Other domestic dramas would occur from time to time.

> I remember [Fabian recalled later] that two friends of mine—they were aged about six—and I were sitting under a haystack on a lovely sunny day, when one of them produced a box of matches. We scooped a hole in the side of the haystack, and then one boy said, 'Why don't we light it? We can easily put it out if it gets too big.' But of course we couldn't. It just went 'Whoomph'; and the whole stack caught fire. We were lucky to escape. We ran to a pig-sty and hid; then went home. I got into trouble and was severely reprimanded. Grandfather (Dr Peake) was staying at the time, and he went to the farmer and offered to pay for the damage.
>
> Oddly enough, later, somebody dynamited the house of the friend who set fire to the stack. It was some kind of island vendetta. They caught the man who did it, and he was put into the Sark prison. It's the smallest prison in the world.

Small improvements were carried out to the house and garden. Gracie, from Derby, who had done the housework for the previous owner, Mrs Judkin, told Mervyn and Maeve that she would now work for them, and was a magnificent source of information concerning local sales of furniture. An attempt was made to build a pergola. Khaki Campbell ducks were acquired. A telephone, Sark 45, was installed. The garden was not neglected, as Maeve later recalled:

> One morning in Sark we were looking at our garden. Many trees and shrubs grow in Sark which would never take root in England. We had a bamboo hedge, and fuchsias in abundance. Our discussion led to the topic of palm trees and how lovely it would be to have one in our garden. There was the absolute place, just in front of the house, sheltered by hedge and house

from the onslaught of the violent winds of an island. We saw it, planned it, longed for it.

A phone call away to a nursery in Guernsey.

'Yes, Sir, what kind of palm tree?'

This was unforeseen. We didn't know.

'May we phone you back?'

'Naturally.'

On our tenth wedding anniversary I had given Mervyn the fourteenth edition (1929) of the *Encyclopaedia Britannica*.

We rushed to it, discovered a suitable species, and with this information ordered a palm tree.

A huge hole was dug, and one morning the tree arrived, covered in sacking.

We uncovered it, and its palm-like hands lay on the grass, aching for life.

We poured water into the hole and Mervyn, myself, our sons and Armand, our gentle Moroccan, who came to help us in the garden, with ropes and ignorance, helped it into the ground. A new home for it, which was in the future to be the stepping stones for our sons to climb and sit like kings among the fibre, looking out at the coast of France, and for our cats to climb also.

We were told it wouldn't live, but it did, and this transplant stood as a memorial of mind over matter for many years.

The Peakes took *Picture Post*, the weekly Hulton Press illustrated magazine. Mervyn and his paintings had been featured in it in the issue of 21 December 1946, under the title of 'An artist makes a living'. The front cover very often featured attractive girls, and Mervyn would black out a tooth, or add wrinkles or spots and sprouts of hair with his aniline dyes. It was done so delicately and skilfully that it was often hard to see that the original print had been altered. Mervyn and Maeve always gave their old copies to the vicar, whose garden abutted on theirs. After looking for a long time at one of Mervyn's 'doctored' ladies, the vicar's wife exlaimed, 'Why do they always put such *ugly* girls on the covers?'

Whenever Mervyn went to London, he would return with unusual gifts and toys for the family. On one occasion he arrived with a whole set of bows, arrows, quivers and targets. The family became toxophilites, particularly the boys, who soon adapted the equipment

The Indian, drawn in an exercise book for Fabian

for their games of Red Indians. Mervyn took an interest in what they were doing, and invented pastimes. Both Sebastian and Fabian had exercise books in which he would draw pictures for them each Sunday, of pirates fighting, St Christopher, an elephant with a dunce's cap on his head. Some of the drawings are extraordinarily detailed and it is astonishing to remember that these were done, not for an exacting editor or for an exhibition, but to amuse two small boys on Sunday afternoons.

Once Mervyn went to London to give a talk on the radio about his work as an illustrator. It is almost the only commentary by him on his development as an artist. He started by amplifying his earlier statement that the army had turned him into an illustrator:

> All my life I have been painting and making drawings, but I only started illustrating books when I was conscripted in 1940. I was a poor soldier and was constantly on the move from unit to unit—and even from regiment to regiment. The Royal Artillery and the Royal Engineers claimed me twice apiece and appeared to vie with one another as to which could get rid of me the quicker. This constant moving about gave me little scope for painting and I found myself continually packing my kit-bag and away again with yet another canvas too wet to travel.

The Arithmetic Lesson, drawn in an exercise book for Fabian

This, he claimed, meant that he could really only take on work with inks that would dry quickly. He had always been fascinated by illustrations:

> I remember the impact of certain illustrations in my school-days. Turning the pages, I would come upon these full-page illustrations, charged, some with terror, some with tragedy, suspense or exhilaration—whose haunting qualities have remained in my mind to this day. There used to be in *The Boys' Own Paper* drawings by Stanley L. Wood. This man was my secret God. His very signature was magic. His illustrations for a serial called *Under the Serpent's Fang* were so potent upon my imagination that I can recall them now almost to their minutest detail—the stubble-chinned adventurer knee-deep in quicksands, his eyes rolling, the miasmic and unhealthy mists rising behind him—I remember the tendons on his neck stretched like catapult elastic and the little jewelled dirk in his belt.

Once he had decided to take on book illustration work, he went about the task of learning his craft with typical care, and

> saw what work I could of the great illustrators—Rowlandson, Cruikshank, Hogarth, Blake, and the Frenchman Doré, the German Dürer, and Goya, the Spaniard. I began to realise that these men had more than a good eye, a good hand, a good brain. These qualities were not enough. Nor was their power as designers, as draughtsmen. Even passion was not enough. Nor was compassion. Nor irony. All this they must have, but above all things there must be the power to slide into another man's soul.

This power Mervyn had to a great degree, and it is this that places his illustrations on so high a plane. It explains why a work by another genius drew from him a work of genius of his own, while a lesser work produced a lesser response. It was, however, fatiguing work, not only because of the high technical standard he set himself, but also because this 'sliding into another man's soul' demanded a high degree of imagination.

Meanwhile, alas, publishers' problems did not decrease. Shortages of paper continued for some years after the war had ended, and although Mervyn Peake was highly esteemed, commissions were few. He received a retainer—between £150 and £200 a year—

from Eyre & Spottiswoode, which he accepted because it meant a small steady income even though it prevented him from working for other publishers. It was not large enough to make luxuries available even in such an inexpensive place as Sark.

Towards the end of 1946, Chatto & Windus re-issued the 1943 edition of *The Rime of the Ancient Mariner*. The drawings for it were reproduced in *Poetry (London) X*, edited by Tambimutu and published at fifteen shillings by Nicolson and Watson. Tambimutu was an enterprising Ceylonese who had suddenly appeared in Chelsea with a scheme for producing a book of representative poetry. The poets, writers and painters who lived in or visited the 'village' of Chelsea were extremely excited, and there was considerable competition to get into it. Tambimutu managed to track down Mervyn Peake during one of his visits to London and persuaded him to allow the drawings of the *Ancient Mariner* to be reproduced. It was a considerable coup for Tambimutu, and undoubtedly the best thing in the book; but it did not bring in much money.

1948 saw the publication by Eyre & Spottiswoode of a book of Mervyn's own: *Letters from a Lost Uncle*, which he had originally written and illustrated in 1945. It was about a 'lost' uncle who kept his typewriter with him and wrote to a favourite nephew about his adventures, in typescript and drawings. It was well received by newspapers as far apart as the *Irish Press* in Dublin and the *Otago Daily Times* in New Zealand. The latter commented, on 29 October 1948, that it was a story supposedly 'written by a family black sheep telling of his quest for the White Lion in the polar regions . . . it is the sort of book a father might buy for his son—and keep for himself.'

Mervyn was not pleased with the way in which the publishers had presented it. Of the production he wrote critically:

1. The illustrations were twice as crisp and dark in the original.
2. The typing paper should *not* have shown up as a *different* paper from the paper the drawings are on. The cut-rate effect ruined the pages.
3. As can be seen on the wrapper the price was (as a result of all this) marked down from 7/6 to 3/6 thus giving the book a second-hand look from the very outset.

As many copies as possible were withdrawn at my request.

Once again, as in the case of the work for the Brewers' Society, Mervyn sacrificed cash prospects for the sake of artistic principle. 'He was always full of fun,' Mrs John Brophy, wife of the author, remembered. 'He never took himself seriously. The only things he took seriously were his art and his family.'

In November Chatto & Windus reissued, in their two-shilling Zodiac series, *The Hunting of the Snark*. At about the same time the Folio Society brought out a new edition of R. L. Stevenson's *Dr. Jekyll and Mr. Hyde*, with illustrations by Mervyn Peake. The Society insisted that the illustrations should be in two colours, yellow and black. This stipulation restricted Mervyn, and the reviewer of *Books of Today* for February 1949 noted:

> Mervyn Peake, whose *Nursery Rhymes*, *Captain Slaughterboard* and *Ancient Mariner* I much admire, has contributed two-colour line drawings in yet another technique of his, and one which I found too thin and sketchy. They certainly have some of Hyde in them, but I wish they had more Peake.

Maeve was expecting another baby in May and although there was an excellent doctor on the island—Dr Hewitt—there was no hospital and no midwife. A nurse was brought from the mainland, at considerable expense. Accustomed to working with wealthy families, she spent much of her time comparing, very unfavourably, the conditions on Sark with those of her more fortunate clients. 'Her name was Sister Kilfoyle,' recalled Maeve, 'but Mervyn, of course, called her Sister Tinfoil. Her only interest seemed to be the Royal Family. She had huge albums of pictures, which she would bring out in the evenings.' She had a great regard for hygiene, and tried, not very successfully, to keep the various animals—donkey, cat and ducks, all of whom had the run of the house—out of the way.

The birth was late, and Sister Kilfoyle suggested strenuous bicycle rides in order to induce it. As day after day passed without any sign of the expected birth, other methods were introduced:

> Sister Kilfoyle [Maeve recalled] gave me large doses of castor oil; and we went for rides over the roughest tracks in Charlie Perrée's carriage. Sister Kilfoyle and I sat in the back. Fabian sat in front with Charlie Perrée. Every now and then Fabian would look round and ask 'Is it born yet?'

When labour pains did start, Maeve began painting a still life.

Mervyn and Clare, 1949

The Peake family, 1949

Mervyn was told to warm a blanket. He had very little knowledge of how this should be done, and put it on top of the Aga. Somewhat to his surprise, it burnt. He then retired with a book and pencil to another room to work, but like many men in a similar situation, he fell asleep.

> I went on painting, [said Maeve] but the pains got worse. After each one, Sister Kilfoyle said, 'That's a good one.' Eventually, about eight o'clock next morning, Clare, weighing nine pounds, was born. She was three weeks overdue, and as Sister Kilfoyle had contracted to go to another family— probably a much more aristocratic and satisfactory one than ours—she left two days after the baby was born. I gave her the still life I had been painting while waiting for the birth. After she had gone, a girl called Winnie Tosh, who had come over from the mainland, came and helped with the baby.

A priest came over from Guernsey, in a gale, and baptised the baby, and the new arrival, though compared to Winston Churchill by her father and to a Khaki Campbell duck by her brother Fabian, was accepted as a member of the family.

By now a new move was planned. Although the island had been a wonderful place in which to write *Gormenghast* (in one folio, seven quarto note-books and one manuscript notebook) and to build up a family life, it had been unsuccessful from the financial point of view, as Mervyn wrote to Maurice Collis. Although life was cheaper in Sark than in London, he had often to make the expensive journey to the metropolis to look for commissions, and although his reputation was high, his distance from his source of income—publishers and editors—made the offers of work far fewer than they should have been.

In the autumn of 1949, the Peakes reluctantly packed all their pictures, books and furniture once again, and, leaving their two sons for the time being at their boarding school in Guernsey, returned to London with one baby daughter and a cat.

CHAPTER 15 Back to Chelsea

The move coincided with the submission of the finished typescript of *Gormenghast* to Eyre & Spottiswoode. The Peakes stayed at 13 Addison Road, W.14, where Maeve's sister Matty and her brother-in-law Henry Worthington were living. Henry, an actor, was appearing in *1066 and All That*. Sometimes Maeve would put Clare and Matty's son, Rory, who was four months older than his cousin, in a large toy pram that had been Matty's when she was a child. One day, outside the post office in Addison Road, a woman, seeing the two babies together and thinking them brother and sister, said, 'You had them pretty quickly one after the other, didn't you?'

On 29 September 1949, F. V. Morley of Eyre & Spottiswoode wrote two identical letters, one to 15 Addison Road and the second to 13 Addison Road, presumably because there had been a confusion over Mervyn's address. In the event, both were received:

Dear Peake,

Mrs Miller ought to have had the pleasure of writing this letter (for it is always a pleasure to be the bearer of good news), but she won't be at the office for the rest of this week, and I don't want to wait to tell you how delighted we are with *Gormenghast*. Mrs Miller has read every word of it, and last night left upon my desk a long report which is positively glowing. She feels that you have brought the whole thing off triumphantly; that your descriptive powers are magnificently sustained, that all the chases are superbly done, that the atmosphere of

151

horror and tension is maintained, and that there is a great feeling in the portrait of the boy Titus, and the stages by which he grows. In short, in her view this second volume is even superior to the first, and she is full of enthusiasm about putting it in hand at once and starting everybody talking about it right now.

It is very nice indeed to be able to report such genuine enthusiasm. I was incidentally torn between two desires. One, naturally, to take hold of the manuscript and read it at my own pace for my pleasure, but I have to go away tomorrow for a few days and I shouldn't be able to take it with me. The other desire is to get the manuscript in the works with the utmost speed. I have just squinted at the pages here and there to whet my appetite, and that makes me quite sure from my own point of view that Mrs Millar's opinion (not that I have any doubt of it) is absolutely right, but not to lose time I have had to restrain myself, and what I have just done is to give it to Mr Goldup for him to get started on the production right away.

One thought occurs. It is a moot question whether *Gormenghast* is covered by the previous agreement for *Titus Groan*, but whether or not I am going to suggest that we have a fresh and separate agreement for it, and I am going to suggest that it should carry a straight 15% royalty from the beginning.

Of the energy and excitement with which we shall publish you need have no doubt whatever. You remember you said the book could go straight into page proofs. I have given instructions accordingly. As soon as we can we shall obtain a large number of page proofs and make sure that everybody in the place reads them and catches the contagion. As for the critics, this volume completes the whole and entire work of the imagination and every critic who isn't afraid of his job will want to get his teeth into it.

Good luck to you. I know that at the moment, with the move and all, you have many problems, before long, however, we would love to congratulate you in person on such a magnificent completion of what we feel to be a great book.

Yours,

F. V. Morley

On 13 October 1949, the family moved into 12 Embankment Gardens in Chelsea. Many houses had remained empty after the war and Chelsea Council, in order to ease the acute post-war shortage of housing, had taken them over and let them out at nominal rents. Mervyn and Maeve had two floors at the top of the house, at £3 a week. They had no telephone, but they had a large living-room and kitchen, a view over the river on one side and the Royal Hospital gardens on the other, and within a very short time they had re-created the atmosphere of their Sark home. Their ability to take their home with them never deserted them. Large empty rooms did not deter them: though short on furniture, they were strong on paintings. Big walls gave them the opportunity of hanging large canvases. Mervyn would paint in the studio in Trafalgar Studios, which he had managed to keep on, while Maeve (they still preferred to paint in separate places) turned the smallest and highest room at 12 Embankment Gardens into a studio.

Winnie Tosh joined them to help with Clare, while Sebastian and Fabian came home for the holidays from the boarding school in Guernsey. The flat seemed very cramped to the two boys, but returning to school by the night train and boat was always a painful business. 'I remember,' Maeve said, 'Fabian standing by the door, with tears running down his cheeks, waving goodbye, and saying, "Oh, blow!".'

Eyre & Spottiswoode had brought out, on 7 October 1949, a new edition of *Treasure Island*, with Mervyn Peake's illustrations. 'For the particular talents which Mervyn Peake commands,' commented the reviewer in the *Scotsman* of 24 November 1949, 'Stevenson's great adventure story affords ample scope; and his drawings—tense, eerie and dramatic—abate nothing of the power of the narrative.'

Mervyn also provided illustrations for a somewhat macabre book of short stories by Dorothy K. Haynes, entitled *Thou Shalt Not Suffer a Witch—and Other Stories*, published by Methuen on off-white 'war economy' paper.

The move to London brought about an immediate financial improvement: Mervyn took a job at the Central School of Art in Holborn, teaching life-drawing, and so he had a regular income for the first time for years. At the same time, magazines such as the *Radio Times* began to commission him to illustrate feature and

other articles. A period of modest financial stability set in.

Hans Tisdall, who was also a teacher at the Central, remembered Mervyn Peake well:

> He was a very gregarious person, yet he always seemed some-what apart from everybody else. He once told me that when he was young he never knew or met any artists at all. As a boy, he lived in the almost non-artistic world of missionaries in China. . . . Because of this, he had, I think, from an early age, to draw his artistic fuel from himself.
>
> He had a wonderful spontaneous sense of humour. It was different from the humour he displayed in his books. His writing was always highly formalised and carefully worked out. He was a great craftsman, who worked with controlled care; but his day to day humour was unpredictable and hilarious.
>
> Once, I remember, when he was getting an exhibition of his paintings ready, he was trying to find a way of interesting the public in what he was doing. He had an idea of going to a shoemaker and having a rubber-soled pair of shoes made. His idea was to have a special pneumatic message carried into the soles; then, armed with a bucket of white-wash, walk about the streets, dipping his foot from time to time into the bucket, and leaving on the pavement, in bright clean white-wash, the dramatic message, 'Buy more Peakes'.

The return to London brought Mervyn in touch, once again, with the theatre. Esmond Knight, who had played the lead in the *Insect Play* and who had almost lost his sight when, as a young naval officer aboard the *Prince of Wales*, he had become involved in the chase of the *Bismarck*, became a close friend as did his wife, Nora Swinburne. Cyril Cusack, Anthony Quayle and many other stage people came to the Embankment Gardens flat, and Mervyn began to think about the difficult but alluring business of play-writing.

In March, Mervyn, Maeve and the baby went back to Sark to 'clear things up' and while they were still there they heard that Maeve's father, Dr Gilmore, had died on 10 April at the age of 88. They returned to London, and to the flat in Embankment Gardens. Although it was cheap it had certain disadvantages. Being at the top of the building, it was reached by a large number of stairs, and there was no lift. Maeve had neuritis in one hand and arm, and the effort of carrying the baby and the shopping-bags up those stairs

was becoming more and more painful. At the same time, the people in the flat below them took a deep dislike to them. Every time they went up or downstairs there would be a pointed slamming of doors. And then, the flat was not large enough for two growing boys on holiday. The Royal Hospital gardens were a poor substitute for the freedom of a whole island. The idea of a move back to the country began to grow.

The Glassblowers, a book of poems, was published in June. It took its title from the factory which Mervyn had visited during the war. The ballet-like movement of the glassblowers had fascinated him. 'I found on entering the huge, ruinous, grimy wharf-walled building a world upon its own, a place of roaring fires and monstrous shadows.' While he sketched the moving figures with their flutes and the molten glass, 'I found at the same time that phrases were forming in my mind, and verbal images tangential or even remote from what was actually taking place before my eyes, began to follow one another.'

The dust jacket showed part of his painting of the glassblowers which had been exhibited at the National Gallery during the war. It is said to have been bought by the city of Birmingham, but this has not been confirmed, and the painting seems to have disappeared.

One of the poems, 'The Consumptive: Belsen 1945', was inspired by his visit to Belsen. He found a girl dying in a hospital ward and did a drawing of her, but this very act made him wonder about his sense of human pity:

> If seeing her an hour before her last
> Weak cough into all blackness I could yet
> Be held by chalk-white walls, and by the great
> Ash coloured bed,
> And the pillows hardly creased
> By the tapping of her little cough-jerked head—
> If such can be a painter's ecstasy,
> (Her limbs like pipes, her head a china skull)
> Then where is mercy?

This dying girl haunted him for years, and is the inspiration for Black Rose in *Titus Alone*, the woman who lives through the grime of the under-river sustained by the ambition to lie in a sheeted bed, only to die when she finally succeeds in doing so. The creative artist's grief at using a real person's agony for artistic purposes is

again referred to in the same *Glassblowers* poem:

> Her agony slides through me: am I glass
> That grief can find no grip
> Save for a moment when the quivering lip
> And the coughing weaker than the broken wing
> That, fluttering, shakes the life from a small bird
> Caught me as in a nightmare? . . .

Also included in *The Glassblowers* is the poem 'To live at all is miracle enough'. It sums up Mervyn's philosophy of life:

> To live at all is miracle enough.
> The doom of nations is another thing.
> Here in my hammering blood-pulse is my proof.
>
> Let every painter paint and poet sing
> And all the sons of music ply their trade;
> Machines are weaker than a beetle's wing.
>
> Swung out of sunlight into cosmic shade,
> Come what come may the imagination's heart
> Is constellation high and can't be weighed.
>
> Nor greed nor fear can tear our faith apart
> When every heart-beat hammers out the proof
> That life itself is miracle enough.

His poetry has never had the same recognition as his illustrations and his novels, yet many people would agree with his brother Leslie's judgment:

> To me, his drawings will always come first. Next comes his poetry. It is not as well-known as his novels; but it is very fine. The novels I put third. I know that it is upon them that his reputation rests; but I think that in time it will be upon his drawings and his poetry that his real fame will be founded.

In July 1950, Mervyn and Rodney Ackland, the playwright, went to Edinburgh. Ackland wanted to write a play about Burke and Hare, and Mervyn was to be responsible for the sets. In a letter to Maeve, he wrote:

> Everything has gone beautifully. Ackland arrived about 2 minutes before the train left King's Cross and 5 minutes later he was sitting on my bed and was talking 10 to the dozen about *Titus Groan* which he was reading madly.

Ackland later wrote in the *Spectator* about a walk he and Mervyn took in Edinburgh, which Mervyn had found 'full of spires and domes and odd sky-line shapes'. Ackland recalled that, while they were walking

> through the blacker slums of Edinburgh, the wynds, closes and vennels of the Royal Mile, I became conscious that the sound of Mervyn's footsteps following my own had ceased. Looking round, I found him transfixed, stock still in the roadway, some yards behind. Enraptured with delight, his gaze was fixed on two small slum shops on the narrow pavement facing him. A butcher's and an undertaker's adjacent. 'Look! Look!' cried Mervyn, drawing my attention to the shop signs. Reading from left to right—butcher and undertaker—I read 'Burke' and 'Hare'.

In the end, the play did not materialize.

On Peake's return, he and Maeve began to discuss seriously the need to get away to the country. The flat was really too small for a boisterous and growing family. The steady antagonism of the people below was taking its toll. One Sunday, at breakfast, Maeve and Mervyn saw an advertisement for a house for sale in Kent. The description of the property included the magic word 'studio'. A telephone call to the agents brought more details, and a few days later Mervyn and Maeve travelled by train (Mervyn loved trains) to Headcorn, near Maidstone. From there, they travelled to Smarden, and, round a corner beyond the village church, they came to The Grange. It was a medium-sized Georgian house, with a conservatory down one side and a lop-sided tin building at the back. There was a small garden in front, and a large orchard at the back. Outside the confines of the property there was a wood. They noticed, at once, the great number of birds and empty gin bottles. The birds were explained because the owners kept an aviary. No explanation was given for the gin bottles.

They were enchanted by the place. Even when the 'studio' turned out to be nothing more than the tin building at the back, they were not put off. Here they would be in the country, with plenty of room for the children. It was near enough to London to make commuting possible on the days Mervyn taught at the Central. The asking price was £6,000—far more than they had. However, their understanding bank manager told them that it was possible

The Grange, Smarden, in 1950

to obtain a loan for the purchase of houses. To those familiar with the mechanism of mortgages and loans, it may seem incredible that, when the documents were signed, neither Mervyn nor Maeve had any idea that the principle as well as the interest would have to be repaid. They imagined the interest would be very little.

> I think we thought [Maeve confessed later] that it was some kind of gift that the bank was making to us. It sounds incredible but we knew absolutely nothing about money matters. I remember my sister Ruth asking, 'Do you know what you're doing, darling?', and I replied, 'Yes', although I suppose I didn't.

In August, Mervyn and the two boys went once more to Sark. From there, on 17 August, he wrote to Maeve:

> I pray that nothing will spoil our Kent plans. I hate our being bullied into having surveyors, although I have no doubt it is wise. It is clearer and fresher than Wattlington [another house they inspected] much as I liked that house. There was a feeling at Wattlington that one was going back into the past—but at The Grange that one was going into the future. . . . I have a feeling that you are going to paint much and well at The Grange and that I am also. And that we will flourish there

and that I shall pay off the bank more quickly than you imagine.

As soon as Mervyn and the two boys returned from Sark, the tenancy of 12 Embankment Gardens was given up. In September, the family moved to The Grange.

We travelled [Fabian recalled] in a hire-car. Chloe, our cat, got lost just before we left. So we all had to get out and look for her. Mrs Bull, the cleaner, came with us. Her husband used to baby-sit; and was known as Sitting Bull.

CHAPTER 16 The Grange

The publication of *Gormenghast* coincided with the move to Smarden. In the months that followed, the reviewers tried, as they had done with *Titus Groan*, to analyse it, to interpret it, and to place it somewhere in the recognized stream of literature. Once again the epithets 'gothic', 'wonderfully weird', 'a gothic fantasy', 'a nightmare', 'cloud-cuckoo land' were brought out, but a new note of puzzlement was to be found in some of the reviews.

R. G. J. Price, for example, wrote in *Punch* on 22 November 1950: 'Having just emerged from Mr. Peake's novel I am quite unable to apply any critical standards . . . this is the finest imaginative feat in the English novel since *Ulysses*, even though *Ulysses* is, of course, much the greater book.' Mervyn was a great admirer of Joyce, and wished that the reviewer had ended his sentence at 'since *Ulysses*'.

Maurice Collis, in *World Review*, wrote: 'The unusualness of *Titus Groan* put the critics on their mettle; they tried their best to fathom its mood and discover whether it was an extravaganza, a vision or what, but found it impossible to pin down Mervyn Peake.' Collis understood that both books were part of a continuous saga: 'the two taken together are an integral whole and amount to a literary feat, to which it would be hard nowadays to find a parallel.'

But if the reviewers were baffled, so too was the reading public. Like *Titus Groan*, *Gormenghast* had a *succès d'estime* and with it, as so often is the case, a lack of popular support. The generation which would understand and appreciate Peake was not yet born at the

160

time of *Gormenghast*'s publication. The success the novels deserved was to come nearly twenty years later.

In 1950 a third book, *The Drawings of Mervyn Peake*, was published by the Grey Walls Press. Though the book had been put together and planned to appear in 1949 (the copyright page states categorically 'First published in 1949'), publication was delayed until 1950. The *Bookseller* of 5 August 1950 reproduced the cover drawing on the dust-jacket, captioned 'Part of the jacket of *The Drawings of Mervyn Peake* announced by Grey Walls Press'.

The reviews date from November. The book was extremely well produced—remarkably so, considering that restrictions on paper and printing were still in existence—and consisted of sixty-two drawings, depicting Mervyn's family as well as outside subjects. He himself wrote the preface, in which he says: 'This is the problem of the artist—to discover his language. It is a life-long search, for when the idiom is found it has then to be developed and sharpened.'

Besides these three books of his own, the Heirloom Library issued a new edition of J. S. Wyss's *The Swiss Family Robinson* with a set of illustrations by Mervyn Peake. The Heirloom Library was, in fact, none other than the chain store Marks and Spencer. For some reason, as yet unexplained, they felt that their sales would be helped by a little 'culture': hence the issue of *The Swiss Family Robinson*. The result was not happy; somebody had the odd idea of 'improving' the book by supplementing Mervyn's illustrations with randomly selected vignettes of doubtful value. Whether the sale of clothing was, in fact, increased has never been made known. All that is known is that Mervyn never supplied another piece of 'culture' to Marks and Spencer.

The Peakes were preparing to celebrate Christmas at Smarden (Matty and Henry Worthington and their children were staying) when, on Christmas Eve, news came that Dr Peake had died at Burpham. They had seen him the previous September and had been photographed with him in his garden. He had seemed frail then, but at seventy-six this was not unexpected. His death was to lead to yet another change of house, but that was still some time in the future.

In the spring came what Maeve later described as the most beautiful letter they ever received. Dated 4 April 1951, it was from the Royal Society of Literature and read: 'I have the honour to

inform you that my Council wish to award you a prize in respect of your novel *Gormenghast* and your book of poems *The Glassblowers*.'

Mervyn was so overcome that the tears came to his eyes as he stood in the hall of The Grange reading the letter out to Maeve. The presentation ceremony was to take place in London. R. A. Butler, later Lord Butler, presented the prize, although he confided, with some tactlessness, that he had read neither of the books. Public recognition was now added to private happiness, and with the award went a cash prize of £100.

John Grome, whose painting the Peakes had bought at the Peter Jones exhibition during the war, had come with his wife to stay in the tin house behind The Grange. This building, described in the *Sunday Times* advertisement as a studio, had become one since Maeve had turned one of its rooms into a studio for herself. In a letter to Maeve John Grome recalled how he returned to England from Italy

> with a large group of paintings and with my wife, who was six months pregnant. The first people I contacted from a hotel bedroom the morning after our arrival in Town were you. You installed us in a cottage in your Smarden garden; and gave us hospitality for a year at, I well know, considerable sacrifice to you both.

Mervyn and Maeve spent their prize money on visiting the art galleries in Paris, something they had always wanted to do, but the trip was marred by the excessive attention of fleas at the first hotel they stayed in. Indeed, the best part was the return to Smarden, and their rapturous welcome home.

At The Grange there were three people actively engaged in painting, with the children running carefree through the orchard and garden (the two boys had been taken away from the Guernsey boarding school and now went to a local school), with animals around them, with the mysterious wood in which lived a doctor turned tramp, beyond the railway line where the two boys would watch the Golden Arrow flash past on its way to the coast.

At the same time Mervyn had started to write a play. He had been thinking of doing so for some time. He and Maeve discussed the play as they had discussed *Titus Groan*. It was to be called *The Wit to Woo*.

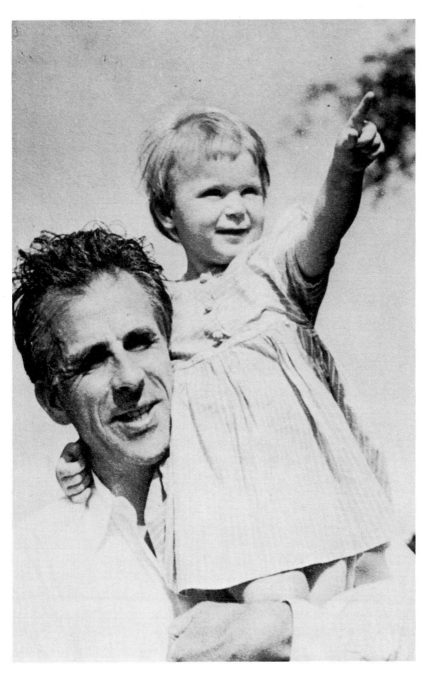

Mervyn and Clare, 1951

A letter from John Grome to Maeve gives a vivid picture of life at The Grange:

> The exuberance of those days and nights at Smarden still remains extraordinarily charged in the front of my mind. You both always had a genius for living in the most improbable of places and an isolated Georgian house with its outsize garden and orchards was no exception. Your nearest neighbour, I remember, was a gentleman who sold a head-busting cider and challenged one to distinguish it from a rare white wine from hills around Orvieto. Even the weeds in the garden flourished with unquenchable spirits. Then it would be nothing at all out of the way if, while one was doing one's stint with the lawn mower, Mervyn would come bounding out of the house, his eyes bright, to ask you what you thought of the coffin bearer's chorus from *The Wit to Woo*. You, more than anyone, knew how Mervyn's art and his life were all of a piece. He was never one of those types who only painted or wrote at certain hours. His creativity was in constant action. You might be talking about potatoes or apples but there was that glint in his eye, that pre-movement of his lips, if I may put it so, that presaged his sudden conception of a new idea for a play, a book, a painting, or, perhaps, *merely* the reorganisation of some piece of work he had been working on or had in mind. . . .

John Grome emphasizes the inter-relation of Mervyn Peake's art and life, with this observation:

> For him, it was quite natural to come out into the garden, do an about-turn, and return instants later with pencil and pad to draw you all as you sat having lunch with the family under a tree. He would enjoy reading the day's work to you after supper in the evening.

Behind this apparently carefree surface, there was a nagging worry. The realization had come, at last, that the arrangement with the bank had nothing of a gift about it. Mervyn and Maeve discovered, to their amazement and chagrin, that they were expected to find a sum which seemed to them astronomical for annual interest and repayment. Despite the publication of three books in one year, almost their sole income came from the few days a week when Mervyn taught at the Central School of Art. It was utterly in-

adequate. Far from being able to repay the original loan, they could not even keep up the interest payments.

In order to facilitate the journeys to London, they had acquired an old Wolseley Hornet. The idea was that Mervyn would drive to Headcorn, leave the car in the station yard, and then take the commuter train to London. The plan was not a success, and landed them into even greater expense. Bits of the small black car would fall off *en route*—on one outing they were surprised to glimpse the sunshine roof flying over a nearby hedge—and it rarely finished a journey without breaking down and necessitating the hire of expensive taxis.

Visitors were welcome at Smarden. Among them was Rodney Ackland, the playwright, who had been to Edinburgh with Mervyn. He noticed that some of Mervyn's illustrations were astonishingly like his children, though they had been drawn *before they were born*. In some cases the resemblance to the child-to-be was uncanny. He wrote:

Lunchtime. Childish yells and sounds of scampering without, and into the living room burst three enchanting bare-footed children and, although I had never set eyes on them before, I knew their every feature; the way their hair grows, the very movements of their childish limbs are all familiar to me. I have seen them before, again and again, in various works of their father's.

Rodney Ackland also recounts an incident when

I said goodnight, went up to bed, opened the door of my room and there, straight out of *Gormenghast*, was a great bat flying. I yelled for help. My host and hostess arrived unperturbed, told the bat to leave me and away it politely flew—back presumably to Gormenghast's stone fields and crumbling belfries.

Esmond Knight was another visitor. He went to Smarden when it was so cold that the water in the wash basins froze. He gave a great deal of practical advice over the writing of *The Wit to Woo*. He 'thought it was extremely good in its original form. It was very funny and full of marvellous language. It had great zest and inventiveness.'

He was there, too, on the occasion when the Smarden Amateur Dramatic Society put on a one-act play of Mervyn's at the church

hall. It was an exciting evening, particularly for Sebastian and Fabian who sat on the front bench. In his pride and excitement Sebastian kept turning round and shouting, 'My father wrote this play!' Mervyn was pre-occupied with the necessity of making a speech thanking the Society for putting on the play. The name of the Society's secretary was Fielding-Mould. 'I know I shall call him Moulding-Field,' Mervyn kept saying as he went over the speech. But all was well.

Living nearby, at Appledore in the Weald of Kent, were Tony Bridge and his wife. Tony was still painting, but was turning towards the church and was soon to enter a seminary for aspiring Church of England clergymen. He was fond of discussing religious dogma with members of other denominations, particularly Roman Catholics. Though Maeve had retained her faith, and the children had been baptised as Roman Catholics, she did not enjoy discussing her religion. Tony's chance came, however, when a travelling priest came to stay at the house for the week-end in order to hold mass (there was no Roman Catholic church at Smarden). The two men became involved in esoteric religious polemics which neither Mervyn nor Maeve could follow.

Mervyn's religious beliefs were muted. He was the son of a missionary, and perhaps because of this he accepted the existence of God as a fact. He was proud of his father, and felt some affection for the Congregationalists, but he did not appear to need church ministrations. He had no interest in dogma and ceremony, but believed in kindness and charity because he was more concerned with the human predicament than with the meaning of religion. To him, life was the greatest miracle of all.

At Smarden he started writing *Mr Pye*, the comic adventures of a plump evangelist who set out on a crusade to Sark. Unlike *Titus Groan* and *Gormenghast*, *Mr Pye* was written with an eye on possible financial reward. The expense of the house was driving Mervyn to extra work in order to make somehow, somewhere, money to pay for the outgoings. Some of his creative spontaneity was being repressed by the desperate need for cash. A new anxiety, the anxiety to make ends meet, was curtailing his freedom. He did not show this anxiety in public or when he was with his friends, but to Maeve, who watched over him, the signs of distress and fatigue were increasingly evident.

He started at the same time an autobiographical novel that was to be called *Chinese Puzzle*. It was begun, as he recorded, with the 'sun slanting through a Kentish orchard where the small, hard callow apples, the "June drop" as they call it, sprinkle the grass in their thousands'. It was the story of a boy, the son of a missionary, and it was set in Tientsin. Although the book was to be fiction, the descriptions of the missionaries' houses in the compound are obviously based on Peake's memories of China.

> In the long compound there were six tall houses; all of them seemed very much the same from the outside, but were very different inside. They were built in grey stone in some kind of late Victorian style, and had no business to be in China. They might well have been flown over, all in a row, from Croydon. But there they were.

In a later version, he added descriptions of each of the houses. Once inside:

> They felt different, they smelt different, they were very different. Because the six missionaries and their wives and children were so extraordinarily different from one another. And so the six identical houses were always so different in his mind, even from without, as if a dog and a frog and a squirrel and a rhinoceros and a pig and a cat were all standing in a line.

Work on Mervyn's other projects, however, prevented him from continuing this story; like the notes he also made at the same time for an autobiography, this work was put to one side.

With the approach of Christmas came the problem of presents for the children. Sebastian was easily satisfied with an electric train (though more often than not it failed to work). Fabian was more of a problem. He had taken to bird-watching and already had a considerable knowledge of ornithology, and so, as Maeve later explained,

> we decided to get him a stuffed bird. We did not know where to go, but thought that Maidstone Museum might help. So we went there, and found out that they were throwing out a lot of stuffed birds, mostly, I think, from India. We salvaged them, and put them in a line behind the curtains in the drawing-room, and on Christmas morning, drew the curtains and there they were. Fabian could not believe his eyes.

Fabian himself remembered those stuffed birds.

I had become interested, living in the country, in bird life. I used to go nesting with the village boys. The rule then was that you never took an egg if there were three or less eggs in a nest. It's now forbidden altogether. I was terrifically pleased to have this Christmas present. I think my parents must have had a great stock of birds, because, after that, a new one used to turn up at odd moments. I remember one suddenly appearing in Clare's play-pen.

On the question of a present for Clare, Maeve recalled:

I think we gave Clare a doll. She had a filthy rag called 'Bye-bye'. Without it, she would not go to sleep. Once she left it on a bus. Luckily, we noticed that it was gone as soon as we got off. Mervyn rushed after the bus, and stopped it. 'I think we've left something,' he said. 'What was it?' asked the conductor. 'A rag,' said Mervyn. The bus conductor was surprised that anyone wanted to hold up a bus just to get a rag.

Their financial status did not improve. To add to their worries, the country went through one of its perennial financial crises, the effects of which were felt even in Smarden. Branch bank managers were instructed by their head offices to restrict overdrafts and call in loans. Something had to be done. As there was no way of increasing income, the only course left was to put the house on the market, and hope to get a high enough price for it to pay off the bank. But here again they were out of luck. Because of the crisis, house prices, particularly in the country, had slumped. There were very few buyers. They had to wait months before they were able to sell the house, and were lucky to get £5,000 for it when they did. All of this went to the bank. Even then they still owed the bank £1,000.

It was with something like relief that they returned to London. Through all the financial difficulties, they had managed to retain the thirty-shilling-a-week studio in Trafalgar Studios and for a time they all lived in it. The two boys went back to boarding school, Sebastian to Mayfield in Sussex, and Fabian to Foxhunt, the prep school for Mayfield. Most of the furniture was put in store, except for a few pieces that were needed in the studio. Clare, now three years old, stayed with them at the studio. Maeve recalled:

It was wonderful to be away from the house, and its terrible

financial burden. We never could make up that £1,000. It hung over us all the time. But we were very happy to be living in a studio again. Mervyn made a little tent for Clare to go to bed in, so that she would not be disturbed by the light, or people coming and going. He also thought it would be a good idea to keep chickens, so that we could have free eggs. He thought they could live around the tent; but though he constructed some shelters for them, we never got any in the end, which was probably just as well, as things were very cramped in the studio, especially when the boys were on holiday. But I never wanted to have another house. I would have been perfectly happy to have stayed at the studio for ever.

But another house was, in fact, on the way. When Dr Peake died, he left Reed Thatch, in Burpham, to Leslie, and the Wallington house Woodcote to Mervyn. Woodcote had been let for some years, and was now a boarding house. The owner of the lease refused to vacate the premises on the grounds that it would deprive the boarders of a home. The case was brought to court and Mervyn had to go to Croydon to give evidence. Thanks to the efforts of his counsel and of the family solicitor, he won the case, and the house was his.

There was no thought at that time of moving, nor was there any question of sudden eviction of the tenants. The sale of The Grange was dictated entirely by financial considerations. Even when they moved to Trafalgar Studios after the sale, they did not think of moving to Wallington. They were more inclined to sell the house in order to pay off the remainder of the Smarden debt, but there were no offers even approaching the £1,000 they needed. So the house slowly emptied until it was vacant.

At about this time, Mervyn thought of turning *Titus Groan* into an opera. With his usual mixture of enthusiasm and meticulous attention to detail, he plotted some of the scenes, sketched the characters, and began the dialogue, covering about fifteen pages of foolscap paper. On the first page of the manuscript, there is a rough sketch of the opening scene: Rottcodd, holding a duster, is seen lying in a hammock which is slung between two of the Bright Carvings. Other Carvings can be seen beyond. In the window on the back-drop is a view of the rooftops of Gormenghast. The opening instructions are as follows:

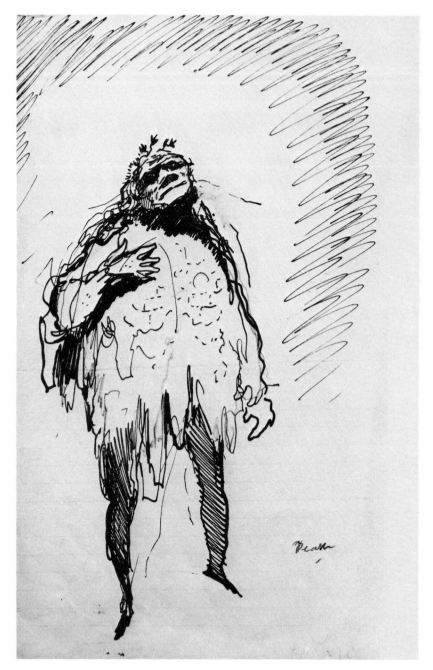

The spirit of Gormenghast for the opera of *Titus Groan*

ACT 1

SCENE TWO

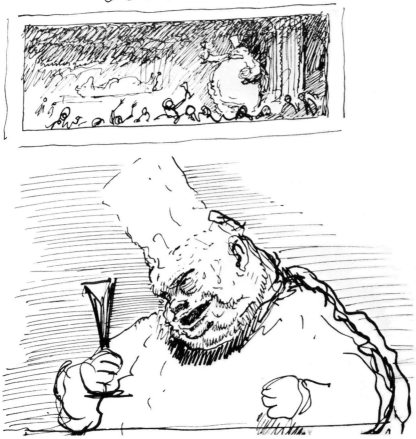

Swelter, from the manuscript of the opera of *Titus Groan*

As the curtain rises Rottcodd can be seen asleep in a hammock. Music suggesting the droning of an endless afternoon, the slow, rhythmic beat of a heart or a clock—and if possible a sense of height. This attic in which Rottcodd is sleeping is three hundred feet above the ground—high above the activities of the castle.

It is interesting to see the development of the book characters into operatic ones. This dialogue between Flay, Lord Sepulchrave's

servant, and Sourdust, the bad-tempered and ill-mannered non-agenarian 'lord of the library', illustrates it.

SOURDUST : By the black blood of stoats why don't you halt or make some sign? Am I to be ignored? By a stick insect? Curse you!

FLAY : Urgent business. No offence. Move your crutch.

S : I'll move my crutch to whistle round your head-piece if you forget your place.

F : My place? That's good! It's at his Lordship's side, that's where my place is. Who could be closer? Let me pass.

(The sound of Sourdust's crutch being ground on the stone floor)

S : Am I guardian of the bloody Laws for nothing? The heart of Gormenghast. A hundred times as old as your master. Lord follows Lord, but the Laws are changeless. What of the new-born?

F : What of him? He has come. Flourish the blood-line!

S : Flourish the line.

F : Are the stags' head to be set on the turrets? Eh? With lanterns slung between their antlers, Sour-dust?

S : Of course.

Mervyn hoped to interest Benjamin Britten in the idea, but nothing came of it. This project, like so many others, was abandoned and stored away in a cupboard.

It was not his first excursion into the world of music. In 1951, during the Festival of Britain, Mervyn was asked to contribute drawings for a Shakespeare sonnet sung by Peter Pears. The recording was shown in the Festival cinema, which subsequently became the National Film Theatre. As the song progressed, the cameras moved slowly over Mervyn's drawings.

In the summer of 1952, the family went on holiday to Adversane in Kent, and on their return they realised that the five of them could not live indefinitely in a one-roomed studio, however attractive it might be. Nor could they find any other accommodation at a price they could afford. So, keeping on the studio—which still cost

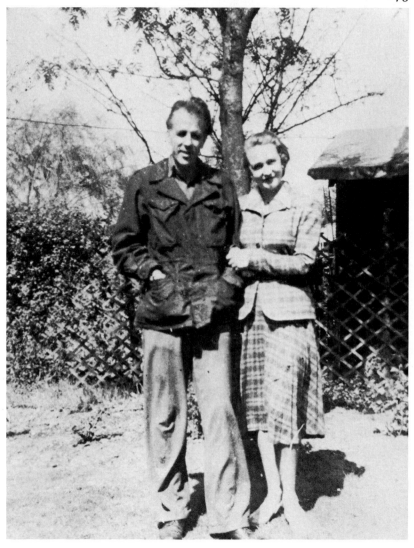

Mervyn and Maeve at Smarden, 1952

only thirty shillings a week—they moved to 55 Woodcote Road, as they always preferred to call it.

It was [Maeve remembered] like going into a church. A huge place with large rooms. There were three empty rooms in the attic. I had two adjoining rooms as a studio. Mervyn, when a boy, had decorated them with scenes from Shakespeare's

plays; but these scenes had been painted over. There was a greenhouse, which had a vine that produced very sour grapes. Sebastian wanted to turn the place into a swimming pool. Mervyn used it sometimes to do sculpture. The boys kept their bicycles there. I'm afraid it was never used in its proper function of a greenhouse. I loved the house, but hated the district.

The house had its advantages, and the first and most obvious one was that it was theirs. Rent or capital repayments no longer had to be considered. (The Smarden debt remained, like the National Debt, indefinitely suspended above their heads.) Wallington rates were low, and the upkeep of the house was minimal. There were a dozen or more rooms where paintings could be hung. There was a large garden, where Mervyn had once played tennis and where now his children could romp and roam. The boys were taken away from their boarding schools, and sent to a highly recommended one in the neighbourhood. There was a good train service to London and the Central School of Art. If Maeve felt depressed by the lack of artistic activity in the neighbourhood, she kept her feelings to herself. Mervyn was busy and the children were happy. That, for the time being at least, was enough.

17 Cause for concern

The manuscripts and typescripts which went into the construction of *The Wit to Woo* are still extant. There are expensively-typed versions of the play, overlaid with corrections in Mervyn's neat handwriting. One whole typescript is used as the scribbling ground for a new version which is written on the reverse side of each page. There are exercise books and loose sheets of notes. Mervyn was tireless in his pursuit of perfection.

> The play [Maeve said] was like a boulder rushing downhill. Nothing could stop him. I was afraid of it, and of what it was doing to him. It seemed to carry a sense of doom in it. There were too many people involved in it—whereas in a book, a painting, a poem, you are only answerable to yourself.

He was setting too much store by this work, counting too much on it. This was a time when it was said that an instant fortune could be made from writing a play, like winning the football pools. He did not want to make a fortune, but he did want to pay off the Smarden debt and give his family the luxuries he felt they needed.

He had stopped writing the *Titus* saga, partly because he was thinking of changing direction where this tale was concerned, and partly because he was busy completing *Mr Pye*. He had abandoned his projected novel *Chinese Puzzle*, but he was still busy trying to interest publishers in the possibility of re-issuing classics with illustrations by himself. Two books in particular interested him: *Don Quixote* and *The Marvellous Travels of Baron Munchausen*. He almost succeeded in obtaining a contract for the latter, but in the

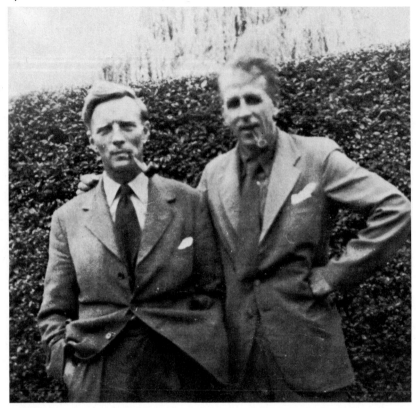

Gordon Smith and Mervyn at Wallington, 1953

end it came to nothing. He wanted, too, to illustrate medical books, with fine linear drawings, but this project also failed to materialize. He did, however, illustrate one book, *The Book of Lyonne*, written by Eric Drake's brother and Clare's godfather, H. B. Drake, and published in 1952 by the Falcon Press. It was a children's book about a zip-up bag, shaped like a lion, that suddenly comes to life.

When *Mr Pye* was completed, it was sent off to Eyre & Spottis-woode, but turned down by them: they were interested in the *Titus* books, but not in something which seemed so very different. This was a setback, but not of long duration, for when Mervyn sent the book to Heinemann, it was accepted, and published in 1953. But the reviewers kept away from it. It was not that they said anything particularly bad about it: they said almost nothing at all. To some it seemed that it was not up to the *Gormenghast* standard; to others,

it was too light-hearted to follow such works as *Titus Groan* and *Gormenghast*. Mervyn's small and specialized followers felt the same, and the larger public had not yet discovered him. Instead of the hoped-for financial reward, the royalties for *Mr Pye* were minimal.

Also published this year was a touching little book called *The Young Blackbird*, by E. Clephan Palmer, who used to be parliamentary correspondent for the *News Chronicle*. It was the true story of how he and his wife found a fledgling blackbird in their garden, took it into their house, and brought it up by hand. By so doing, they changed it from a wild creature into something that preferred the company of human beings to that of its own species. It lost, too, its instinct for self-preservation, and was unable to foresee the danger of a prowling cat. The story ends with the inevitable fatal encounter.

Mervyn produced a series of sensitive drawings for the book, but because of the need for economy, the minimum amount of space was allocated to him; most of the drawings, mainly of the blackbird itself, cling precariously to the cliff-like edges of the text. It had been hoped that it would have a run-away sale, like Paul Gallico's *The Snow-Goose*, of the war period, but it did not stir the public.

In the meantime, *The Wit to Woo* started on its travels. It went first to Laurence Olivier for an opinion. Olivier's reaction was frank and critical, and the effect of his letter was to make Mervyn recast and rewrite the play, and send the new version off again. He felt quite sure that success, for which he had worked so long and hard, would one day be his.

But something was wrong with his health. At first, the signs were very slight: there was a tendency for his hands to tremble for no reason; he would tire more quickly; he needed more sleep; his body would suddenly be shaken by an inexplicable tremor. He and Maeve made a joke of it. It would soon go. That is what they said to each other: it would soon go.

1954 saw the publication of a strange little book, *The Wonderful Adventures of Tom Thumb* by Paul Britten Austin, with drawings by Mervyn Peake. The title was followed by the unexpected words:

English Spräkkus I Radio. Sommaren 1954 Radiojänst
Britten Austin worked on the Swedish Radio and ran an English-speaking course for his listeners. The small four-by-five-and-a-half-inch teaching book was so successful that a second part, of the

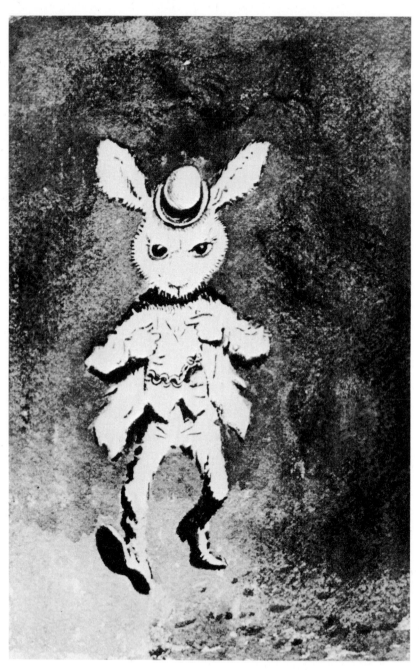

Preliminary sketch for the White Rabbit

The White Knight

Preliminary sketch for character in *The Wit to Woo*

same size and with further drawings by Mervyn Peake, was published in the following year.

The English version of the 1946 Zephyr edition of *Alice's Adventures in Wonderland and Through the Looking Glass* was at last published, in 1954, by Wingate. Malcolm Muggeridge wrote a crisp introduction, comparing Father William to Lord Beaverbrook and suggesting, as Frances Sarzano had done earlier, that *Don Quixote* should follow. But no requests for *Don Quixote* came from the publishers.

Mervyn sent a copy of *Alice* to Graham Greene, and Greene replied, on 10 September, that he felt that Mervyn was the first person since Tenniel to be able to illustrate the book satisfactorily. Despite this, Mervyn was upset to find, on making a rapid tour of

London bookshops, that no one seemed to have *Alice* in stock. He wrote to Graham Greene again on 27 September, 'I have just rung up Wingate to ask them why no bookshop in London has my Alice. None will have it. I am rapidly qualifying as the arch-untouchable.'

On Monday 4 October Gollancz published *Figures of Speech* in time for the Christmas market. It consisted of twenty-nine line drawings by Mervyn, illustrating well-known catch-phrases such as 'coming up to scratch', 'to cut a long story short', 'it came to a head', and so on. There were no words to the drawings themselves, but a list of answers at the back. It was a book of games to be played at parties. Each member would be shown a drawing and asked to identify the phrase. But, alas, as with Mervyn's other work at this time, the public did not respond, and *Figures of Speech* sold no better than *Mr Pye*.

He seemed to have entered a doldrum period. However hard he worked, and he was working harder than ever, he could make little or no headway. The trouble was that his genius for illustrating was not wanted and the audience for his writing had not yet grown up. If anyone ever lived out of his time, it must surely have been Mervyn Peake. Had he lived earlier or later, he would have found appreciative audiences; as it was, his own generation largely ignored him.

Television was now beginning to take a grip on the country, and many kinds of programmes were tried out. Someone at the BBC had the bright idea of sending out a group of artists, archae-ologists, sociologists, historians and geologists to Yugoslavia and getting each of them to give his or her impression of the country. Mervyn was chosen, not as the artist of the party—that was to be Robin Jacques—but as the writer.

Term at the Central School was over, and he set off, on 9 April 1955, for Yugoslavia. In a letter to his wife, dated 14 April, he describes his arrival at Buda:

> We arrived last night after a long, hair-raising journey from Dubrovnic which would have excited the boys, and you too as far as the beauty went, but Sebby and Fay and Boo-Boo [Sebastian, Fabian and Clare] would have been amazed to see the sheer drop of thousands of feet into the valley as our coach rattled around the hairpin bends which were only wide enough to take the wheels, so that if one looked out of the window, one looked straight down to the valley.

Old Man, Yugoslavia, 1955

Although he was not the official artist, he did, in fact, spend most of his time sketching. Nothing escaped his artist's eye:

> Yesterday in the dusk, with the pallor of pink light suffusing the mountains that are always looking down in silence, a group of little urchins galloped down to the sea below the windows of the hotel and had a fight, using long palm boughs as weapons which they swung at each other. I made a few quick drawings of them which I would like to work into something.

There are sketches in the letter of the urchins and, on a later page, amongst endearments to his wife and children, there is a sketch of one of the palm trees with the note: 'They trim these palms as

The Card Player, Yugoslavia, 1955

Crufts Show poodles in England—bulges in and out at all sorts of angles.'

A few of the drawings he did were used in a children's television programme, but the series never materialized, and many of the drawings joined the ever-growing pile of unused work stacked in drawers of the Wallington house. Despite the lack of financial success, Mervyn never gave up trying. He was always full of ideas, plans, suggestions and schemes for breaking into new worlds.

> Sometimes, [Maeve later recalled] somebody, John Clements for example, would ring up with hopeful news about the progress of *The Wit to Woo* through the terrible theatrical jungle. If I were in my studio in the attic he would come rushing up with the news. I dreaded seeing his confidence, exuberance and hope. I never trusted the world of the theatre. I never thought it would do him any good. I could see that he was wearing himself out with these plays; for others followed *The Wit to Woo*. He was quite sure that the solution to all our financial problems lay with the stage. It was an irrational belief, based on hope. Some people had made money at the theatre. He felt that he could do so too.

During the previous Christmas holidays he had been to Dedham in Suffolk, in the Constable country, so that he could start *Titus Alone*, the third of the Titus books. It was extremely cold, and after a week he returned to Wallington and to the sound of Sebastian's set of drums. Mervyn liked to work in a family atmosphere, to be detached from, and yet within, sight and hearing of them all. The occasional escapes to less noisy environments inevitably led to a lessening of work, and a return to his home surroundings.

The tremors had increased, particularly in his hands, upon whose steadiness he depended for his drawing and painting, and for his writing as well, for he never learnt to type or use a dictaphone: he had a horror of mechanical gadgets. He was now beginning to show new symptoms, and yet they were not those of any recognizable illness. He would be seized with a form of restlessness, a compulsive moving from place to place for no apparent reason. He was having difficulty in writing *Titus Alone*: he found it hard to concentrate. Sometimes his handwriting was almost illegible, but he went doggedly on with the book, and accepted new work as well.

The Wit to Woo was still going on its theatrical journeys. The

revised version had been sent back to Laurence Olivier; Vivien
Leigh, Olivier's wife, had liked it and saw herself in the lead. It was
to be sent first to H. M. Tennent, the theatrical management, and
then on to Peter Brook. As Esmond Knight said later:

> You could not have better than that. Both Larry and Vivien
> were wildly enthusiastic about it. She was going to be the
> woman in the play, and Larry, Percy Trellis. How could
> Mervyn not feel encouraged by backing such as that?

But Quentin Crisp, who also knew a great deal about the theatre,
took a different view:

> He was so successful in so many spheres, illustration, painting,
> writing novels and poetry, that I think it was a mistake going
> into the world of the theatre. He didn't really understand
> theatre people. For example, when an actor says 'I've got a
> part as Hamlet', he means that he has read in *The Stage* that
> a certain management was looking for a Hamlet.

Mistake or not, he continued to write plays, or, at least, to start
them. One of them was called *Manifold Basket*. The reason for this
curious title was as follows: the Peakes had exchanged their Wolseley
Hornet for a large shooting-brake (Fabian, on first getting into it,
had exclaimed: 'I'm in Dreamland! I'm in Dreamland!'). Mervyn
subsequently painted the whole of the interior woodwork with
elaborate and colourful patterns. During conversations with the
garage owner, somebody had mentioned a manifold gasket. Although
Mervyn had no idea of the use of this gadget, he was fascinated by
the unusual juxtaposition of words, and his active mind immediately
conceived the *Manifold Basket* play, which was set in a school and
brought in a number of *Gormenghast* teachers, including Bellgrove.
It was written in a shiny travel book, Mervyn going to the trouble
of pasting clean sheets over the photographic sections. It is not
complete, but there are some magnificent line drawings to illustrate
the text.

Aaron Judah, whom all the family called Joe, suggested col-
laborating on yet another play. Mervyn had met him a short while
before this when Joe was working as a dresser in a theatre. Joe was
looking for somewhere to stay, and took a room at the Wallington
house for ten shillings a week. He fitted it up with all sorts of Heath
Robinson contraptions, such as pulleys and string to open the door
without his moving from the bed, and when he was not working at

a Sauna bath clinic he spent his time writing books, mainly for children. Sometimes, he would fetch Clare from school or take her for walks. In the winter when it was very cold (the house had no central heating, indeed very little heating at all) he would abandon his official room and retire to an airing cupboard, which he would share with Chloe, the much-travelled cat, who had followed them from Trafalgar Studios to Glebe Place, Sark, Embankment Gardens, Smarden, and now Wallington.

Joe's idea was to write a play around an Oblomov character, a man who, though having great gifts, had decided against using them, and would devote his life to doing nothing on a grand scale. The theme appealed to Mervyn, and with great industry he started to write about a man doing nothing. It was called *Mr Loftus*, or *A House of Air*. He wrote it very quickly, and when it was finished sent it to Kenneth Tynan for an opinion. Tynan was not very impressed by it, and returned it with some critical comments. Other ideas for plays were in Mervyn's head, or half committed to paper, including a play for children called *Noah*. But despite this activity, he was still not getting anywhere financially; the tremors in his hands were increasing, and the power to concentrate was harder to maintain.

Then, in the early summer of 1955, the BBC asked him to condense his two-hundred-thousand-word novel *Titus Groan* into an hour's listening for the Third Programme. He undertook the formidable task, and by careful selection managed to work within the time-limit and still allow his characters to retain their identities. The version was broadcast early in 1956, and further adaptations were made for the French Overseas Radio Service.

In the meantime, ever looking for new sources of work, Mervyn went to the Rediffusion headquarters in Aldwych with the suggestion that his *Letters from a Lost Uncle from Polar Regions*, originally published in 1948, might be transferred to the television screen as a children's programme. The television company acted promptly and agreed to the proposal. There were to be twelve programmes, each representing one of the letters. It was a very complicated business. The original drawings, amongst the most subtle Mervyn ever did, had to be redrawn on a much larger and simpler scale, mainly in wash and heavy line, so that a camera could pan across them while an actor spoke the lines. Mervyn would prepare about twelve large drawings every week, and when they were complete

he would catch a train from Wallington to Victoria, and then a bus to Aldwych. On one awful occasion, he left the whole portfolio of drawings on the train. It was never found again, and he had to return to Wallington and spend the next two days and nights, almost without sleep, re-doing the lost drawings, so that they could be rushed to Aldwych in time for the next screening. He was paid the highest fee he ever received—£100 for each set—but it did him little good, for every penny of it went to the bank to help pay off the Smarden debt that hung above their heads as formidably as ever.

He was working too hard. The tremors in his hands had now spread to his arms and legs. Sometimes his whole body would shake. But still no one could find anything organically wrong with him. It was put down to strain and worry: what was needed was a good holiday. But how and where? On a promise of remaining anonymous, a friend of theirs, who was becoming as worried as Maeve by the change in him, offered to pay the fares, hotels and other expenses for both of them, for a holiday in Spain.

Having made arrangements for the care of the children and the cats (a new one had joined the veteran Chloe), they flew to Spain at Eastertime 1956. A photograph taken by an airport photographer at the Spanish airport shows Mervyn in dark glasses and looking, for the first time, strained and harassed. Unlike the earlier time in Paris, the three weeks in Spain were a tremendous success. The Peakes were able to see everything they wanted to see. They even had the Prado to themselves because it was officially closed to the public. Walter Starkie, the brother of Enid Starkie the writer and a great lover of Spain, gave them a letter of introduction to the Curator. So great was Starkie's reputation and influence that the Curator had the Prado opened exclusively for them, and they spent the whole day with an ancient attendant, looking at everything, particularly the works of Velasquez, El Greco and Goya. They visited Goya's house and were shown over the convent at Avila, where St Theresa had been Mother Superior. They saw her pickled finger with an amethyst ring on it. Mervyn's congregational missionary upbringing was repelled, but his sense of drama was thrilled by the sinister strength of Spanish religious fervour. (Both took seasickness pills before going to a bullfight.)

Spain had a therapeutic effect on Mervyn. His drawn and

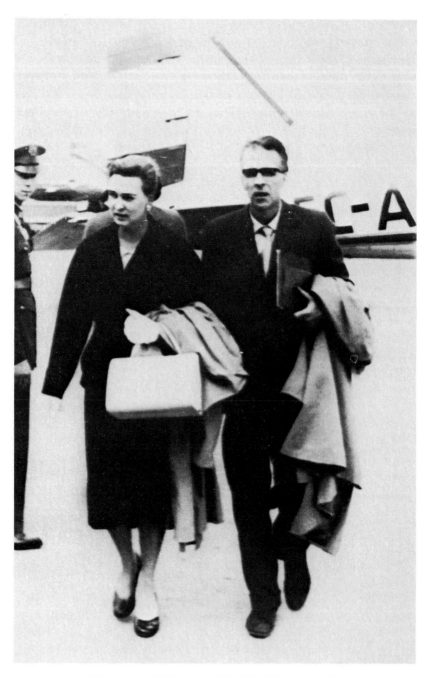

Mervyn and Maeve at Madrid Airport, 1956

worried look was replaced by one of eagerness and excitement.
The tremors stopped. He seemed to grow younger and more carefree
every day. The jokes and the laughter increased, and as she watched
him, Maeve could believe that the trouble in England had been
successfully overcome. They returned, laden with presents for their
children, refreshed in mind and body, ready once more for work.

Besides the plays, the writing of *Titus Alone*, and the occasional
commission for a portrait, there was plenty to be done. Eyre &
Spottiswoode commissioned three writers—John Wyndham, William
Golding and Mervyn Peake—to contribute a tale of mystery to a
volume to be called *Sometime, Never*. Mervyn's contribution was the
short story 'Boy in Darkness'. It was a separate adventure of Titus
Groan, outside the Gormenghast environment. In it, man has lost
his humanity and survives only as the bullying man-hyena and
the sychophantic man-goat, who slavishly serve their terrible
master the lamb. The arrival of Titus leads eventually to the
release of the two humans trapped in their bestial shapes, and the
destruction of the lamb. The story was a statement of Mervyn's
faith in the eventual triumph of the human mind over adversity
and oppression.

On 5 July 1956, Mervyn flew on his own to Dublin to be present
at an exhibition of his paintings organized by the Waddington
Gallery. Immediately on arrival he wrote to Maeve.

The same day as I saw you on.

Most darling,

This is a note written hurriedly in the Dublin huge post
office. I am in love with you. I love you all the time in my
mind.

Waddington and his wife were delighted to see me. They
want me to stay the last night with them—and have some
people to meet *me*. Yes ME.

He is definitely coming to London and he may have a
gallery there in the West End. He is anxious to see your pictures.
I told him about them. Must rush now. Will write tomorrow.

Your own adoring husband.

Love to the children.

A few days later, he wrote from the house of some friends of
Lady Moray to whom he had an introduction:

Spaniard, sketched in Retiro Park, Madrid, 1956

Here I am in Tipperary where it has been raining up to date
fairly steadily. I have done a number of water colours and
drawings nevertheless; some rather successful ones from a
beautiful t'ang horse . . . they have several friends who are
coming who may buy and the best thing of all are the sales at
Waddingtons—six of them I think. Waddington said when I
spoke to him that he would work out how much he owes me
and make out a cheque then and there but I told him to wait
till I came to see him on the return journey.

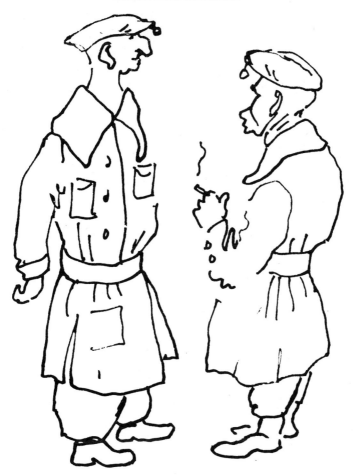

Spanish Soldiers, Madrid, 1956

I am going to spend the night with him and his wife and
they are going to run me to the airport on the next day. This
I've arranged at this end too. He sold a drawing of mine on
the very day I dropped in on him.

Every topic here (and they talk a lot) revolves round
farming, of which I know nothing, herds, and flocks, and stock
and tillage. Everyone is very friendly, but O how I wish it
was just the two of us, you and me.

He was always concerned about Maeve's health, and with the

various problems of bringing up their children. In a further letter he hoped that Sebastian will do a bit of 'swotting' before his exams. In this letter he enclosed one of his quick sketches, this time of a blinkered horse with earcaps. Under the drawing, he wrote 'They have these things over their ears to protect them from flies.' He wrote too, of a mysterious 'financial' idea he had had, adding, 'It isn't anything you could think of.' It certainly wasn't. It was only when he reached the house in Wallington late the following Saturday that the 'financial' idea was revealed. Maeve was in bed. First he asked her to close her eyes. When he told her to open them again, she saw that the bed was covered in lovely, crisp, white five-pound notes: he had been paid cash for some of his sales. This money, at least, would not be swallowed up in the Smarden debt, unlike the November advance for *Titus Alone*, which simply went into the bank and disappeared. They began to feel that they would never be free of this burden, but Mervyn was absolutely sure that *The Wit to Woo* would be produced, and that their problems would be solved: it was just a question of being patient a little while longer.

CHAPTER 18 'Heads float about me'

On 8 January 1957 a letter arrived that seemed to justify the long struggle to stage *The Wit to Woo*. It was from Michael Codron, the producer. It was short but decisive. Codron was definitely interested, and within an astonishingly short time a contract was signed and the play, which until then had been a script passed from hand to hand, now became a reality. A theatre was found, the Arts Theatre in Great Newport Street; a director, Peter Wood, was engaged; and a cast, headed by Zena Walker and Colin Gordon, and including Kenneth Williams, was chosen.

It had been a long trek. From Laurence Olivier, the play had gone, in 1952, to Anthony Quayle; then to John Clements, who, with his wife Kay Hammond, was enthusiastic. By 1955 Peter Hall was showing interest; but although a £45 option was taken out in March that year, nothing came of it until Michael Codron's concrete proposal another two years later.

Mervyn was enormously buoyed up. He went to rehearsals and could think and talk of nothing but the play. Even Maeve's fears and reservations were dispelled when she, too, visited the theatre, and came into contact with the enthusiasm of the cast. Perhaps this venture was the right one for Mervyn, and would lead to the rewards he craved so desperately. Watching him, as he returned, day after day, in high excitement from the theatre, she prayed that all would be well.

On the first night Laura Beckingsale, who had taught him in Tientsin, insisted on paying for a room for them at the Royal

Court Hotel in Sloane Square, so that they would not have to face the tiresome journey back to Wallington in the evening. Maeve had a dinner jacket especially made for Mervyn. Before setting off, fearful and silent, for the theatre, they took, appropriately perhaps, seasickness tablets. This was Tuesday, 12 March 1957.

The theatre was full. John Clements and Kay Hammond were there; so were many friends, acquaintances and members of both families. People came in groups to 'support Mervyn'. It was a tremendously exciting evening. Mervyn looked very distinguished in a dinner jacket, and Maeve fragile and attractive as she sat beside him in the stalls. They both seemed, somehow, out of place in the noisy, 'hullo *dar*ling' world of the theatre, innocents brought suddenly into contact with a harsher world. During the interval, they were hustled along to the bar and there, surrounded by friends, told what a tremendous play it was, what magnificent acting, what a success it would be. But some of the critics had left early. When it was all over, there was a great deal of clapping, and then everybody dispersed. Mervyn and Maeve were taken out to dinner at Prunier's by Henry and Matty Worthington, Maeve's sister and brother-in-law. It was a sumptuous meal with lobster and champagne. The air was full of euphoria, but next day the reviews brought disillusionment. They were not good. *The Wit to Woo* was compared unfavourably with Christopher Fry's popular verse plays, and as the Peakes read the newspapers in their hotel room, they realized that the optimism of the night before had been misplaced, the work of seven years wasted: the magic wand that was to solve all their worries had broken.

They had arranged to meet some friends at the King's Head and Eight Bells, just off Chelsea Embankment, at twelve o'clock that morning; they turned up as though nothing was wrong, and everything had gone exactly to plan. But it was noticed that Mervyn walked very slowly and hardly spoke a word. His wife was equally silent, but she walked with a kind of determination and courage. There was a sense of watchfulness about her, as if she were preparing herself to face a blow. One friend, aware of this tension, wanted to say some words of consolation and sympathy, but could not do so as the pretence had to be kept up that the evening had been an unqualified success.

Esmond Knight was later to blame the many changes in the

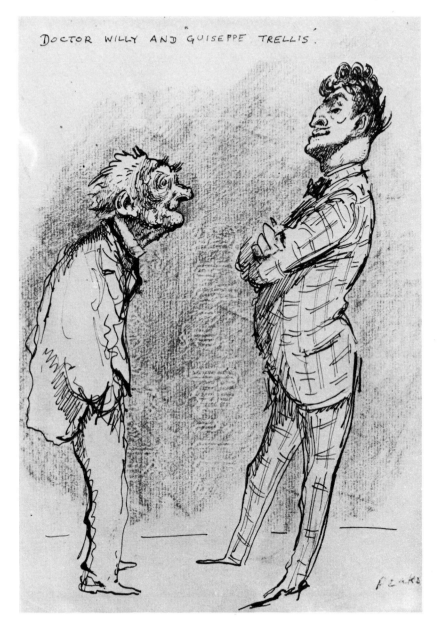

Doctor Willy and 'Guiseppe Trellis', from *The Wit to Woo*

script and the smallness of the theatre for the bad notices:

> So many people altered it that it lost its original sparkle. There was a scene when an old man was to be lowered to the stage, but they couldn't do it properly because of the size of the theatre. If the original play had been produced in a large theatre, as it should have been, it would have been a success. I'm sure of that. As it was, the reception shattered Mervyn.

He had expected too much from it, had worked too hard on it, and had held at bay the illness that had started to take hold of him. The holiday in Spain had revitalised him, the hope for the play had held him together since. Now, suddenly, that hope was dispelled.

The first crisis came on Saturday. Maeve sent the children to friends, and lived through a day of torment, followed by a week-end which seemed as though it would last for ever. Sometimes Mervyn would lie inertly on the bed, sometimes cry out in delirium. The local doctor could make little of it, prescribed pills and suggested that more expert opinion should be sought.

His daughter Clare, who was seven at the time, always remembered that day vividly:

> He was sitting in a leather armchair, absolutely shaking all over. I did not know what had happened, but I knew that it was terrible. We went out to tea. I don't remember coming back, but I remember going. I thought that by the time we returned, everything would be all right again.

It looked as if he was suffering a nervous breakdown due to overwork. Various specialists were consulted, and agreed to disagree on what was the matter with him. Life, however, had to go on; and after the first week-end of torment contact with reality was re-established. He still had his job at the Central School, and here he would go twice a week to teach. One of his students there was Susan French, later to achieve a considerable success with her ingeniously painted stone animals. Sue, as the family called her, would drive Mervyn back from the art school: he could no longer travel on his own.

The play had a very short run. The indifferent reviews had killed it, despite the sparkling cast. One reviewer remarked that if it had been written by an established playwright of light comedy, it would probably have run for a year. As it was, a sad little entry in

the 'Work Done' account book which Maeve had started in January 1956 records, against the date of 17 April 1957: 'From the Arts Theatre: £17, sent direct to pay for rates.'

In the hope of finding peace so as to start writing again, Mervyn tried one of his 'retreats' and went to Sark in July. He began to work again on *Titus Alone*. His writing was very shaky, but his thoughts were clear. 'I have been working as hard as I can,' he wrote to Maeve, 'but one has to keep in the shade. I believe you've had it hotter in England. We've had a light breeze to alleviate (there's no such word but one rather likes it) the sun.'

The BBC was planning to put on a radio version of *Mr Pye*, under the direction of Jack Dillon, and Maeve went to the rehearsals in London. Jack Dillon sent a copy of the transcript to Sark, and Mervyn wrote that he was going to telephone various producers and tell them to listen to the broadcast, with a view to making a film of the book.

In another letter to her, he wrote: 'It is going very well. New ideas flooding in. I wish I could get my sentences onto the paper without the process of writing down every word. The time taken up by the sheer nib-driving is awful.'

He returned to England, and in August he, Maeve, Sebastian and Clare went on holiday to Weymouth (hotel bill £29.0.0.), while Fabian was taken to France by Maeve's brother, Dermot, and his family. The Weymouth holiday was not a success: Mervyn's restlessness had grown worse.

In the autumn, Mervyn went back to work at the Central. Money was particularly hard to find. Wards' Bookshop in the King's Road sold a drawing in September for £12.12.0., and this was the first earned money since a royalty payment, on 31 July, of £7.12.3d. In October, a book jacket for the Oxford University Press produced another £14.14.0d. Then, a letter arrived from Mervyn's brother who was now living with his wife and children at Reed Thatch. In it, Leslie, or Lonnie, as he was more familiarly called, remembered how Maeve and Mervyn had given him a home on his return from the Japanese prisoner-of-war camp, and also how they had sheltered Lonnie's family on their return from Canada. He enclosed a cheque for £1,000. 'We could hardly believe our eyes,' said Maeve later. 'Such munificence. Such a huge sum. It all went into the bank to pay off the Smarden debt.'

There were others, too, who came to their help.

Towards the end of the year, Mervyn went on a 'retreat' to Aylesford Priory in Kent. This Roman Catholic Priory would take people of any denomination, and he wanted peace again, as in Sark, in order to finish *Titus Alone*. At first all went well. On New Year's Eve he wrote to Maeve:

> The New Year is going to be a thundering success. We have such potentialities which we must re-assess. Yesterday, I did another $7\frac{1}{2}$ pages, so I'm on my way with 15 in 2 days—One of the monks knows my work and is very keen to meet today and talk about life in general and is going to show me the treasures of the Priory.

He liked the twelfth-century priory, and its library, even though it was 'full of religious books'. The food was good and the atmosphere relaxed. But though he wrote a postcard on 2 January 1958, saying, 'Am really enjoying and profiting by this break', his restlessness was keeping him awake at night. Sometimes, he would walk up and down his room for hours because he could not sleep. There were complaints from the other visitors to the Priory, and the abbot rang Maeve and said that Mervyn would have to leave. She arranged for him to be put on the train, and Ruth met him at Victoria station and sent him on to Wallington. The lack of co-ordination in his movements was now so pronounced that he could be a danger to himself on a journey, and elaborate precautions for his safety had to be taken.

Laura Beckingsale, who saw him soon after his return, was so concerned that she persuaded him to see a specialist, who prescribed a number of pills which had little effect. Then came an introduction to Dr Robbins, who very quickly came to the conclusion that Mervyn was suffering from Parkinson's Disease, or the shaking palsy as it used to be called. (The name was changed to Parkinson's Disease after the Dr Parkinson who had in 1817 made a study of the illness and published his *Essay on the Shaking Palsy*.) The diagnosis agreed with Maeve's opinion. For some time she had been visiting Gordon Smith's old father, who was now living at Wallington. She would help Mrs Smith to feed him, and she noticed that the old man had, to a greater degree, the same trembling limbs and shuffling gait as her husband.

His [Mervyn's] past history [declared Dr Robbins later] had been healthy. He had had, he told me, pleurisy when he was a boy of nine or ten in China; but this could not have had any connection with his present illness. He had, however, an attack of encephalitis at the age of twenty-two. It did not seem a very serious one at the time, but it is a well-known fact that this condition can lead twenty or thirty years later to Parkinsonism.

Perhaps both the earlier disease and this present one went back even further, to the sleeping sickness epidemic of 1917, of which Dr Oliver Sacks was to write in his book *Awakenings*:

> In the first quarter of this century, with the advent of the great sleeping sickness epidemic (*encephalitis lethargica*) a 'new' sort of Parkinsonism appeared, which had a clear and specific cause . . . [it] could affect people of any age, and could assume a form and a severity much graver and more dramatic.

In a footnote Dr Sacks added the pertinent sentence: 'The onset of such symptoms may be delayed until many years after the original attack.'

Dr Hewitt, who had been the Peakes' physician on Sark, also believed that Mervyn's illness was due to the 1917 sleeping sickness epidemic, but few of the specialists consulted in 1958 were of this opinion. Many of them believed that Mervyn was merely suffering from a nervous breakdown, but it was obvious that some action had to be taken. After a further visit to a neurologist at the National Hospital in Queen's Square, London, Mervyn was admitted to the Holloway Hospital at Virginia Water.

A friend drove him and Maeve to the hospital, where she had to sign papers and then leave him. He was given electric treatment, which he feared and hated, as did all those who underwent it. He would telephone Maeve, asking her to take him away, but she had to persuade him, for his own sake, to stay. She would visit him, taking gifts and drawing-books, two or three times a week, making the tedious cross-country journey from Wallington to Virginia Water.

Mervyn was writing poetry and drawing a good deal again. Most of the poems had nothing to do with his illness or his predicament. They were reflective and calm. Only 'Heads Float About Me' touches on his dilemma:

Heads float about me; come and go, absorb me:
Terrify me that they deny the nightmare
That they should be, defy me;
And all the secrecy; the horror
Of truth, of this intrinsic truth
Drifting, ah God, along the corridors
Of the world; hearing the metal
Clang; and the rolling wheels.
Heads float about me haunted
By solitary sorrows.

He wrote home continuously. In one of the earliest letters, dated 3 March, he wrote, 'I'm in a ward for six but there are only 3 in it . . . I'm in, as you know, a corner. There are no female nurses but it's quite bright in our ward with the sun pouring in instead of the smiles from the nurses.' Three days later, he wrote to Maeve, 'I have been $\frac{1}{2}$ drugged since I wrote to you. So I haven't much to report. I have had 9 injections and I feel like a pin-cushion. Today is lovely outside. Wish I were out in it . . . God bless you. All will come right and we will storm the citadels together.'

The next day he wrote to say that he had had his 'first tea up', and on 16 March: 'I've had 4 electric treatments. I don't like them much—but I believe they do good. O days! DAYS! Roll along. Tell the children I loved their letters. I long for my family again.'

He would still illustrate his letters with drawings of strange beasts, and in one letter he did a sketch of a man in a bed opposite him and captioned it 'Actually they're not as moronic as this.' In one of his letters is the heart-cry, 'O Maeve—may this *never* happen again.'

As time went by, he regained his confidence, and in a letter written on 9 June he was able to say: 'I have had my best morning's concentration so far.' He could write about his love for Maeve and the family, discuss the portents of a letter from his publishers, and end optimistically: 'The golden gates have begun to swing slowly open.'

But he was still concerned about what he considered to be his failure as a provider. On Wednesday 18 June, when Maeve had to go to the Artists' Benevolent Fund for help, he wrote:

Today is the day on which you have to go through the ordeal—
thanks to me and my lack of normal prudence and looking-
ahead-ness.

God knows I am ashamed of the ineffectual way I have gone about the business side of my life. All I can hope and pray is that we can re-capture lost ground at one imaginative burst. May all good things be with you today.

The Wallington house had become noisy with the exuberance of youth. Sebastian was now seventeen, Fabian fifteen and Clare nearly eight. Sebastian's prowess on the drums had led to the formation of a group. Although she was so young at the time, Clare remembered that

All Sebastian's friends seemed to be Teddy Boys. Their hair was plastered down with Brylcreem. Fabian, on the other hand, had shaved his head like a Red Indian. They had made a club in the air-raid shelter in the garden. They decorated it, and put stools in it. They had a record player and would spend hours there. I was too young to be allowed in the shelter.

Fabian also remembered the air-raid shelter:

It was under a mound. We put planks and earth over it and planted grass. It did not last long. One morning on going into the garden, we discovered that it had fallen in. Luckily we weren't in it at the time.

My father had a very broad knowledge of subjects. I remember he once told me about the stars. He said that there was a star so much brighter than the solar system that our sun would seem like a pinpoint against it. He said that it was called Beetlejuice. For years I thought that this was one of his inventions. It wasn't until I began to study the solar system in earnest that I realised that he was talking about a real star: Betelgeuse in the constellation of Orion.

Dr Robbins was not pleased with the treatment at Holloway Hospital. 'The hospital authorities,' he said, 'did not believe that it was Parkinsonism. Some of the treatment they were giving Mervyn aggravated the Parkinsonism, rather than improved it.' However, the hospital doctors did eventually acknowledge the fact that their patient was suffering from Parkinsonism, and, as this type of disorder was not in their province, they were obliged to discharge him. This they did on 22 August, and he returned to Wallington.

That summer, the whole family went to Sark. They stayed at the Dixcart Hotel, where Mervyn had, some years before, painted

the sign-board. For a time everything was, or seemed to be, as it used to be. There were picnics on the beach, scrambles over the rocks, family life again. Sark, like Spain, had a therapeutic effect on Mervyn. The happiness of the past was recaptured, held and treasured for a few weeks. When they got back, he seemed better, and yet he was not really better. He started work again at the Central School of Art, where his job had been kept open while he had been in hospital. He would travel, with increasing difficulty and slowness, to Holborn, and return in the evenings exhausted and yet unable to rest.

Hans Tisdall, a fellow teacher at the Central School of Art, recalled:

> Morris Kestelman [the departmental head] was wonderful. He held the job open for Mervyn against the whole weight of the 'establishment'. He would cover up for him, but though Mervyn's movements were slow, and he had this strange trembling, he taught just as well as before. He had all his humour with him too.
>
> It has always seemed to me that people have never given enough credit to his wife. She was always gay, attractive and very feminine. Yet she must have had an enormous reserve of strength to have survived this terrible time, while at the same time bringing up a family on almost no money.

The money was becoming more and more of a problem. The Artists' Benevolent Fund had made a payment of £155.18.0d. in July, for the education of Clare, but there was very little else coming in: £5.5.0d. for a Christmas card designed in full summer; royalties on the earlier *Titus* books of £1.18.9d.; a *Radio Times* drawing for £8.8.0d.; a tax refund of £41.0.8d. There were gifts from Maeve's sister, Ruth, and from Billy Thorne, an old friend of the family, while Lady Moray, whose friendship with the family continued unchanged through all their troubles, put them in touch with a Trust designed to help the needy. It was able, from time to time, to send them much-needed funds.

The Waddington Gallery had moved from Dublin to London, and now it mounted a new exhibition of Mervyn's work. When the show opened he was in hospital again, this time in the National Hospital in Queen's Square, for yet another series of tests to determine what was really the matter with him. The doctors here came

to the conclusion that he was suffering from something more than the after-effects of a nervous breakdown, but they were not able to come up with anything more definite than that it was a case of premature senility. This was announced to Maeve with awful brutality, in a crowded hospital corridor, by a doctor who was probably in too much of a hurry to be tactful.

However, Mervyn was allowed out for the Private View of the exhibition, and the revival of interest in his pictures undoubtedly did him a lot of good. His work was well received; he was back in the world he knew; the nightmare consequences of *The Wit to Woo* and the inexplicable slowing down of his abilities, which he did not understand any more than anybody else, were for a little while forgotten. More important was the appearance on 5 January 1959 of a cheque from the gallery for £100.

Colin Gordon, who had played the lead in *The Wit to Woo*, and his wife, Gwen Cherrell, took Mervyn and Maeve back to the hospital in their car. They had driven Maeve down to Virginia Water to see Mervyn two or three times, and remained good friends despite many difficulties. At the same time, the bursar of the hospital arranged for both Mervyn and Maeve's paintings to be hung on the walls of the hospital. As the pictures were for sale, some much-needed extra cash came to them in this rather unexpected way.

CHAPTER 19 Diagnosis

In the summer of 1959, a letter arrived from the BBC suggesting that Mervyn should do a set of drawings for the 'Monitor' programme to illustrate some of the characters in *Titus Alone*, which was shortly to be published. The televised programme would have a sound-track of Mervyn's voice superimposed upon the visual programme, explaining his attitude towards his art and other matters. He might still have been able to produce the necessary drawings, even though his reactions were slower, and his memory, even of the characters he had created, was defective. Maeve would have been there to remind him. But his speech was now slurred, and sometimes it was difficult to understand what he was saying. These defects would have been magnified by the process of recording, which tends always to exaggerate a defect, and the 'Monitor' suggestion was dropped.

His movements were also affected by the progressive march of his illness. His sense of balance would suddenly desert him, and he would lurch and fall against objects and people. This could often lead to embarrassing misinterpretations. One evening, when he and Maeve were at the Mermaid Theatre, they went, during the interval, to the bar. A theatre critic was there. Mervyn, who knew him slightly, went across to him to say hello, but the critic, mistaking the lurching gait and slurred speech, turned away, saying: 'The man's drunk.' He was not to know that Mervyn had had nothing to drink, and that his condition was due to illness. The rebuff hurt, particularly as Mervyn was only half-aware of his own condition,

and to Maeve, watching nearby, the comment seemed unnecessarily cruel.

But still the doctors could not decide what was really the matter. There was still a tendency to believe that this was a result of the nervous breakdown of two years earlier, perhaps even a deliberate withdrawal on his side after the failure of *The Wit to Woo*. More tests were applied, more pills were prescribed, more expense was incurred at a time when, owing to lack of commissions, money was even more difficult to find. The National Health Service was of no use: as no one could say, in advance, what Mervyn was suffering from, its bureaucratic machinery could find no way of testing him, and nearly everything had to be done through the more flexible channels of private practice.

Titus Alone was published on 29 October. It received good reviews and was accepted as the final book of the trilogy, because the publishers said that it was. The reviewers were becoming more discerning. John Davenport, for example, realized that this was not a 'gothic' trilogy set in a remote area of human experience, but a description of 'real life'. It was a conception that was still hard for the general public to accept. As the reviewer in the *Cork Examiner* commented pertinently:

> The public at large will, I imagine, take a while to warm to Peake's disconcerting vision. This trilogy is a work of art so far outstripping the fashionable that it will be some time before a popular audience can adjust itself to its particular world.

In its three volumes and 1,276 pages, the trilogy had now covered the first twenty-one years of its hero's life.

> Mervyn never intended to write a trilogy [said Maeve later], nor were the books only to be about Gormenghast. There was to be the developing theme: the life-story of one person; perhaps loosely based on his own life. I think he intended to take Titus on to old age and death. I don't think he ever intended Titus to return to Gormenghast, just as he, himself, could never see himself returning to China. But, just as he retained always a memory of his distant childhood in China, so Titus would always have kept with him the memory of his childhood at Gormenghast.

The twice-weekly journey to the Central was becoming more and more difficult to undertake. Mervyn would lurch dangerously

close to an oncoming train. At times, he would forget where he was going. The fretful old man's shuffle, so characteristic of Parkinson's Disease, was now more pronounced than ever.

His daughter, Clare, was now at the Convent of St Philomena nearby. She and her best friend Elena used to pray for his recovery. Once they stood as a penance, with their arms outstretched, mutely appealing to God to intervene:

> I thought of making a pilgrimage to Lourdes. The whole school prayed for him. All the nuns were in love with him, and prayed for him too. Elena and I used to tie up his shoe laces for him, as he could not do it himself anymore. We used to race each other to see who could finish first.

By 1960, it was evident that Mervyn's illness was nothing to do with the breakdown of 1957, which had in some ways distracted the doctors' attention from the real symptoms: some kind of destructive physical agent was at work. Some now agreed that it might be Parkinson's Disease, but others thought it might be a rare germ picked up in childhood in China, and only now emerging. But even though the doctors might at last be identifying the illness there was no sign of a cure.

For some time now, a move from Wallington had become desirable. It was not just because of the twice-weekly journey to London: there were other reasons which made such a move both necessary and attractive. Wallington was not a district that any of them, even Mervyn, really loved. The house was convenient; it had large rooms; there was a fine garden, but the district remained alien. The problem was that the Peakes had never been offered more than £1,000 for it, and there was no alternative available at that price. By early 1960, however, Wallington began to engage the attention of the developers. Old properties were being bought up, with a view to pulling down the Victorian houses and building blocks of flats on the vacant sites thus obtained. Land values increased. So it looked, at last, as if with luck a better offer might be received.

While this matter was being thought about, a letter arrived from the Folio Society, concerning the possibility of illustrating Balzac's *Contes Drolatiques*:

February 2, 1960

My dear Peake,

Confirming our conversation today, we shall be very glad if you would go ahead with one or possibly two specimen drawings for the *Contes Drolatiques*.

It was suggested that these should be drawn in black and blue-grey for reproduction by two-colour line, i.e. using flat colour rather than tone. You summed up exactly the feeling of the book with the word 'rumbustious' and I should prefer at least one specimen drawing to show this rather than the more macabre side of the stories. As you say, a fairly free and vigorous treatment is required and I do not think that the drawings should be squared up though I should be glad if they could approximate to a type area of about $7\frac{1}{2}'' \times 4\frac{1}{8}''$. Subject to my Board's approval we would suggest about twenty-four full-page drawings for the book for which we could pay a fee of about £10.10.od. a drawing, the originals to remain our property.

We should need the completed work by the end of June and one drawing for our Prospectus by the end of April.

I much look forward to seeing the preliminary drawings in two or three weeks' time.

<div align="center">Yours sincerely,
Charles Ede</div>

P.S. I forgot to mention this afternoon that our usual arrangement is to pay 50% of the fee on delivery of the work and 50% on publication, to be not later than March 1961. I hope you will be agreeable to this.

It was an interesting proposition, even though the fee for the work was modest enough. The problem was that Mervyn, who had once found it so easy to concentrate, now found it almost impossible to retain a passage long enough to transpose it into a drawing. It was necessary for Maeve to read the passages to him so that he could prepare the two pilot drawings in time for Charles Ede to show to his Board.

One day, Maeve's brother, Roderick Gilmore, came to them with an offer. He was in the property business, and his firm was prepared to pay £8,000 for the Wallington house. They accepted,

and, with the promise of this—to them—fabulous sum, they started to look for a house in Chelsea, where they longed once more to be. The first one they looked at was too dilapidated, but the second one, in Drayton Gardens, S.W.10, looked promising. It had once been the home of Clemence Dane, the playwright. It had enough large rooms for the paintings, a small garden with a walnut tree at the back, and a bay tree in front. A laurel hedge sheltered it from the road, and it was near enough to the Fulham Road and other centres of creative activity to be alluring. They nearly lost it through neglecting to sign the contract, but their devoted solicitor, who had helped them over the Wallington house, went briskly into action to save them.

While these negotiations were going on, a letter arrived in March and ran as follows:

> 25a Royal Avenue
> Chelsea
> London S.W.3.

Dear Sir,

I am taking the liberty of enclosing a copy of the current number of *Two Cities*, an Anglo-French magazine of which I am the London Editor, and also help to publish.

For the summer number I am planning a feature to be called 'The Artist in England' in which my idea is to ask three, four or more artists/writers/musicians the one general question, 'What is it like to be an artist in modern England?' I approach you as an artist rather than as a writer for no special reason other than I am also approaching David Jones, and would like to include you both in the same number. The first of this short series will, I hope, be devoted to painters and sculptors, and I would be delighted if you would be willing to contribute, say about 1,000 words on this theme, answering the question in whatever way you choose.

I have to admit that *Two Cities* operates on a fairly precarious budget, and although I would be delighted to pay you for this, we are not in the position to pay a great deal. Perhaps, if you agree, you would be good enough to suggest a sum.

I greatly look forward to hearing from you.

> Yours truly,
> Edwin Mullins

This sort of work was, however, beyond Mervyn's capacity, but Edwin Mullins received a polite letter in reply suggesting a meeting.

There were still moments of recognition and appreciation. On 29 March, Mervyn received the following letter from the Oxford University Press about the design of a book jacket which he had produced with great difficulty:

> Dear Mr Peake,
>
> Your design for the *Dickens World* is really quite beautiful and should look quite first rate with lettering added. You shall see a proof and we will do our best to keep as near to your fog colour as we can.
>
> A cheque for twenty guineas will be with you within the next few days with our warmest thanks and I hope that before long we may be able to offer you something else to do for us.
>
> <div align="center">Yours sincerely,
John Bell</div>

At about the same time, Edwin Mullins was reading the courteous letter he had received from Mervyn:

> I had been daunted by the thought of what kind of man could be the author of the *Titus* books, and where on earth the creator of *Gormenghast* might live. The answer turned out to be Wallington, in Surrey. The letter explained that he had been ill over the past two years, but that if I did not need it in a hurry he would be pleased to write me something . . . more than ten years afterwards I realised that it was actually Maeve Peake, Mervyn's wife, who had written that letter, Mervyn being already too ill to write.

She was, in fact, taking on more and more responsibility for conducting what work he could still do. At the time, the sale of the Wallington house was being finalized, and, as if this were not enough, she was preparing an exhibition of her own paintings to be held at the Woodstock Gallery in London. Canvases had to be chosen, frames made, prices agreed, and a catalogue compiled.

In May 1960 the Peakes moved at last, with their usual paraphernalia of books, cats, paintings and curious pieces of furniture, which now included Fabian's stuffed birds and the vertebrae of a whale washed up in Sark. They left behind a few broken-down sofas and chairs, much to the appreciation of tramps who made

the Wallington house their home for some months, before it was pulled down and replaced by the inevitable block of flats.

The house in Drayton Gardens was in a good condition of repair, even though the green trellis design of the wallpaper in the hall was not exactly to their taste, and some of the paintwork was dull. However paintings and drawings were quickly hung wherever there was a spare place, and blemishes were soon hidden. Books filled up the whole of one side of the sitting-room and, between the tall and elegantly shaped Georgian windows that led on to a small balcony, a much-loved painting hung. In a very short time Maeve and Mervyn had re-created the combination of family home and artist's studio that was so typical of them.

Mervyn's concern about his family was as strong as ever. Clare recalled later:

> He used to tell us that we should all look after each other. He never thought about himself or his illness. I remember once, just before my eleventh birthday, I was crying in bed because I had taken one grape from a fruit-shop, and thought I was the most wicked person in the world. He came and comforted me and, in order to cheer me up, told me that I would soon be eleven, and could then go to confession, and the sin would be wiped out. That was strange, as he was brought up in quite a different religion, although I did not realise this at the time. I remember he took me once to mass at our local Catholic Church on Christmas morning. I was so embarrassed because of course, not being used to the Catholic service, he did everything wrong. I tried to pretend I wasn't with him. But he was always kind and gentle to me. Even when he was ill he used to take Elena and me out to play football which, though we were girls, we loved. I only remember him being angry with me once, and that was when I was reading a book, and in my eagerness, licking my finger and flicking over the pages. He told me very severely to stop doing that. He said, 'You must always treat books with care.' And, since then, I always have.

Edwin Mullins, who had received further courteous letters from, as he then thought, Mervyn, was now able to arrange a visit with his wife. Maeve opened the front door and led them upstairs to the drawing room:

The stairway was flanked by dozens of framed drawings, some of which I recognised from the books I had read as a child. In the sitting room hung illustrations for *The Ancient Mariner*, and some large canvases. Mervyn, himself, was not there. 'If you will wait just a minute I'll go and call him,' Maeve said quietly. She was away quite some time, but after a while I heard slow footsteps on the stairs and the sound of Maeve's voice repeating several times in a low voice our names and why we were here.

Mervyn eventually shuffled into the room, a stooped, lean man with greying hair, looking rather bewildered. He held out a hand, muttering something I could not catch. Maeve led him over to a chair and kept up a conversation. Mervyn contributed nothing for a long time, while we felt increasingly uneasy at being there at all. Then he did say something—I have forgotten precisely what it was—but I remember it was so startlingly funny that we all burst out laughing, whereupon Mervyn relaxed into that marvellous shy smile of his which, all the time I was to know him, was always liable to break through the fog of his illness and pain at the most unexpected moments.

In the meantime, the Folio Society had accepted the pilot drawings, and it was now a question of producing the rest of the illustrations. As Mervyn could not read the text, Maeve sat with him in the room on the ground floor which was his work-room, and went through each of the stories slowly so that he could get the idea, and produce a drawing. But his memory was so defective that after a few moments he would forget what he had heard. Maeve would then re-read the passage to him. From time to time his grasp of his brush would weaken, and it would fall to the ground. She would pick it up for him and they would start again, laboriously, side by side at the big table in the room, trying to complete the drawings in time.

In one corner of the room was the Chinese piano that had come all the way from Tientsin with Dr and Mrs Peake. Maeve would go to it from time to time and play a Beethoven sonata, or perhaps some of the nursery-rhyme music she had collected. 'Mervyn was a wonderful person to play for,' she said later, 'he knew very little about music, and so never noticed the mistakes I was making, and

always thought I was a very good player, which, though inaccurate, was nice.'

The drawings were eventually finished and sent off. In Maeve's account book, against the date of 13 August 1960 is the entry, 'Folio Society illustrations: £127'. It was the first instalment of the promised payment. The remainder would come on publication.

CHAPTER 20 Slowness and uncertainty

By now Mervyn's illness was increasing its grip. When he lay down, he wanted to get up. If he were up, he needed to lie down. He would walk about, light cigarettes, move clumsily about the house. His balance was so uncertain that he was in constant danger of falling down the steep, narrow stairs of the Georgian house in Drayton Gardens. Yet he was still going to the Central School of Art. He was still selling a few drawings here and there, and the royalties, rarely over £30 or so, were coming in from his books.

The poet in him survived the onslaught of the disease for a little while longer. Though his handwriting was distorted now by the sudden trembling of his hand, the thought was clear, as this poem, written to Maeve for her birthday in 1960, shows:

For Maeve

Now, with the rain about her, I can see
This is her climate, O my aqueous one
How you do scorn the bright beams of the sun!
How you do drink the wet beams of the sky!

Her head is glimmering in the slanting strands
It is her climate for the storm is making:
While others bask, she wanders to her slaking,
How rare she is, her brow, her breast, her hands.

From Mervyn

Fabian, Maeve and Mervyn in Drayton Gardens, 1960

The University of Indiana asked Mervyn to become 'artist in residence' there, and when he could not accept the invitation they invited Maeve. It would have meant a considerable lifting of the financial burden, but she refused to leave her husband and he was too ill to go with her.

It was obvious that something would have to be done about his worsening condition. He longed for a cure. He felt that if he could only regain physical control of his body, he would be able to write, paint and draw as vigorously as before, for his ideas were still as strong as ever. The frustration of not being able to express them was filling him with a despair that would be revealed from time to time in terrible soul-racking sighs.

A schoolfriend of Maeve's called Joss had married a man called Stephenson. They lived in Kent, and the early convent friendship had been renewed during the Smarden days. Stephenson had Parkinson's Disease, and had had an operation. The resulting

improvement had been astonishing, and so Maeve went to Dr Robbins and asked his opinion. Dr Robbins said that he could not guarantee the result: brain operations were known to be risky, and no two people reacted in the same way. He did, however, arrange for an interview with a neurological surgeon. The surgeon was willing to perform the operation, but he, too, could not guarantee the result. He felt tolerably certain of being able to still the tremors, of bringing peace of mind to the patient, but he could say nothing of the rest. It was for them to decide.

Mervyn was in favour of the operation. Anything seemed preferable to the present frustration and misery. He begged Maeve, who would, the doctors said, have to make the final decision, to agree to the operation. It was a terrible decision for her to have to make. On the one hand, there was a man clamouring to be rescued; on the other, doctors gravely unsure. There were children to be thought of, a whole family's future to be decided. But Mervyn could not go on as he was and some remedy had to be attempted.

Christmas was approaching. In November, the second instalment of the Folio Society commission had been paid. There was thus enough in the bank to pay the surgeon—there was no chance of the operation being performed on the National Health Service—and the decision was taken. Arrangements were made for Mervyn to be admitted to hospital immediately after Christmas, and for the operation to take place as soon as possible after that.

Lonnie came up to London from Burpham, and he and Maeve spent the hours of the operation sitting, numb with anxiety, in a cinema in Victoria Street, watching a film called *Pollyanna*. Neither of them could ever recall anything about the film except its title, but the enveloping darkness and the close remoteness of the people around them formed some kind of a shield against their fears.

They went to the hospital after the cinema. They were told that the operation had been a complete success. There had been no difficulties, no complications. Already, to the busy surgeon, it was one more triumph to file away with the others, and Dr Robbins wrote to Maeve on 4 January 1961:

> I saw your husband yesterday and was satisfied with his progress. There is an obvious improvement in both the tremor and the stiffness of the right arm and he himself is in extremely good order. The only unusual feature is some difficulty with

his speech. He has a tendency to use the wrong word on occasions which is more noticeable than on previous occasions when I have seen him. The reason for this is probably a temporary reaction present in the brain tissues, which are bound to be swollen as a result of the surgical interference. I am hoping that this will completely subside over the next week or two.

Dr Robbins had started as an advisor and now he became both the family's doctor and its friend. He admired Mervyn's work, and he hoped for a cure almost as strongly as did Maeve. The Central School of Art was keeping Mervyn's job open for him in the hope that he might be well enough to return there in a month's time. But in Maeve's small account book appeared for the first time the ominous words 'sickness benefit'.

Sebastian celebrated his twenty-first birthday on 7 January 1961. It had been decided, before Mervyn had gone into hospital, that, whatever happened, Sebastian was to have a traditional twenty-first birthday party. This was duly organized with great care and the abundance of food and drink which was a feature of all parties at Drayton Gardens. There was music and dancing and singing, and a feeling of family happiness. There was sadness that Mervyn could not be there, but this was tempered by the knowledge that the operation had been successful and the hope that he would soon be fully recovered.

He came back about a fortnight later. It seemed for a little while that the miracle had happened. The tremors had gone. His hand was steady. The restlessness was abated. He tried once more to take up his writing, painting and illustrating, but though there was an improvement in the purely mechanical side of his body, the ravages that the illness had caused to his mind remained. Where once ideas emerged swift and clearly defined, there was now nothing but slowness and uncertainty. His genius was still there, struggling desperately to emerge, but the means of its expression were blunted. He was trapped within his own body.

There was no possibility of his return to work at the Central, and the long devotion of Morris Kestelman, and the care of his friends there, particularly Cecil Collins and Hans Tisdall, ended. But there was still some work to be done. One day when he was going through the big cupboard in his working-room on the ground

floor at Drayton Gardens, he came across a poem that he had written in Sark just after the war. It was called *The Rhyme of the Flying Bomb* and told the story of a sailor and a new-born baby who came together during an air-raid in London:

> A babe was born in the reign of George
> To a singular birth-bed song,
> Its boisterous tune was off the beat
> And all of its words were wrong;
>
> But a singular song it was, for the house
> As it rattled its ribs and danced,
> Had a chorus of doors that slammed their jaws
> And a chorus of chairs that pranced.

A sailor finds the baby, and takes it into his care. They shelter in a blitzed church, but the flying bomb seeks them out. Humanity's compassion, displayed by the sailor, is the baby's, and therefore the world's, only hope of survival.

The poem was sent to H. M. Dent and was accepted for publication, on condition that it was illustrated by Mervyn. An advance of £45.0.od. was paid on 24 April. Then came the problem of preparing the drawings.

If the illustrations to Balzac's *Droll Stories* had been hard to produce, these were a thousand times worse. Mervyn could not seize or retain an idea or thought long enough to convert it into a drawing. With the Balzac book, it had been enough, tedious though it was, for Maeve to select the necessary passage: he could still retain an idea long enough to get it on to paper. Now, she had to remind him how each line should be done. He would forget the beginning of the verse—the words he had written—before she had got to the end of it. The felt pen would drop from his hand. The movement that used to be so assured would falter and stop. He would begin a line and then let it slither away to nothing. The restlessness had come back, though without the tremors. He would get up and stumble about, go out, fall. Maeve would help him up, see that he had not hurt himself, and lead him back to the work-table. Each illustration was built up, painfully, slowly, stroke by stroke, until at last the twenty-two drawings were completed and sent off to the publisher.

Mervyn had been going regularly to see the surgeon who had done the operation, for post-operation checks. The surgeon was satisfied that the tremors had ceased, but it was becoming more and more evident that the hoped-for cure was as far away as ever. Indeed, there was now a feeling that a cure was out of the question.

They had an introduction, through the agency of Walter de la Mare, to Sir Russell Brain, later Lord Brain, the specialist on brain operations. Sir Russell's view was simple: Mervyn should not have had the operation.

> That, [as Maeve said later] was his opinion. No two doctors ever seemed to agree. But it was too late now. If he had not had the operation, I think the *realisation* of what was happening to him would have been too terrible to bear. After the operation, the realisation was blunted; to that extent, at least, the operation was successful.

In May 1961, Maeve went by air to Germany for a few days on family business. Mervyn stayed with Ruth and Lonnie Peake at Reed Thatch. It was a very hot May. Fabian, in a letter to his mother, wrote: 'I've just come back from meeting Dad at Victoria. He is fantastically sunburnt. He looks (now) as though he has been to the South of France. You see we have had exceptional weather over the past four or five days.'

Mervyn wrote every day, sometimes twice a day. The envelopes were pre-addressed by Maeve. His handwriting starts off clearly enough, though it is very fragile, but trails off towards the end of the letters as if the illness can't be kept away any longer. The tone is gentle and loving: '. . . it really is a perfect day. . . . I long for you in my arms. That's where I want to be—deep in your arms. What of the journey by air. O darling. Did you feel funny. . . . This *is* a choice spot . . . a place where we could be happy . . .' He included a drawing of one of his strange beasts climbing a mountain.

In another letter, written later the same day, he notes: 'I am leaning up against the trunk of Doc's favourite pines. The sun is fled along the gardens. We are all fed and fine.' Two days later: 'Again a lovely day. A bit more mist than usual. I am thinking of you all the while. Today I look out and feel the world is terrific . . . something like a dream. Come to me, sweetheart, with your hair of barley.'

The physical manifestations of his illness increased; on Maeve's

return to Drayton Gardens, life became hard to bear. He had to be dressed, shaved and fed. He had to have somebody with him the whole time, in case he fell and hurt himself. He could not sleep at night, but would get up and wander about the house. He had a curious need, when he did get back to the bedroom, to make the bed over and over again.

Maeve was being worn down, too. Though friends like Sue French and Lesley Wentworth would take over for a while and allow her some time off, they could not stay long, and the engagement of full-time nurses, both for day and night, was the only solution if he were to be kept at Drayton Gardens. This was far beyond their means, and the only other solution was to find a hospital. Maeve appealed to Dr Robbins and he promised that he would do what he could. A little while later he came and told her that the only National Health Service hospital that would take her husband was the psychiatric hospital at Banstead, Surrey.

> I was horrified when I heard this [said Maeve]. The trouble was, as before, that there were no adequate provisions on the National Health Service for people suffering from Parkinson's Disease. But, because he had had a brain operation he qualified for admission to a psychiatric hospital. My sister, Ruth, hired a car and drove us there. It was a terrible place, although it did have lovely grounds. The staff were kind and helpful. After a while, the doctors at Banstead wrote to Dr Robbins and said that, as there was nothing mentally wrong with Mervyn, it would not be good for him to stay there. After that, I swore I would never let him go to a place like that again.

In the meantime, production of *The Rhyme of the Flying Bomb* was going ahead. Maeve was now the one to whom the publishers wrote, and who was responsible for getting Mervyn's agreement on any alterations required. On 15 August, F. Martin Dent wrote:

Dear Mrs Peake,
 The Rhyme of the Flying Bomb
 Thank you very much for returning the proofs which I sent to you. We shall go ahead with the next stage of the proofs in the text in grey, and we will also let you see our suggestions for the jacket before we go ahead. I am glad Mr Peake likes the drawing which we had reversed from black to white. If we use

this for the jacket we can use the sailor's head on the title page.
I don't think it would matter using it there as well as in the
appropriate position in the text.

I do hope Mr Peake is going on well in hospital. Please give
him my best wishes when you next see him.

Yours sincerely,

F. Martin Dent

The work of preparation went on, and by the autumn the book
was ready, numbering forty-eight instead of the original sixty-four
pages. The meticulous care that poetry requires had been given to
it, and the illustrations looked good. By January 1962, the shade
of ink had been agreed upon, the binding found satisfactory. Later
in the spring it was published. A copy was sent to Mike Moorcock,
the science-fiction writer who had been an admirer of Mervyn's
since the age of sixteen.

> It was [he said] a case of hero-worship on my side. I wrote to
> him, and finding that I lived nearby was able to call on him.
> He was my ideal of a writer: utterly without self-consciousness,
> and with a tremendous discipline over his imagination. In his
> writing he always had complete control of his characters. It
> was the same with his drawings. Unlike Arthur Rackham,
> who let his imagination take over, Mervyn's line was always
> controlled.

Their meeting had developed into an enduring friendship. On
receiving his copy of *The Rhyme of the Flying Bomb*, Moorcock wrote
to thank Mervyn and Maeve:

> Reading it again, I was so engrossed that I went several stops
> past my destination on the bus. I hope Pasternak's volume of
> poetry does not get all the review space—but there is a likeli-
> hood that the two volumes will be reviewed together.

Though so much of his work was becoming unobtainable or out
of print or not being re-issued, Mervyn still had his followers. One,
for example, was the gentleman from County Durham who posted
this letter to Mervyn:

> Dear Sir,
>
> I have NOT read all your works; I have only read the
> Titus tetralogy; but the primary reason for this is that your
> other works are generally unavailable. But what I HAVE

read is magnificent: it is a tapestry, densely woven, in red gold and silver-green, smelling of old spices.

It is because of my admiration that I ask for an autographed photograph of you: I want to see the man behind the book, causing, I hope no inconvenience. A handwritten letter from you would be blue and yellow wine to me.

As a tailpiece, the address is a Mirror of my egotism; I am not MISTER but MASTER; I am only fourteen. I HATE flaunting my age!

Please do not disappoint me.

Thank you.

> I am,
>
> Yours,
>
> J. N. Gray.

He was duly sent the signed photograph and a handwritten letter, but as Mervyn could hardly write a word, it is more than likely that the writer was not the one he imagined.

There had been very little response from the reviewers to the publication of *The Rhyme of the Flying Bomb*. Mervyn, who had been living at Drayton Gardens since his return from Banstead, was now at an expensive convalescent home for a few weeks, and Maeve, who was going to visit him, wanted to bring him some encouraging news about the book that had been such a struggle for him to complete. But she was not able to get the news in time. Instead, the following letter arrived the next day:

Dear Mrs Peake,

I tried to ring you a few minutes before ten this morning, but there was no reply or again shortly afterwards, so I had to assume that you had gone a little earlier than you had anticipated. I am sorry that you didn't have such information as there is for your husband though I am afraid there isn't a lot to report. We sent out 57 review copies in all, but up to the moment, apart from the *Guardian* which you have seen, there have only been reviews in the *Illustrated London News* and the *British Weekly*. I am afraid I haven't copies of these by me at the moment, but if I can get hold of them, I will let you see them.

I am sorry to hear that Mr Peake is away in a convalescent home and I hope that he is making good progress.

> Yours sincerely,
>
> F. Martin Dent

CHAPTER 21 The years of neglect

Now began the years of neglect when, as he sank slowly beneath the increasing burden of his illness, the outer world chose to forget Mervyn. His books were out of print or had been sold off cheap in bulk; there was no new work coming along; the galleries were not interested. Maeve would take along some of his drawings or paintings and line them up under the gaze of a supercilious assistant. There would be the shake of the head, and the paintings and drawings would be gathered up and taken away. The words 'sickness benefit' occurred more and more frequently in the black cash-book.

There was some help. The Royal Literary Fund donated £250, and Maeve's sister Ruth contributed £450 towards the hospital fees that were becoming increasingly heavy. There was no longer any pretence that a cure might be effected. This new form of Parkinson's Disease had got too strong a hold. Though it confused his nervous system and shadowed the creative part of his brain, it left untouched the mechanical side of life; indeed the restlessness that made it impossible for him to stay still, kept him in good physical condition. There was no fear of his developing unnecessary fat: at fifty, he was as lean and spare as he had been at twenty.

He had to be looked after twenty-four hours a day, and this could not possibly be done at home. The National Health Service could only offer another Banstead, and Maeve was determined to avoid this if she possibly could. When she began making enquiries at private hospitals, she found the old difficulty: so little was known

about Parkinson's Disease that even an organization like the Cheshire Homes could not take him: unlike the severely handicapped, he was extremely mobile—excessively so. He might have to be fed and dressed, but there was nothing the matter with his legs. He could and did move continuously, and this told against him. When he went to a nursing home in Brighton in order to give Maeve a rest, she was asked to take him away after a few days because his restlessness was disturbing the other inmates. He went to Northampton hospital—where the poet John Clare had once been—for six weeks, again to give his wife a necessary break. Nuns in Lambeth could not keep him. He was, for a while, a National Health patient at the Westminster Hospital.

> I used to visit him every day [recalled Maeve]. He was put in
> a room with a man who was in a coma, and who was in a bed
> that was like a child's cot, with high rails all round.

He was there for several weeks until the drugs were changed to alleviate the great restlessness, and then he returned to Drayton Gardens, where, sometimes, a member of the Red Cross would come and sit with him. One such occasion was when Maeve had to attend the private view—her second—at the Woodstock Gallery. When she returned, the woman from the Red Cross said, 'I don't know how you manage on your own. If I come again, I'll have to bring a companion.'

He would still go out occasionally. Elaborate arrangements were made with the local shopkeepers. There was a tobacconist, Bobby's, on the corner of Old Brompton Road and Bina Gardens. Mervyn would go there to buy a packet of cigarettes, and as he could not manage money any more, the tobacconist would collect the money from Maeve later on. Sometimes he would go as far as the hair-dresser's near Gloucester Road underground station. Here, the two barbers, who looked like twin brothers doing a double act on an old music-hall stage, would cut his hair. Once again, there would be the same arrangement concerning payment. Sometimes he would walk, in the strange urgent shuffle that is typical of the disease, to the Fulham Road, and stop at the Old St Gothard Café, opposite the cinema, for a cup of tea. Again, payment was on a credit basis. He had around his wrist a bracelet with his name and address on it, and complete strangers would appear at the Drayton Gardens address to bring him home.

Two years after the publication and failure of *The Rhyme of the Flying Bomb*, the BBC decided to broadcast a version of the poem on the Third Programme. The music was by Tristram Carey, and the essence of the poem—the dialogue between the sailor and the new-born baby, whose wisdom was far in advance of its years—was spoken by Marius Goring and Marjorie Westbury. It was received with ecstatic reviews, the first sign of appreciation for years.

Mervyn's friends, led by John Brophy, the writer, now decided to help. Brophy's idea was to set up a trust. Income from it would be available to pay the fees of any private hospital that might admit him. Brophy threw himself with great energy into the scheme, and wrote to everybody who came to mind. He asked Kenneth Clark (later Lord Clark) to be president of the trust. Many people expressed their approval of the scheme, but few came forward with any real promises of cash, and in the end, John Brophy collected only four cheques of £100 each. One was from himself, one from his daughter Brigid, one from Iris Murdoch and one from Lesley Wentworth. These were sent to Maeve.

After a period of thought, she returned them to the senders. 'They must,' she said later, 'have been very upset; and I couldn't explain to them that the setting up of a trust in recognition of Mervyn's work was one thing. Accepting personal charity was another.' Mrs Brophy recalled that her husband '. . . was very upset at the time; especially as he had put so much work into the scheme; but, in the end, he understood Maeve's feelings. It was such a small sum, it would not have helped much anyhow. They both deserved better than that.'

There were still sporadic attempts at writing. Mervyn had begun the fourth of the Titus books. There are in existence the first three or four pages of this new work. In them, Titus wakes up in a hut on a mountain in the snow. Then the writing stops. A clue to what would then have happened is contained on a single sheet of paper, headed:

TITUS among the—

Snows	Fires	Affluence
Mountains	Floods	Debt
Islands	Typhoons	Society
Rivers	Doldrums	
Archipelagos	Famines	
Forests	Pestilences	
Lagoons	Poverty	

Soldiers	Monsters	Pirates
Thieves	Hypocrites	Mermaids
Actors	Madmen	Dreamers
Painters	Bankers	Decadents
Psychiatrists	Angels	Athletes
Labourers	Devils	Invalids
Eccentrics	Mendicants	Blood-Sportsmen
Lepers	Vagrants	
Lotus Eaters		

Shapes	Sounds	Colours
Echoes	Tones	Scents
Textures		

It seems that a picaresque novel of movement was intended. The first set of three columns shows the places Titus would have visited, from the snows and mountains, where the book opened, down to islands, rivers and lagoons. The second set of names seems to indicate the characters Titus was to meet on his journeys. The third set shows some of the themes of the book. There was no indication that Titus would have returned to Gormenghast, but like all grown men moving through life, he would undoubtedly have retained the memories of his childhood.

Mervyn still had a need to write poetry, though even by 1962 his writing had become so bad and his means of communication so hampered by his illness that nothing emerged from what in his mind was a complete poem but this:

O light of love where are you gone away
O light of love
For it is love that haunts me
Night and day
O light of love

From East and West where are you escaping?
O ————
O ———— and ————
From ————
From emptiness in the North and South
O light of love

The pigeons are the one ——, these pigeons
But what ————
O Maeve, O my Sweet Maeve
Roar in the wind, an in a
Along the ——— burgel the burgel light
—————————
————————
———————— and eyes
Chained in a chain ———
O ————————
O light of love

Love of my life, life of my ——
———————— gold
My ——————
O light

Even these disjointed and scarcely legible notes soon gave way to incomprehensible lines that were no longer sentences, words or even letters, but the meandering scribbles of a seismograph.

The ability to draw remained longest. Edwin Mullins recalls an evening that he and Maeve spent with him and his wife at their flat in Redcliffe Square. Mervyn had sat, head bowed and in silence, for most of the evening, and then suddenly:

> he made a motion towards Maeve, and as she leant over him he indicated that he wanted some paper and something to draw with. My wife produced a sheaf of quarto typing paper and placed a ballpoint pen in his hand. We went on talking

while he sat with the sheaf of white paper on his knee.

Then I noticed that his hand had ceased its normal shaking, and that he was sitting upright with the paper held firmly, concentrating. For more than an hour he seemed to lose touch with his illness altogether . . . And then the spell was broken. He dropped the pen, and his hand began to shake again. Nevertheless Mervyn looked highly pleased, and very weary.

Before he left, Mervyn, with his usual generosity, gave the whole sheaf to Edwin's wife. For some years after this the moment of artistic ability would occur occasionally, and he would draw again.

Fabian was now at the Chelsea School of Art and had met Phyllida Barlow, who was also a student there and later became his wife.

Everyone at the school [recalled Phyllida] knew that there was something the matter with Fabian's father; but his illness was so mysterious that nobody knew what it was. It was even rumoured that he was an alcoholic, because of his slurred speech and uncertain movements; yet he never drank anything. When I first met him, I was terribly upset. I was very young and self-assured; and, coming from a medical family, felt that something could and should be done to save a man of such great talents. Doctors, nurses, everyone showed terrific good-will, but seemed to be getting nowhere. In my frustration, I think I must have been very brash, telling people what they should do, and how they could save him. It's only now, with hindsight, that I realise that nothing could save him and that there was no cure and that he was condemned from the beginning.

Although there were harrowing days, there were also hilarious times, though it may sound strange. His sense of humour and fun would break through at odd moments. I remember once when Fabian and I were having dinner at Drayton Gardens, he went into the airing cupboard in the corner of the room, and then came out, as if he were making an entrance on the stage, impersonating a corporal or a general, or some other military character, and kept us in hysterics of laughter. And for a while we would forget his tiredness, his restlessness, his susceptibility to illness, and the many times he had to be supported upstairs.

Quentin Crisp recollected that soon afterwards

> I was crossing the square when I saw Mrs Peake supporting an old man. She didn't have her arm in his. She was taking his whole weight. She hadn't changed a bit. She looked just the same as when I had last seen her. As I passed, I realised that the 'old man' was Mr Peake. He said, 'Oh look; there's Quentin.' I think that it was soon after this that he went into hospital for the last time, and I did not see him again.

Mike Moorcock remained a friend of the family, and his admiration for Mervyn continued unchanged:

> Despite his illness, he still retained his sense of fun. I remember visiting him in hospital once with Maeve. He did a little dance on the lawn to cheer her up. Although I am certain he knew what was happening to him, he did not want her to be upset. Although it was harrowing to see him in that state, I enjoyed making contact with him again.

The search for a suitable hospital or nursing home continued. All kinds of friends and acquaintances, including Graham Greene's brother who was a doctor, wrote with suggestions. No solution was found until Dr Robbins suggested The Priory at Roehampton.

The Priory was a large, nineteenth-century building in Scottish baronial style, set in beautiful grounds in Priory Lane, near the Roehampton Gate of Richmond Park. A rather dilapidated wooden fence ran along the lane for about a hundred yards, when a gap gave a glimpse of a badly-tarred drive turning away to the left. This was quite short, and ended in an open space surrounded on three sides by buildings. The main part of the hospital was a tall, massive, grey structure, with a few windows punched indiscriminately in it and a medieval-style door. To the right was a long wing of the house, to the left a series of lower outhouses. It looked like a cut-price Victorian version of Gormenghast.

It was extremely expensive. The black cash-book for 1965 records this new financial drain with laconic poignancy:

24th March	The Priory	£108.8.5d.
18th May	The Priory	£178.18.0d.
14th June	The Priory	£118.9.4d.
24th July	The Priory	£114.6.10d.
12th August	The Priory	£118.11.7d.

20th September	The Priory	£118.9.4d.
13th October	The Priory	£114.14.4d.
4th November	The Priory	£119.2.10d.
1st January (for December)	The Priory	£94–19–4d.

Yet it was the only place for Mervyn. Here he was cared for and looked after; here there was comfort and civilization. The grounds were truly beautiful, and it was near enough to Drayton Gardens for frequent visits to be made. Maeve used to go two or three times a week. Sometimes she would go by bus, taking the number 30 down the Old Brompton Road, and then, changing to a 74, get carried across Barnes Common. She always dressed in her best clothes, and would carry a basket. In it there would be sweets, drawing-books and pencils. Sometimes Sebastian would drive her there; sometimes friends like Dagmar Blass, a Danish lady who lived in a studio house in Cresswell Place that was always full of paintings, good Danish smörbrod and hungry guests, would take her on Saturday mornings. Maurice Collis, and his daughter, Louise, went too. Maurice was so upset at the change in Mervyn that he wept.

One friend recalls driving Maeve there one morning, and then waiting for her to reappear:

> After an hour, the portico door opened, and she came, with her sprightly step, onto the gravel. I brought the car to the steps, and she got in. She still had her basket, but now it was empty. She did not say anything as we drove away, but as we turned out of the drive, I noticed that a tear was running slowly down her cheek. She did not talk until we were well clear of the Priory; then she said, wiping the tears away: 'I'm sorry. I always look forward so much to seeing him. Sometimes, he's quite well and recognises me at once, and gives me a smile. Sometimes, we even have a little dance. Today, he wasn't too good. He didn't want to do any drawing. He couldn't hold the pencils. They fell out of his hand. He threw them away. But he liked the sweets. He has a sweet tooth. And just before I left, he 'came back', looked at me as he used to do, and even said a few words. It was worth it, just for that.'

Mervyn at The Priory, 1966

CHAPTER 22 Further away

Despite the almost solid indifference of the art galleries to Mervyn Peake's work—one dealer offered £1,500 for everything he had painted or drawn, including the incomparable *Mariner* drawings and four hundred others—there began, mainly through his wife's continuous efforts, a slight stirring of interest in his writing. On 4 December 1964, Maurice Temple-Smith, who was working with Eyre & Spottiswoode, wrote to Maeve:

> I told you a little while ago that we were exploring the possibility of issuing the whole Titus Trilogy in a single volume. We have just had some estimates from the printer and my God . . .
>
> Unfortunately, all printers are raising their prices yet again next year and it would apparently be impossible to publish the trilogy under 50/- or perhaps 63/-. I am afraid this would be altogether too high for the fiction market and very reluctantly we have decided that the job just cannot be done. I am afraid this means allowing *Gormenghast* to go out of print. I wish we could avoid this but I just do not see how we can.

Although this was a negative and disappointing letter, it marked the beginning of a return of interest in Mervyn's work, or, perhaps more correctly, the end of the public indifference that had followed the failure of *The Wit to Woo* in 1957. But it was slow work. A year later, Temple-Smith was writing:

> I am still negotiating with the Macmillan Company of New York in the hope of redoing *Captain Slaughterboard*. At the

231

moment I am hung up because we can only find a single file copy which is in America and we need another to estimate costs over here. Have you by any chance got a copy I could borrow?

During this year Maeve had an exhibition in the Town Hall of Portmeirion, in North Wales, where Clough Williams-Ellis had built a complete Italian village on the foreshore of a Welsh estuary. Fabian drove a hired van with all the paintings in it to Wales. Though some pictures were sold, they could not hope to fill the devouring needs of The Priory.

By 1966, the stirrings of interest were beginning to take on some real substance at last. On 28 March Maurice Temple Smith, who was leaving Eyre & Spottiswoode, wrote before doing so:

Before I go I'll try to leave everything in order insofar as it relates to Mervyn's work. As you know, there are two things in hand at the moment and have been for some time. We are all set to publish a new edition of *Captain Slaughterboard* provided that we can arrange for the Macmillan Company in New York to buy a reasonably large number of sheets from us so the price can be kept down . . .

The other matter, of course, is the *Gormenghast* trilogy. I gather from Maurice Michael [Mervyn Peake's agent] that he has strong hopes of selling the American rights and I told him some time ago that as soon as he could do so and we could be certain of sharing production costs we would be very happy indeed to go ahead with producing the new edition. The probable form would be a single omnibus edition hard covers with paper back editions of each book printed from the same type.

There was an important postscript to this letter, which ran:

P.S. Since this was written we've heard that Penguin are interested in making an offer for *Gormenghast* and *Titus Groan* (though not *Titus Alone*). They have not yet put forward a figure but if they do and it's a reasonable one this would almost certainly be the best way of tackling the paperback publication. It wouldn't necessarily prevent hardcover republication by Eyre & Spottiswoode simultaneously or later on.

The American publishers were Weybright & Talley, and an agreement was reached to bring out a hard-cover edition of the

Titus books. More important still, Ballantines also agreed to bring out a paperback edition in America. The result in hard cash can be seen in the black cash-book:

| 27th August 1966 | Ballantine's advance: | £2,574.1.10d. |
| 9th December 1966 | Penguin advance: | £450.0.0d. |

This money meant that Mervyn's continued stay at The Priory could be assured, and that some of the overdraft at the bank could be paid off.

There was, too, a renewal of interest by the galleries. Two of his drawings, for example, were sold at the Portobello Gallery in May 1966 for £35 and £28 respectively. Later in the same year, the Upper Grosvenor Gallery put on an extensive exhibition of his paintings and drawings. The gallery was run by the Duchess of St Albans and consisted of two rooms, a large one in front and a smaller one at the back. The private view was a very elegant affair. Drinks were handed out by Ralph Lavers, a convivial painter and illustrator, who had a knack for making people feel happy. Among the many guests was Peggy Guggenheim's sister, Hazel McKinley, in so huge a rose-covered picture hat that it was something of a miracle that she could keep it on her head at all. The exhibition had a prestige success. Some of the paintings and drawings were sold, and the sum of £850 was paid in two instalments into The Priory account.

As forecast by Maurice Temple Smith, Macmillan of New York agreed to bring out in 1967 a new edition of *Captain Slaughterboard Drops Anchor* and paid £167 for it. From a financial point of view, 1966 was the best year for a long time. The irony of it all was that Mervyn's illness had now reached the point where, even when he was told about these events, he rarely showed the slightest interest. Even when, in 1967, Rota brought out a new book of poems entitled *A Reverie of Bone*, he did not show any reaction. But he did react to another publishing event. The Macmillan edition of *Captain Slaughterboard Drops Anchor* had a bright yellow background to a number of the drawings. Nelson, not Eyre & Spottiswoode, published an identical edition in the United Kingdom, using the same yellow motif. When Maeve, who wanted Mervyn to realize that there was a renewal of interest in his work, took a copy along with her to The Priory and showed it to him, he brushed it angrily aside. When she

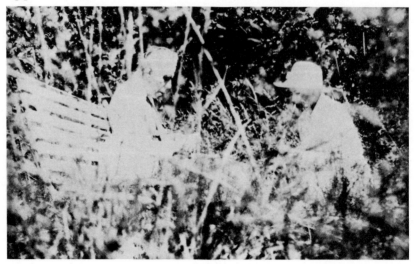

Mervyn and Maeve on his 56th birthday, at The Priory

returned home that evening, she said, 'He didn't like it. In fact, he got quite annoyed with it. He said the colour spoilt his drawings. But, at least, he recognised it as his book; and I think he was pleased, all the same, to know that it had been republished.'

Only his outraged artistic flair could rouse him from the apathy produced by his illness and the sedatives he was given to combat his restlessness. His physical appearance changed. At fifty-six, he was like a man twenty or more years older—stooped and bent, and only able to walk by leaning heavily on a male nurse, or, when Maeve visited him, on her. They would walk slowly round the garden, mostly in silence. But, sometimes, a few words would come out of him, a momentary smile, a look that showed that still somewhere inside the ravaged body was the vibrant and vital person he used to be, the person whose works were now, at last, on the point of being widely understood.

The Governors of The Priory decided that a portion of the grounds should be sold to a development company for the construction of flats, and that the activities of the nursing-home should be curtailed. Some of the patients were men who had been wounded in the Great War of 1914–18, others were 'pop' stars who had found the going too hard. The wing where Mervyn had his room was to be closed down, and the building demolished.

But already Maeve was looking for another hospital equipped and willing to take him. Oddly enough, it was from close at hand that a solution was found. Maeve's eldest brother, James, was a doctor. Some years earlier, he and his wife had started a home for the old and the sick, near Abingdon in Oxfordshire. It was called The Close, and it claimed that no one was ever turned away. Dr Gilmore had suggested, when he was on a visit to his sister, that it might be the place for Mervyn as his symptoms were now very much like those of old age. The Close would be happy to look after him. He could feel that he was in a family environment, and the country air would be good for him. The expense would be a quarter of that of The Priory. So Maeve went to Oxfordshire to have a look at The Close. It had a beautiful garden, a lawn running down to the banks of the Thames, trees and flowering shrubs and views across the peaceful Oxfordshire countryside. The atmosphere, as Dr Gilmore had said, was like that of a home. But still she hesitated. 'It's so far away,' she said, 'it will be difficult to see him so often. As long as he can still recognise me, I want to go on seeing him. Perhaps I'm being selfish. Perhaps he would be better in the country.'

But the moments of recognition were becoming rarer. During the three years he had been at The Priory, he had filled, little by little, during her visits to him, ten note books full of drawings. Some of them were mere scribbles and wavering lines, but some were startlingly assured, as if the inner talent was still able, at times, to break through the bonds of his illness and regain its old strength. But now he was not drawing any more. When she held out the books and pencils for him, he would push them petulantly away.

She would come away now from The Priory more and more frequently in tears. 'He didn't recognise me,' she would say. 'Oh, where has he gone? He's leaving us for good now. I know it. I sense it. Perhaps, it is better for him that way. He may be happier now.'

The doctors were also urging her to send him to the country, and with the date for the closure of his part of The Priory now almost settled, she had very little choice. One blustering day in March 1968, an ambulance called at the Priory, and Mervyn, with Maeve beside him to calm his fears, was driven to The Close.

There was an almost immediate improvement in his condition. The country air indeed had an invigorating effect on him. He would

sit with the old people, some of whom were twenty-five or thirty years his seniors, dozing or lost in an unknown inner world. The tremors had largely subsided as if they had worn themselves out, and the restlessness that was such an exhausting feature of the illness had been replaced by indifference and calm. He ate well, and there were sometimes flashes of his old sense of humour. There was optimistic talk that he might start drawing again, but whenever paper and pencil were put in front of him, he continued to push them angrily away.

Once a week, usually on a Saturday, Maeve would visit him. Members of the family or friends would drive her. Just as when she was going to The Priory, she would put on a pretty dress and take her basket of sweets and presents. It was almost as if she were going on a picnic. As week followed week, the English countryside, passing from spring to summer, became more and more opulently beautiful. Mervyn and Maeve would walk by the river, or sit together by the trees. 'He's much happier there,' she would say, on the way back to London, 'but he's gone further away, much further. It's almost impossible to break through to him now. It's sadder for me, but better for him, and that's what matters.'

In the meantime the preparations for the re-issuing of the *Titus* books, in both America and Britain, were going steadily ahead. Eyre & Spottiswoode were producing thick, well-illustrated editions of *Titus Groan* and *Gormenghast*, but were faced with a problem where *Titus Alone* was concerned. Mervyn had been so ill when he was writing it that a good deal of the manuscript was illegible, and some of it was incomplete. He had not been able to correct it himself, and the 1959 original edition had been severely cut by the publishers. When the question of reprinting the book had come up, Michael Moorcock suggested that Langdon Jones should restore as much of the original as possible. The publishers eventually agreed to this, so that the new edition of the third volume of the trilogy would be different from the first edition.

Advance copies of the first two volumes were sent to Drayton Gardens during the late summer of 1968. Next time Maeve went to The Close, she took the two volumes in her basket with her. Although the drawings on the dust-covers were by Mervyn, they were different from those on the original editions. Inside, there were some of the illustrations he had drawn when writing the book.

That afternoon, on her way back to London, she said, almost with happiness, 'He recognised them. He knew they were his work. He kept fondling them as if they were precious stones. I think he realises that interest in his work is really being re-awakened.' The American publishers, however, were not prepared to use any of Mervyn's drawings for their dust-covers. Ballantines had recently published Tolkien's *Lord of the Rings* with pseudo-gothic illustrations, and they employed the same artist to prepare the dust-covers of the *Titus* books. The result was 'Disney medieval', and made the books look as if they were about the adventures of King Arthur and the Lady of Shalott. Maeve called them 'Hieronymus Disney' and Michael Moorcock 'Walt Bosch'.

The drawing-room at Drayton Gardens contained a desk that had followed old Dr Peake from China to Wallington and Burpham. He used to keep many Chinese ornaments on it, and when Sebastian and Fabian were small boys, he would take them on his knees and move the objects about as though they were playing some kind of game. Now it contained the family's letters, ledgers and bills. Here Maeve would sit, slowly writing her own recollections of Mervyn, in order to relieve the pain his illness caused her. Behind her, beneath the 'Still Girl' painting on the wall, a round table contained the vertebrae of a whale, with a bowl of flowers on top, and around it were always scattered the latest of Mervyn's publications. But it took her a long time before she could put the 'Disney medieval' books out, and she never, remembering his dislike of the yellow illustrations to Nelson's *Captain Slaughterboard Drops Anchor*, showed them to him.

Mrs Ballantine wrote from New York suggesting that Maeve should go there to represent her husband at the time the books were due out. It would be good publicity, and good for sales. She and her husband would like to invite her to their home near Woodstock. It would be a visit combining business and pleasure. America 'in the fall' was beautiful. Maeve agreed, somewhat reluctantly. Like Mervyn, she did not transplant well. She did not like 'abroad' very much. But she liked Mrs Ballantine, whom she had met on a number of occasions in London. Mervyn was well settled at The Close, lost to the family, and aware only of his immediate surroundings, of the sunshine, the river and the flowers— almost, as far as could be seen, at peace. He could be safely left for

the few weeks the visit would take. She was always prepared to do anything to rehabilitate Mervyn's name and to bring him the recognition she felt should be his. Clare, now nineteen, would go with her.

So it was arranged, and one day, in the early autumn of 1968, Sebastian drove his mother and sister to London Airport, and presently their aircraft wheeled away to the outfield, and took off for the United States.

New York that autumn was exceptionally hot, yet the hotel, on the edge of Greenwich Village, had the central heating full on. Air seemed to be in short supply, for very little of it was ever allowed into the building. New York was an exhausting, frightening place, but everyone was kind and it was gratifying to see Mervyn's books displayed so prominently in the bookshops. Here, at last, was tangible evidence of the revival of interest. And the week-end at Woodstock, with the Ballantines, was a glorious holiday.

Nevertheless, Maeve was pleased to be back in London, and to be able to go, once again, to The Close and to sit for a little while with the silent man whose work it was they had all been talking so enthusiastically about on the other side of the Atlantic.

23 Recognition

Suddenly, towards the beginning of November, Dr Gilmore telephoned from The Close and said that there had been a physical deterioration in Mervyn's condition. Maeve and Dr Robbins immediately went to Abingdon. They found Mervyn in bed. He no longer sat with the old men and women. He was only eating with great reluctance. He seemed to be completely unaware of what was going on around him. 'He's given up,' she said on her return to London. 'He's not fighting any more. I don't think he wants to go on living.'

But with a disease like Parkinson's, no one could tell. He could live, the doctors believed, for twenty or twenty-five years in a semi-conscious state; on the other hand, the disease might, at any time, make a new move and destroy a vital organ.

On Saturday, 16 November, Maeve went down again to The Close. It was a cold, wet day; the clouds raced across the open Oxfordshire sky, endlessly forming turbulent patterns. From time to time, squalls of cold slanting rain slashed at the brick walls of The Close. Beside the bed where Mervyn lay utterly motionless, Maeve and her brother spoke in whispers. From time to time they looked at the sick man, but he never showed by so much as a quiver that he knew that anyone was in the room.

Later, on the way back to London, she said in a low, trembling voice: 'There's something else the matter with him now. It's not Parkinson's. I don't know what it is. He seemed dead. I can't see how he can go on living.' For the first time, in all the years of sorrow

and endeavour, the sprightliness had gone out of her. She sat quietly in the car, the tears running unchecked down her cheeks.

When she got back to Drayton Gardens, she walked straight into Mervyn's room, turned on the light and went over to the old Moutrie piano that had followed Mervyn all through his life. His mother had played tunes to him on it in their house in the French compound in Tientsin, and his wife was playing for him as he lay dying in her brother's house in Oxfordshire. Despite the optimism of those around her, she felt that this time there would be no future, no return, an end to false hopes. In the morning, she would go down to Abingdon again, perhaps for the last time.

Her instinct was right, but the end came faster than she imagined. The next morning, soon after breakfast, the telephone rang. It was her brother James, telling her that Mervyn had died. She took the news with stoic calmness, rang Fabian and told Sebastian and Clare, who were still living in Drayton Gardens. Sebastian was to drive them all down to Abingdon. Lonnie got permission from the vicar for Mervyn to be buried in the graveyard of the little Norman church at Burpham, where his mother and father lay already. It was a quiet and beautiful place, with peaceful views over the Downs. Now, it was just a matter of putting into effect the plans already laid down, and Dr Gilmore took charge of the necessary arrangements.

Because Mervyn had been ill for twelve years, and had spent the last four wholly in hospital, his death did not have a cataclysmic effect on his family. There was no traumatic disruption of their way of life, no upheaval or removal to another part of the world. He had, so far as his family and friends were concerned, died years before. Their lives had been reshaped then. His physical death was a confirmation of an earlier spiritual one.

Besides, his presence existed in his work. His paintings and drawings still hung on the walls of Drayton Gardens. His room on the ground floor remained untouched. The two easels still held their canvases, as if he had just gone out of the room for a few hours. The table was covered with papers, drawings, letters, ever-thickening bundles of press-cuttings and books. The work went on. For years now, publishers and those in search of information had been coming to Maeve for guidance. They continued to do so in ever-increasing numbers. There was so much that had never been

published, or was in need of republication, that it was almost possible to believe, as new drawing after new drawing was revealed, that he was still somewhere, secretly at work.

Most artists and writers leave very little of worth unpublished behind them. But Mervyn's case was quite different. For a relatively short period he had turned out an almost superhuman amount of work, at a time when he was only spasmodically recognized. Then illness had struck, and for twelve years virtually nothing had been produced. Now, at last, he was to find real popularity.

A memorial service was arranged for 6 December at twelve noon in St James's Church, Piccadilly. The Vicar of St James's was to be in charge of the service, Sir John Clements was to read a selection of Mervyn's poems, and Tony Bridge, Mervyn's companion at the Royal Academy Schools and on Sark, and now the Dean of Guildford, was to give the address. The church flowers were arranged by Maeve's sister, Matty, who, with her husband Henry, ran a profitable flower business.

Over four hundred people made their way to the elegant Georgian church. There were, in addition to the family, representatives from publishing firms and art galleries, and many of the friends who had known Mervyn at different times in his life. The Countess of Moray, whom he had taught to paint and who had remained a devoted friend of the family ever since, was there; so were Esmond Knight and his wife, Nora Swinburne, and Miss Greek who had modelled for him, for Maeve, and finally for Fabian.

There were people, too, who had met him only for a short time, but who had always retained a vivid memory of him—such for example as Edmund Laird-Clowes and his wife:

> We went to Sark on holiday in 1950 [he recalled]. I was working then with Eyre & Spottiswoode, and we had recently published his book, but that was not why my wife and I were there. It was just by chance that we chose Sark. He was there with his two sons, Sebastian and Fabian, while his wife and baby daughter were in London. They had just moved, and I think they were back in Sark to tidy up. Our eldest son was very ill and screamed a great deal; I remember Mervyn said that babies who screamed did not worry him in the least. He seemed to be completely at his ease with children of all ages, and did a wonderful chalk drawing of our son. We were there a fortnight, and though we

did not pursue the friendship on our return from holiday, neither my wife nor I ever forgot him.

Many of the congregation noticed, when they came out of the church, that two tramps sat, side by side, in complete silence, on a bench in the forecourt. Their faces were so odd and their clothes in such a tattered state that they might have been waiting there for Mervyn to make quick sketches of them, for use in some future book. They sat as still as statues for a little while, and then, quite suddenly, they were no longer there. One of the guests, not normally fanciful, said afterwards, 'I'm sure they *knew*, and had come from Gormenghast for the service. When the service was over I expect they went quietly back to the castle!'

The first volumes of the Penguin edition of the *Titus* books were now on sale, and the reviews followed each other from then onwards.

John Hartridge, in the *Oxford Mail*, wrote: '. . . it is strange to reflect that the generation that took to Tolkein has not yet taken to Peake. It still may.'

The Penguin editions began to sell immediately, and as soon as stocks were exhausted in the bookshops, re-order slips were sent to the publishers. The people who bought the books were a new generation. To them, Peake became a cult figure. Young men and women on the road to Katmandu would have 'a Peake' in their knapsacks. Others attempted to make the pilgrimage to South Kensington, and were somewhat surprised to find that Mervyn Peake had not been an English Che Guevara, but came from a conventional and middle-class family with such characteristics as a taste for cricket and an inclination towards patriotism. The Titus books became a subject of theses. Visitors from the U.S.A. would make a point of ringing Maeve for an interview. A Titus Groan pop group was formed. So too, in 1975, was a Mervyn Peake Society.

While the bulk of the new readership came from the under-twenty-fives, older readers were also buying the books. As the popularity of the books increased, so, too, came a renewed interest in the paintings and drawings—especially the drawings. Gallery owners, who had dismissed him a few years earlier, were now eager to get hold of anything of his. Private buyers approached Maeve and offered sums that a few years earlier would have been welcomed. But on this one subject she showed the bitterness that constant

rejection had engendered. 'Nobody would look at his work when we were in desperate need,' she said quietly. 'Now that he is a cult figure, they are falling over themselves. It's too late.' She was accused of wanting to hold on to the paintings and drawings in order to get better prices later on, but here again there was a mis-understanding of her objectives: he should receive the recognition that was his due. 'I would like the Tate or the National Gallery to have a collection of his work,' she said. 'There have been offers from foreign galleries, but his work should remain in his own country.'

There were other signs of Mervyn's increasing popularity. His long short story 'Boy in Darkness', which had originally been published as part of *Sometimes, Never*, was re-issued in May 1969, in company with two science-fiction stories, by the new publishing firm of Allison & Busby; a few days later, Tim Souster's *Titus Groan Music* was put on by the Macnaghten Concerts. In October of that year, Allison & Busby republished *Mr Pye*, which had been largely ignored while the author was alive but was now hailed by the critic of the *Illustrated London News*, on 1 November, as 'a witty debate about good and evil'.

For the past five years, Maeve, herself, had been writing a book about the life she and Mervyn had led. She had started it to relieve the tensions and strain of seeing the slow destruction of the man she loved, but when it was finished she was persuaded to show it to a publisher, who kept it for nine months and then returned it. Mike Moorcock, who had become well known as a science-fiction writer but was ever ready to spring to the defence of Maeve and Mervyn, told Giles Gordon, then a director of Gollancz, about the book, and persuaded Maeve to send it to him.

Gollancz promptly accepted the book and arranged to publish it on 18 June 1970. Maeve was extremely nervous of the reception it might receive, and her agitation was not lessened when she heard that Harold Wilson had chosen that day for a General Election. Though friends assured her that this would have no effect on the reception of the book, she asked, with mock seriousness, 'Why did he have to chose the day my book comes out?' She hoped he would lose, to serve him right for being so unkind; as it turned out, he did. The book, *A World Away*, was an immediate success, both with the critics and the public. Many letters came from people whom she

had never met, and she was quite overwhelmed by the success. 'I did it for Mervyn,' she said. 'I wish he had been alive to see it.'

She was approached by the National Book League with the idea of arranging the first comprehensive exhibition of Mervyn's work. Clifford Simmons was in charge of the exhibition, which was to be part of the 'Word and Image' series he was mounting to show the works of artists who were also writers, and writers who were also artists. It opened on 5 January 1972 at the National Book League's premises in Albemarle Street. There was an appreciative review in *The Times* on the opening day, headed 'Return of the Peake District' and written by Brian Alderson. This carried two illustrations of Mervyn's work: a pencil drawing of W. H. Auden, done in 1937, and an illustration from *Captain Slaughterboard Drops Anchor*. The *Guardian* ran a huge four-column article by Alex Hamilton under the title 'Mervyn Alone'. It had illustrations of two of the drawings exhibited, and a reproduction of a romantic photograph of Mervyn and Maeve together when they were first engaged. On Friday, 14 January 1972, the BBC2 programme 'Review' featured Mervyn's work; on the following day, Terence Mullaly wrote, in the *Daily Telegraph*, an appreciative article, 'The Message of Mervyn Peake'; *Time Out* reproduced *The Sphinx*, the cat-lady drawn in 1948 which illustrated the cover of the catalogue.

The public poured in. The exhibition was a revelation to many people, for it showed for the first time the enormous diversity of Mervyn's genius. Many people knew some aspect of his work: some had read his books; some had seen his paintings; some appreciated his poems; many considered his illustrations to be his finest work, but this was the first time that anyone, outside his immediate family and close friends, had been able to glimpse, even partially, the whole range. Despite the electricity cuts caused by a miners' strike, the exhibition attracted people in their hundreds. It was to have closed on 28 January, but was extended until 3 February. A delighted Clifford Simmons said that they had had more people there than for any exhibition except the Beatrix Potter one.

Since then, edition after edition of the Titus books has been printed and sold; collections of previously unpublished works have been put together and published, usually with an introduction by

Maeve. Expensive and lavishly illustrated collections of his drawings, paintings and writings have been produced. More recently, there have been approaches by well-known and not-so-well-known film directors.

Though success is always appreciated, the tragedy still remains that this time it came too late. In those last few years of his life, Mervyn was, perhaps, half-aware that recognition was coming. In one of his earlier poems, he philosophically writes:

> In death's unfelt fraternity the cold
> And horizontal dead bestrew the world.
> And you and I must add our little quota
> To the globe's veneer.
>
> What is more ghastly than death's brotherhood?
> This doomed, this fragile life, this pounding blood,
> This hectic moment of fraternity.
> This *you* . . . this *me*.

He added more than a little quota to the globe's veneer, although he himself would have denied this. As Tony Bridge said at the memorial service, Mervyn would have been astounded, and not a little amused, that the service had been held at all. Except for those last few years, when illness almost completely clouded his mind, he retained the humour and the awe that life inspired. As he wrote earlier, in *The Glassblowers*:

> The vastest things are those we may not learn.
> We are not taught to die, nor to be born,
> Nor how to burn
> With love.
> How pitiful is our enforced return
> To those small things we are the masters of.

On his tombstone, in the quiet graveyard in Burpham, is carved the first line of another poem of his:

> To live at all is miracle enough.

BIBLIOGRAPHY

1. PUBLISHED WORKS. All published in London, unless otherwise stated

Captain Slaughterboard Drops Anchor. Country Life, 1939
 Eyre & Spottiswoode, 1945
 Macmillan, New York, 1967
 Nelson, 1967

Shapes and Sounds. Chatto & Windus, 1941
 Transatlantic, New York, 1941
 Macmillan, Toronto, 1941

Rhymes Without Reason. Eyre & Spottiswoode, 1944
 Methuen, 1974

Craft of the Lead Pencil. Wingate, 1946

Titus Groan. Eyre & Spottiswoode, 1946
 Reynal & Hitchcock, New York, 1946
 Collins, Toronto, 1946
 Weybright & Talley, New York, 1967
 Eyre & Spottiswoode, 1968
 Penguin, 1968
 Ballantine, New York, 1968

Letters from a Lost Uncle. Eyre & Spottiswoode, 1948
 Collins, Toronto, 1948

Drawings by Mervyn Peake. Grey Walls Press, 1949
 British Book Centre, New York, 1949

The Glassblowers. Eyre & Spottiswoode, 1950
 Collins, Toronto, 1950

Gormenghast. Eyre & Spottiswoode, 1950
 British Book Centre, New York, 1950
 Collins, Toronto, 1950
 Weybridge & Talley, New York, 1967
 Eyre & Spottiswoode, 1968
 Ballantine, New York, 1968
 Penguin, 1969
Mr Pye. Heineman, 1953
 Allison & Busby, 1969
 Penguin, 1972
Figures of Speech. Gollancz, 1954
Boy in Darkness. Eyre & Spottiswoode, 1956
 Allison & Busby, 1969
 A. Wheaton, 1976
Titus Alone. Eyre & Spottiswoode, 1959
 Weybright & Talley, New York, 1967
 Eyre & Spottiswoode, 1968
 Ballantine, New York, 1968
 Penguin, 1970
The Rhyme of the Flying Bomb. Dent, 1962
 Colin Smythe, 1973
Poems and Drawings. Keepsake Press, 1965
A Reverie of Bone. Rota, 1967
Selected Poems. Faber & Faber, 1972
A Book of Nonsense. Peter Owen, 1972
 Picador, 1974
The Drawings of Mervyn Peake. Davis-Poynter, 1974
Mervyn Peake, Writings and Drawings. Academy Editions, 1974
 St Martin's Press, New York, 1974
Shapes and Sounds. Village Press, 1974
Titus d'Enfer. Stock, Paris, 1974
Twelve Poems. Brans Head Books, 1975

2. BOOK ILLUSTRATIONS. All published in London, unless otherwise
stated

Ride a Cock Horse and Other Nursery Rhymes. Chatto & Windus, 1940
Carroll, Lewis, *The Hunting of the Snark.* Chatto & Windus, 1941
 Zodiac Books, 1948

Coleridge, S. T., *The Rime of the Ancient Mariner*. Chatto & Windus,
<div align="right">1943</div>
<div align="right">Zodiac Books, 1949</div>
<div align="right">Chatto & Windus,</div>
<div align="right">1971</div>

Joad, C. E. M., *The Adventures of the Young Soldier in Search of the Better World*. Faber & Faber, 1943
 Ryerson Press, Toronto, 1943
 Arco, New York, 1944

Crisp, Q., *All This and Bevin Too*. Nicholson & Watson, 1943

Laing, A. M., *Prayers and Graces*. Gollancz, 1944

Hole, C., *Witchcraft in England*. Batsford, 1945
<div align="right">Irwin Clark, Toronto, 1945</div>
<div align="right">Scribner, New York, 1947</div>

Carroll, Lewis, *Alice's Adventures in Wonderland*. Zephyr, Stockholm
<div align="right">1946</div>

Collis, M., *Quest for Sita*. Faber & Faber, 1946
<div align="right">Day, New York, 1947</div>

Grimm, the Brothers, *Household Tales*. Eyre & Spottiswoode, 1946
<div align="right">Methuen, 1973</div>

Stevenson, R. L., *Dr Jekyll and Mr Hyde*. Folio Society, 1948
<div align="right">*Treasure Island*. Eyre & Spottiswoode, 1949</div>

Haynes, D. K., *Thou Shalt Not Suffer a Witch*. Methuen, 1949

Wyss, J., *The Swiss Family Robinson*. Heirloom Library, 1950

Blackwood, A., *The Wendigo*. Lilliput, 1952

Drake, H. B., *The Book of Lyonne*. Falcon Press, 1952

Palmer, E. C., *The Young Blackbird*. Wingate, 1953

Carroll, Lewis, *Alice's Adventures in Wonderland and Through the Looking Glass*. Wingate, 1954

Sander, A., *Men: A Dialogue between Women*. Cresset Press, 1955

Niklaus, T., *Harlequin Phoenix* (jacket and frontispiece only). Bodley Head, 1956

Drake, H. B., *Oxford English Course for Secondary Schools*, Book 1. O.U.P., 1957

Laing, A. M., *More Prayers and Graces*. Gollancz, 1957

Gissing, G., *New Grub Street* (jacket only). O.U.P., 1958

Judah, A., *The Pot of Gold and Two Other Tales*. Faber & Faber,
<div align="right">1959</div>

Balzac, H. de, *Droll Stories*. Folio Society, 1961

3. SOURCES OF REFERENCE

Most of the material in this book has not been published before, as it was compiled from interviews, correspondence and fragments of information put together over a period of five years.

Only one memoir of Mervyn Peake has appeared so far, and that is Maeve Gilmore's moving account of her husband and their life together, *A World Away, a Memoir of Mervyn Peake* (Gollancz, 1970, New English Library, 1971).

A critical exploration, with a short biographical foreword, was written by John Batchelor: *Mervyn Peake, a biographical and critical exploration* (Duckworth, 1974).

Various articles and introductions to other books have given information about Peake's life and work. These include:

Brogan, Hugh, 'The Gutters of Gormenghast', *Cambridge Review*, 1973

Crisp, Quentin, *The Genius of Mervyn Peake*, Facet, 1946

Denver, Bernard, 'Mervyn Peake', *Studio*, 1946

Gilmore, Maeve, Introduction, *A Book of Nonsense*. Peter Owen, 1972
Picador, 1974
Introduction, Mervyn Peake Exhibition
Catalogue, National Book League, 1972
Preface, *Shapes and Sounds*. Village Press, 1974

Gilmore, Maeve and Johnson, Shelagh, Introduction, *Mervyn Peake, Writings and Drawings*, Academy Editions, London, and St Martin's Press, New York, 1974

Hutchinson, Pearse, *Mervyn Peake*. Comhan, 1959

Moorcock, Michael, *Architect of the Extraordinary*. Vector, 1960

Sarzano, Frances, 'Mervyn Peake', *Alphabet and Image I*. 1946

Spurling, Hilary, Introduction, *The Drawings of Mervyn Peake*. Davis Poynter, 1974

In addition, the following works have been consulted:

Peake, Dr E., 'Memoirs of a doctor in China'. Unpublished

Sacks, Oliver, *Awakenings*. Duckworth, 1973
Penguin, 1976

Witting, Clifford (ed.), *The Glory of the Sons*. Headley Bros., London, printed for the Board of Governors, Eltham College, 1952

INDEX